HISTORIC PHOTOS OF
GREATER
HAMPTON ROADS

TEXT AND CAPTIONS BY EMILY J. AND JOHN S. SALMON

TURNER
PUBLISHING COMPANY
NASHVILLE, TENNESSEE PADUCAH, KENTUCKY

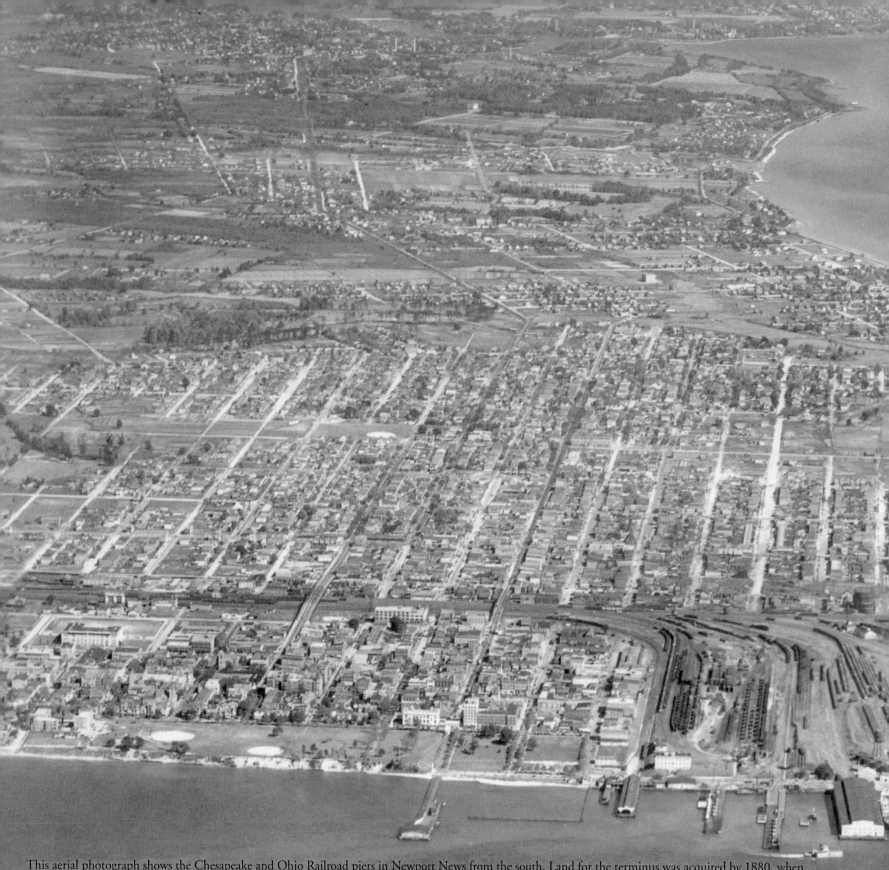

This aerial photograph shows the Chesapeake and Ohio Railroad piers in Newport News from the south. Land for the terminus was acquired by 1880, when Collis P. Huntington, owner of the railroad, announced the project. The railroad then extended from Newport News through Richmond and westward to the great Pocahontas coalfield in West Virginia. Huntington considered Hampton Roads, with its sheltered, ice-free, deep-water harbor, the perfect place to gather and then ship coal and other products out to the world.

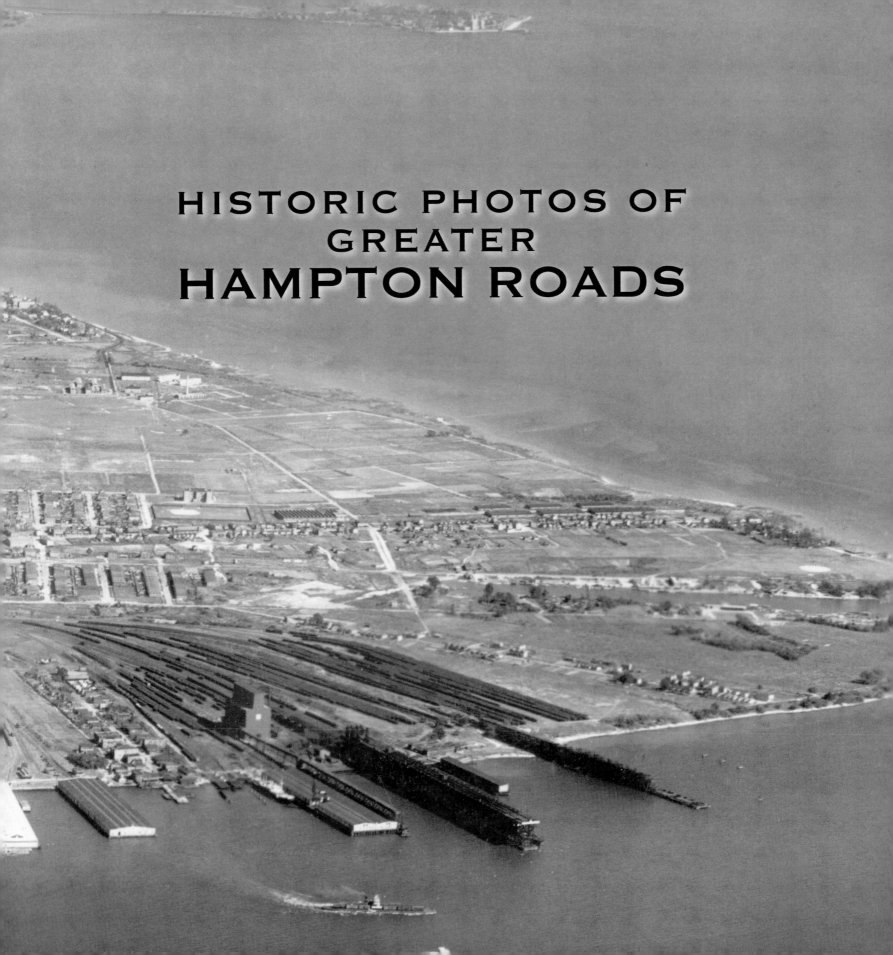

HISTORIC PHOTOS OF GREATER
HAMPTON ROADS

Turner Publishing Company
200 4th Avenue North • Suite 950 412 Broadway • P.O. Box 3101
Nashville, Tennessee 37219 Paducah, Kentucky 42002-3101
(615) 255-2665 (270) 443-0121

www.turnerpublishing.com

Historic Photos of Greater Hampton Roads

Library of Congress Control Number: 2007929604

ISBN-13: 978-1-59652-397-5

Printed in the United States of America

07 08 09 10 11 12 13 14—0 9 8 7 6 5 4 3 2 1

CONTENTS

Four young women pose as fishers on the Virginia Beach pier in this promotional photograph from 1957.

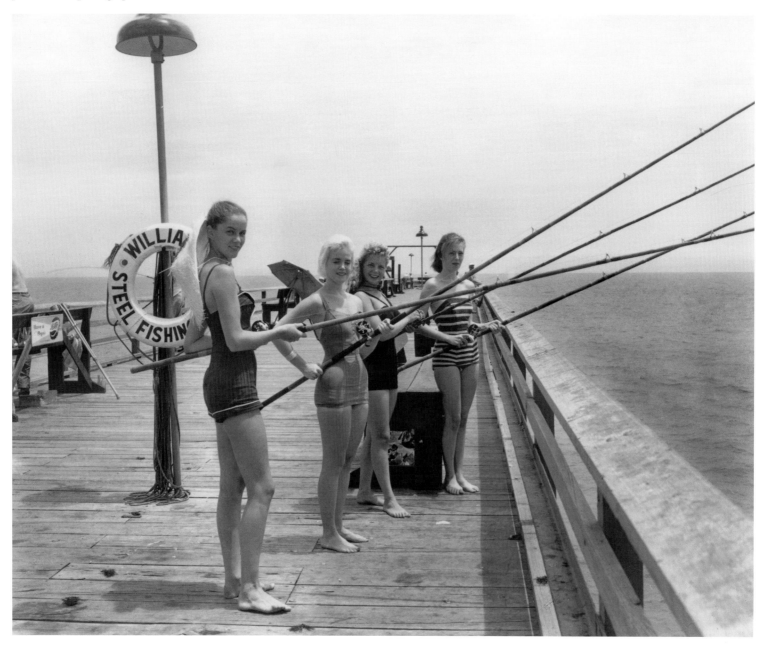

Acknowledgments

This volume, *Historic Photos of Greater Hampton Roads,* is the result of the cooperation and efforts of many individuals and organizations. It is with great thanks that we acknowledge the valuable contribution of the following for their generous support:

Hampton Library

Library of Congress

Library of Virginia

Virginiana Collection, Main St. Library, Newport News Public Library System, Newport News, Va.

Portsmouth Public Library, Portsmouth, Va.

PREFACE

The history of the Greater Hampton Roads area has been captured in thousands of photographs that reside in archives, both locally and nationally. This book began with the observation that, while those photographs are of great interest to many, they are not easily accessible. The area today is growing and prosperous, with new residents arriving every day and prompting a demand for additional infrastructure and housing. Many residents, new and old, are curious about the local history, especially as the streetscapes and individual buildings associated with that history sometimes seem to be in the way of progress. Many people are asking how to treat these remnants of the past. The decisions made affect every aspect of the urban environment—architecture, public spaces, commerce, infrastructure—and these, in turn, affect the ways that people live their lives. This book seeks to provide decision makers—citizens and officials—a valuable, objective look into the history of Greater Hampton Roads through photographs of the area.

Although the photographer can make decisions regarding subject matter and how to capture and present it, photographs, unlike words, seldom interpret history subjectively. This lends them an authority that textual histories sometimes fail to achieve, and offers the viewer an original, untainted perspective from which to draw his own conclusions, interpretations, and insights.

This project represents countless hours of research. The editors and writers have reviewed thousands of photographs in numerous archives. We greatly appreciate the generous assistance of the individuals and organizations listed in the acknowledgments, without whom this project could not have been completed.

The goal in publishing this work is to provide broader access to these extraordinary images, to inspire, furnish perspective, and evoke insight that might assist those who are responsible for determining the future of Greater Hampton Roads. In addition, we hope that the book will encourage the preservation of the past with adequate respect and reverence.

With the exception of cropping images where needed and touching up imperfections that have accrued over time, no other changes have been made. The caliber and clarity of many photographs are limited by the technology of the day and the ability of the photographer at the time they were made.

The book is divided into four eras. Beginning with some of the earliest-known photographs of Greater Hampton Roads, the first section records the destruction caused by the Civil War, the rebirth of the area afterward, and the commemoration of the first English settlement nearby. The second section spans the first decades of the twentieth century, when the region grew as both an industrial and a vacation center. Section Three covers the years of the Great Depression and World War II. Section Four continues the story from the postwar years to the 1960s.

In each of these sections we have made an effort to capture various aspects of life through our selection of photographs. People, commerce, industry, recreation, transportation, infrastructure, and religious and educational institutions have been included to provide a broad perspective.

We encourage readers to reflect as they drive or walk the streets of Greater Hampton Roads, enjoy the beaches and parks, and experience the amenities of this bustling metropolitan area. It is the publisher's hope that in utilizing this work, longtime residents will learn something new and that new residents will gain a perspective on where the region has been, so that each can contribute effectively to its future.

—Todd Bottorff, Publisher

USS *Sabine,* shown in Hampton Roads in December 1864, was a ship-rigged sailing frigate built at New York Navy Yard and launched in 1855. Put into service as part of the North Atlantic Blockading Squadron in September 1861, *Sabine* spent the next three years sailing along the East Coast searching for Confederate blockade runners. In August 1864, the frigate was sent to Norfolk for use as a training vessel for navy apprentices and landsmen.

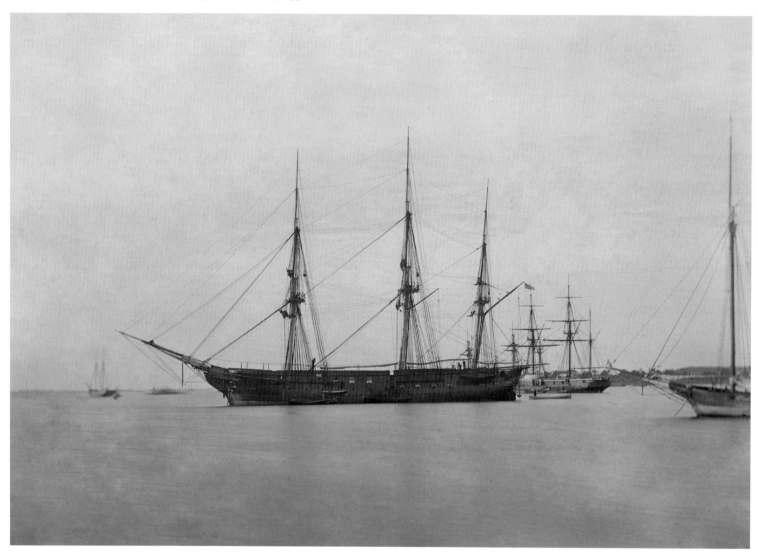

War, Rebirth, and Remembrance

(1860s–1909)

The English colonists who settled at Jamestown first set foot on the earth of America in what is now Greater Hampton Roads. They stepped ashore at present-day First Landing State Park, at a place they named Cape Henry, on April 26, 1607, before sailing up the James River to found their permanent settlement. Captain John Smith led expeditions through the region the next summer as he explored the Chesapeake Bay. Before long, the English had established outposts in the area of Hampton Roads to keep an eye out for Spaniards who might come and wipe out the little colony. The advantages of the natural harbors there and the abundance of oysters and sturgeon and other seafood delicacies quickly led to the settlement of Hampton Roads and Old Point Comfort.

A "roads"—short for roadstead in English nautical terminology—is a sheltered body of water that is not quite a harbor, in which ships may ride at anchor. That term describes Hampton Roads, a protected stretch of water that links the James River, the Chesapeake Bay, and the Atlantic Ocean. Today, the phrase "Greater Hampton Roads" is meant to include the cities of Chesapeake, Hampton, Newport News, Norfolk, Portsmouth, Suffolk, and Virginia Beach—the subjects of this book.

Harbors and rivers line the Roads, offering the colonists good sites for towns and ports. In some cases, as at Kecoughtan (present-day Newport News), they simply took over a preexisting Virginia Indian town. Later in the seventeenth century, the area was settled enough that several counties had been formed. By the mid eighteenth century, two principal towns—Norfolk and Portsmouth—had been built, and Hampton Roads and its towns constituted the prosperous center of the transatlantic trade in Virginia. From there, tobacco and other goods were shipped to England, and through the ports finished products and enslaved people were imported into Virginia. Shipyards, both for building vessels and for repairing them, were plentiful.

Prosperity did not ensure safety, however, and in fact the importance of the region made it a military target on more than one occasion. At the beginning of the Revolutionary War, the British and Americans burned most of Norfolk to the

ground. To keep that from recurring, the huge masonry Fort Monroe was constructed at Old Point Comfort during the early part of the nineteenth century to guard Hampton Roads, the Chesapeake Bay, and the James River. At the start of the Civil War, the Confederate authorities ordered Hampton (the town adjacent Fort Monroe) and the Gosport Navy Yard at Portsmouth evacuated and burned. Hampton was devastated for years, but the shipyard was quickly rebuilt. The area remained under Federal occupation throughout the war. Early on, slaves found that if they could escape to Fort Monroe, they would be treated as "contraband of war" and not returned to their Confederate masters. A contraband camp quickly sprang up around the post, nicknamed Freedom's Fortress. Efforts to educate these self-liberated people soon were under way, led by a local black seamstress, Mary Kelsey Peake, and from these modest beginnings Hampton Institute arose after the war.

During the immediate postwar period, commerce quickly resumed, and in the 1880s Newport News rapidly developed as a port and a city when Collis P. Huntington, the railroad magnate, decided to locate the terminus of the Chesapeake and Ohio Railroad there. Within a few years, he added a shipyard nearby, first to repair and then to build the vessels that transported the coal that arrived on his trains. Workers and managers alike began to visit the nearby beaches for relaxation, and boarding houses and hotels soon provided lodging for increasing numbers of visitors. Harrison Phoebus, owner of the Hygeia Hotel outside Fort Monroe, encouraged the extension of the railroad from Newport News to Old Point Comfort; the citizens of the community outside the fort gratefully named the town in his honor when it was incorporated in 1900. Two areas remained largely rural until well into the twentieth century: Nansemond County (present-day Suffolk), where large crops of peanuts were grown and a few knitting mills operated, and Princess Anne County, now Virginia Beach.

In 1907, a national celebration of the establishment of Jamestown was held at Sewell's Point in Norfolk, then largely vacant land. A host of exhibition buildings were constructed there for the Jamestown Ter-Centennial Exposition, some of which still stand. The event was not particularly profitable, but it turned national attention to Hampton Roads. From there, President Theodore Roosevelt sent the Great White Fleet on its goodwill (and intimidation) tour of the Far East, and naval men noted the advantages of the Hampton Roads area for future reference.

Hampton was burned under the orders of Confederate general John B. Magruder in August 1861 to prevent the Union army from housing troops and escaped slaves there. This scorched-earth act shocked Union lieutenant Charles Brewster, who wrote, "Such a picture of war and desolation I never saw nor thought of and hope I shall not see again." In the background of this photograph in front of the trees are the remains of historic Saint John's Church. Brewster lamented, "I pass through the courtyard round the celebrated Hampton Church [which dates from 1728], the oldest one in use in the United States, it is completely destroyed all but the walls and they are useless." Fortunately, Brewster was wrong; the walls were still strong enough to be repaired, and with contributions from all over the United States church services resumed there in 1869. Saint John's Church stands today as the only building to survive the burning of Hampton. This view depicts the town in December 1864 with mostly wooden dwellings.

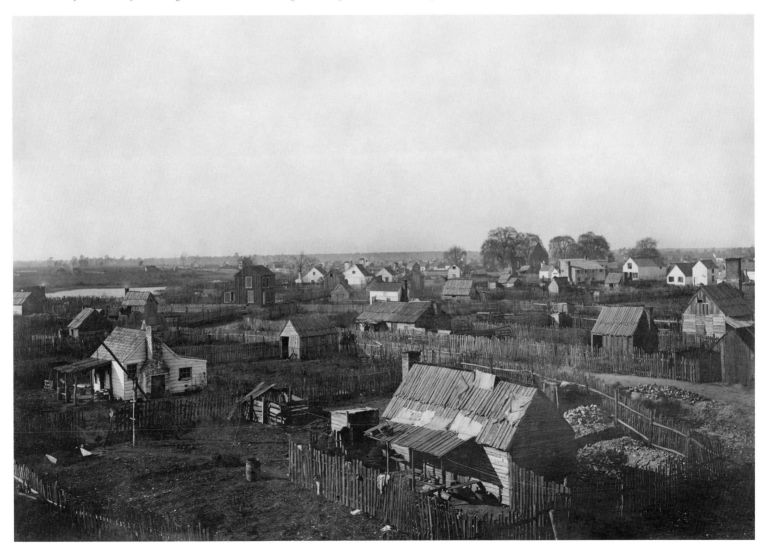

Union rear admiral David D. Porter and his staff are seen here in December 1864 aboard the flagship of the North Atlantic Blockading Squadron in Hampton Roads, USS *Malvern.* The ship, a 1,477-ton iron side-wheeled gunboat, had been built in 1860 and used as a Confederate blockade runner until captured by USS *Niphon* in November 1863. Named briefly *Ella and Annie,* the ship was used to hunt the Confederate steamship *Chesapeake* and then converted to a warship. Commissioned in February 1864 as USS *Malvern,* it came under the command of Rear Admiral Porter soon thereafter and served for the rest of the war as his flagship.

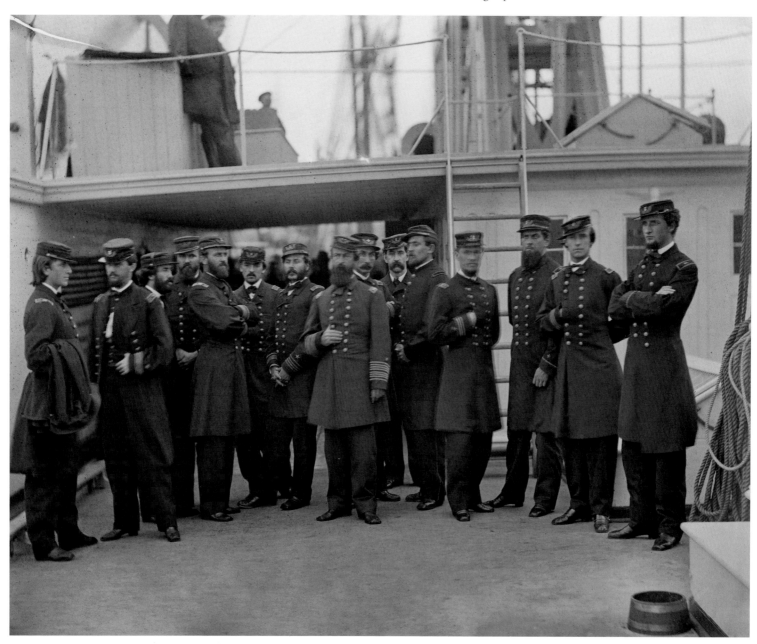

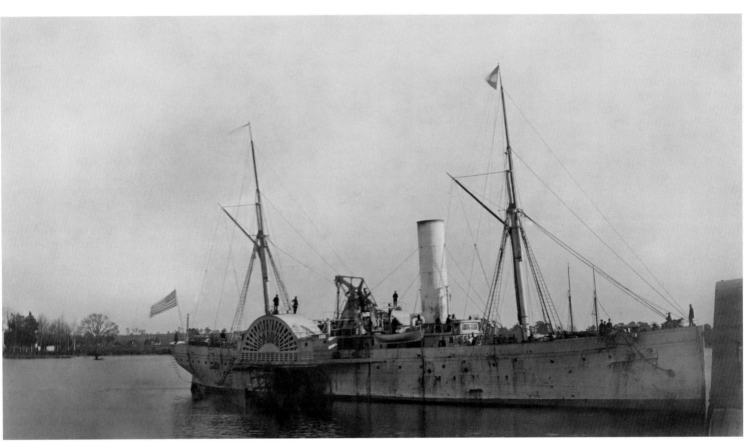

Anchored at Hampton Roads in December 1864, the steamer USS *Fort Jackson* was a 1,850-ton wood side-wheel cruiser built in New York City in 1862 as the civilian steamship *Union*. The U.S. Navy bought the ship in July 1863 and refitted it as a warship, commissioned as *Fort Jackson* in August. The ship joined the North Atlantic Blockading Squadron late in 1863 and spent the next year helping to enforce the blockade along the Confederate Atlantic Coast.

The Chesapeake Military Hospital in Hampton, seen here in December 1864, was founded in 1854 as the Chesapeake Female College. When Union major general Benjamin F. Butler arrived at Fort Monroe in May 1861, he took over the college to prevent the Confederates from using it as a location for spying on Fort Monroe. In November that year, the school was converted to a hospital for officers and named the Chesapeake Military Hospital. At the same time, on September 17, 1861, the American Missionary Association opened their first school for freedmen on the grounds of the former school. In 1870, the federal government converted the property for use as the Southern Branch of the National Home for Disabled Volunteer Soldiers, in part to care for members of the United States Colored Troops who did not want to go north for treatment. It appears to have been the first integrated federal facility in the United States.

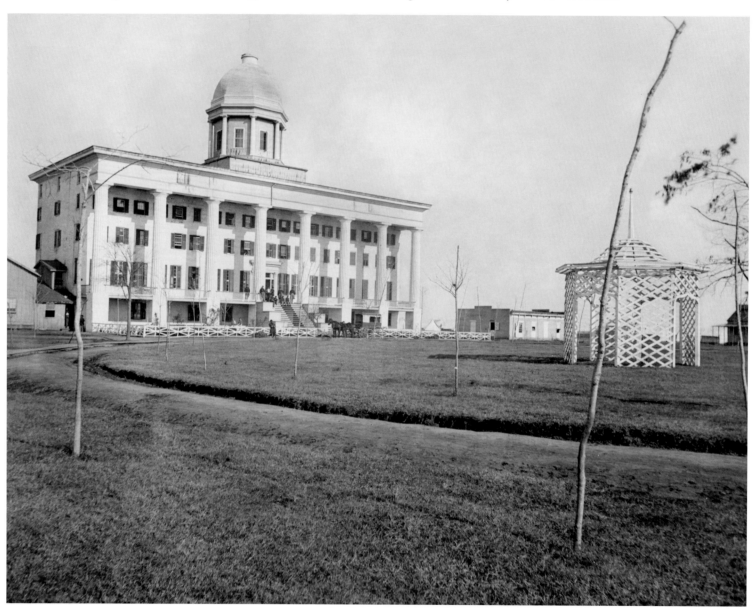

In this photograph taken sometime after Hampton's burning on August 7, 1861, the town stands in ruins, victim of the Confederate desire to prevent Union troops and escaped slaves from being housed there. The *Richmond Daily Dispatch* assumed that Union troops and slaves were responsible for the town's burning and reported on August 9, 1861, "The news of this last crowning act of barbarity seems to be confirmed. The quiet, unoffending old village, which even the British spared in the late war, has been converted into a heap of ashes by the black Republican invaders. A more wanton, unprovoked and infernal piece of pure diabolism was never committed." Before the war, Hampton had had thirty businesses and more than one hundred homes. Fewer than six buildings remained intact after the fire.

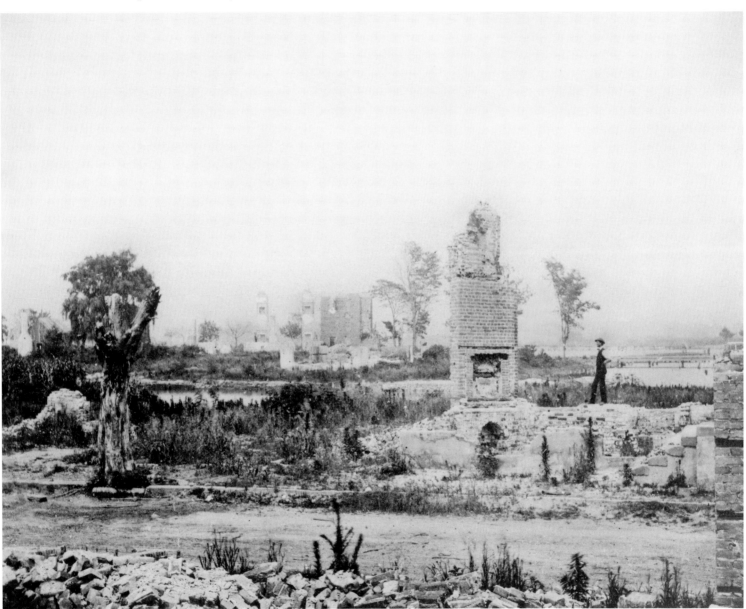

In their zeal to leave nothing useful for the invading Union forces, the Confederates also destroyed most of the Gosport Navy Yard in Portsmouth in May 1862 after the Union troops had occupied nearby Norfolk. The war correspondent for the *Philadelphia Inquirer* described the action for his readers in the May 13, 1862, edition: "The barbarous and wanton Rebels on the other side of the river have just learned that the city is occupied by Federal troops, and they are already applying the torch to everything that will burn at the Gosport Navy Yard. Now, at eight a.m., I can plainly see the entire yard in flames, which leap madly upward as if fanned by the cowardly Rebels behind as they fly before the advance of the union armies. The ship house, machine shop, carpenter shop and barracks, with the officers' quarters, are all in flames." In spite of all their efforts, however, the Confederates did not succeed in completely destroying the navy yard, today called the Norfolk Naval Shipyard although it is located in Portsmouth.

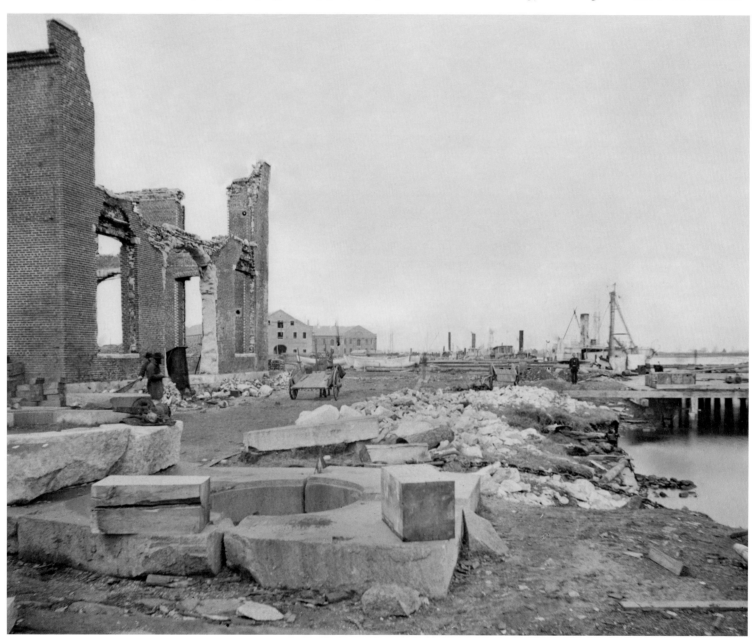

Believed to be the earliest photograph ever taken of downtown Portsmouth, this image shows High Street in 1871 looking west from Crawford Street after snow had fallen. Seen at lower-right is the sign for Howlett's Photography, perhaps the source of the photograph. The fourth building on the left with a high basement had been the home of Richard Cleveland, minister of the First Presbyterian Church and father of United States president Grover Cleveland. The elder Cleveland had served at the church for almost two years in the 1830s before taking a church in Caldwell, New Jersey, where the future president was born.

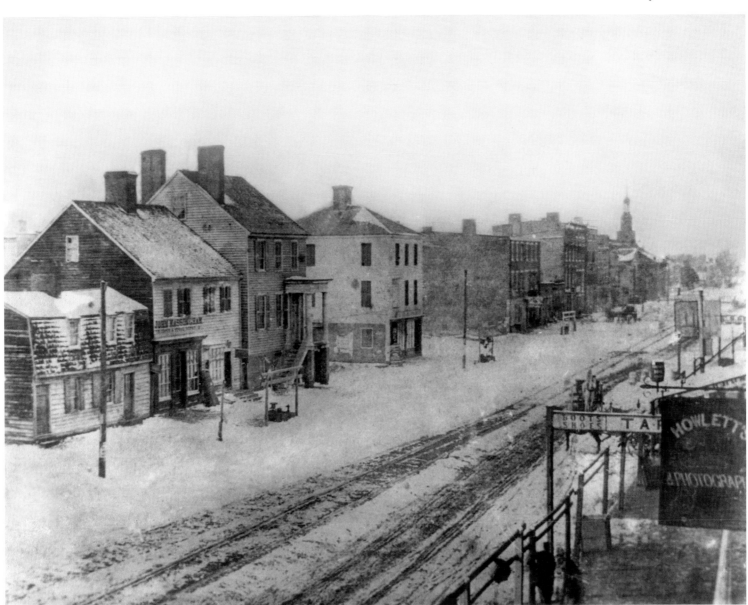

This view of the Newport News Shipbuilding and Dry Dock Company shows food wagons brought there by concessionaires to sell the shipyard workers snacks and lunches. Among the vendors are, in the foreground, the Union Bakery cart from 2508 Jefferson Avenue, and at center, the Newport Pie Company Dinette wagon.

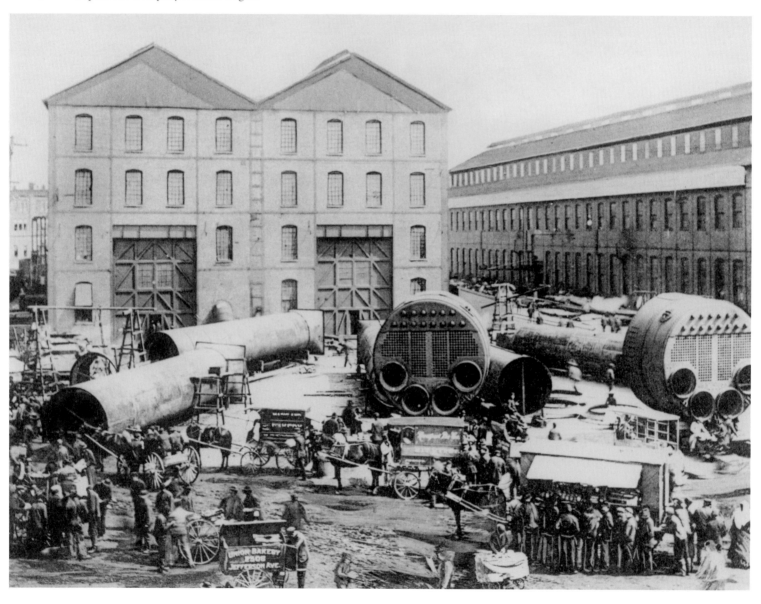

Warwick River County was one of eight Virginia shires enumerated in 1634. The county's name was shortened to Warwick County in 1643. Tradition has it that early court sessions were held under a large elm tree at Richneck Plantation, home of Colonel Miles Cary, Jr., near Denbigh, which became the county seat. Constructed of brick, Warwick's first courthouse was erected at Denbigh in 1810 and also served as the clerk's office and jail. The county built a new and larger courthouse in 1864 on the same tract, while the clerk's office remained in the old building, both of which served the county until it merged with the city of Newport News on July 1, 1958. This image is taken from an early-twentieth-century postcard and was made perhaps on the monthly court day.

Trinity Episcopal Church on High Street in Portsmouth, seen here in 1892, stands on the corner of High and Court streets. The original church was built at the site about 1762. During the American Revolution, the British garrisoned soldiers there for a time. After they departed, the church bell cracked following excessive celebration when the British finally surrendered at Yorktown. By 1828, the old church had deteriorated so much that instead of enlarging it, the congregation built a new one on the site. The new church, consecrated in January 1830, retained only one wall of the old one, which is believed to be part of the present church. In that same year the steeple and a new bell were added as well. During the Civil War, the church was used as a Confederate hospital. This view shows the church before it was greatly enlarged in 1893 and the belfry removed in exchange for a tower and an annex. The graveyard at the church was the only one in Portsmouth for many of the town's early years and tombstones there date to 1763.

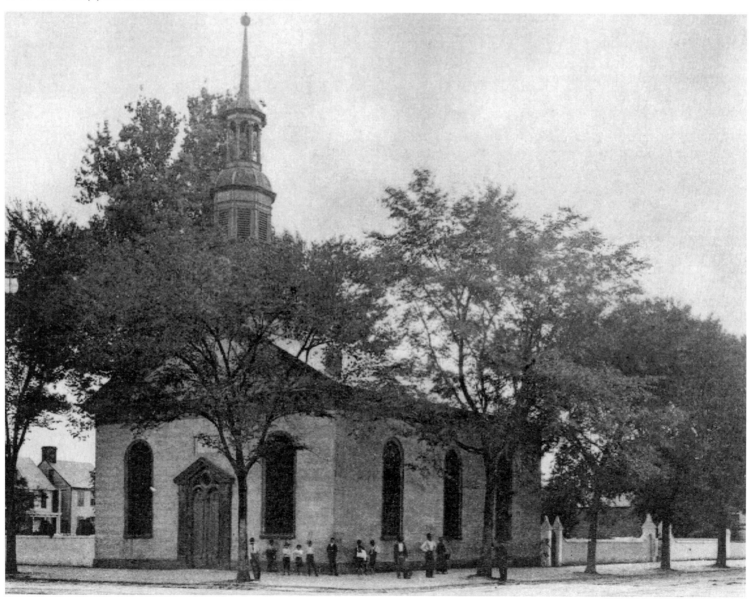

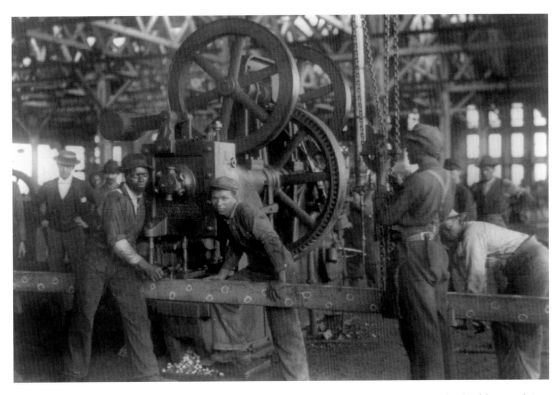

Workers operate a metal-punching machine about 1898 at the Newport News Shipbuilding and Dry Dock Company, punching single bars for the battleship USS *Illinois*. The vessel was laid down on February 10, 1897, and launched October 4, 1898. After service in World War I, the ship was excluded from service as a warship by the terms of the Washington Treaty and assigned instead to the New York Naval Reserve. On January 8, 1941, *Illinois* was renamed *Prairie State* so that her original name could be assigned to a planned new battleship. During World War II, she was used as a U.S. Naval Reserve Midshipmen Training School at New York. After the war, New York retained the ship on loan as quarters for a Naval Reserve unit until December 31, 1955. The former battleship was then towed to Baltimore and sold for scrap.

This happy group poses in a wagon on Queen Street in Hampton for local photographer Christopher E. Cheyne on July 12, 1895, en route to Buckroe Beach on the Chesapeake Bay. The beach had begun as a tourist site in 1883 when Mary Ann Dobbins Herbert opened the first Buckroe Beach boardinghouse there, adding a bathhouse and a dancing pavilion. Edward Chiles began operation of the first public bathhouse there in 1894 and provided horse-drawn transportation from Hampton, perhaps this very wagon seen here.

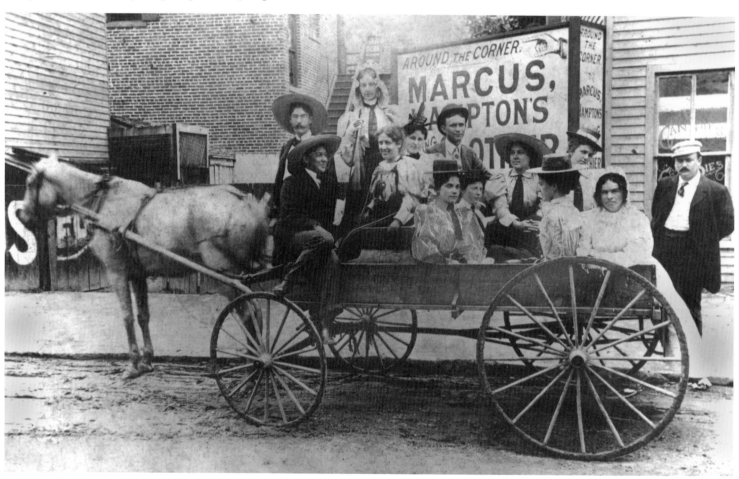

In the post–Civil War period, Princess Anne County was still largely rural and in need of new capital, labor, and transportation. Efforts to run railroad lines to the coast failed until July 16, 1883, when the Norfolk and Virginia Beach Railroad and Improvement Company successfully inaugurated its eighteen-mile line from Broad Creek to "that delightful watering place" at the oceanfront. Through September that year, a new pavilion built there near the rail line attracted several thousand visitors, who danced on the new pavilion floor and ate at tables that had been part of the pine forest by the shore just weeks earlier. Within a year, the Virginia Beach Hotel opened with 100 rooms "to accommodate those who may desire to remain over night." There were also bath houses with hot or cold baths. And for enthusiastic beachgoers such as those seen in this photograph made by Harry C. Mann, a Norfolk photographer, "the surf cannot be excelled by any [other] on the Atlantic Coast."

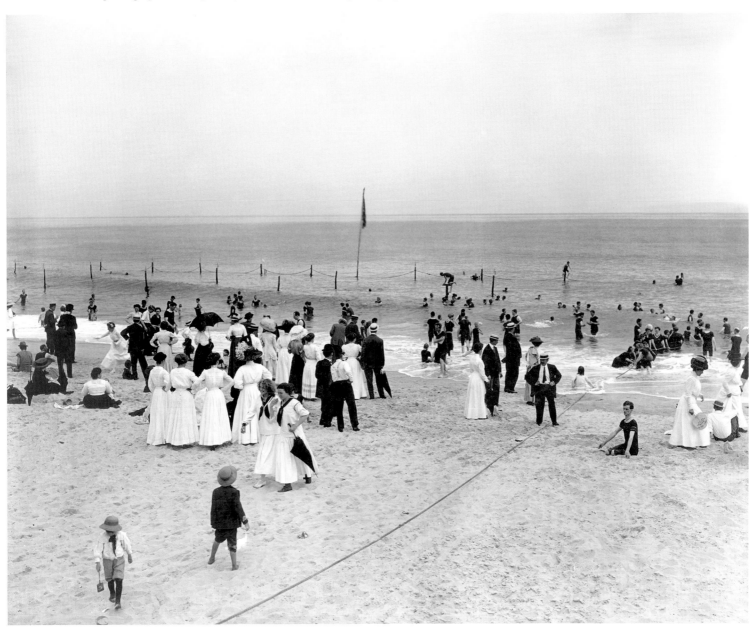

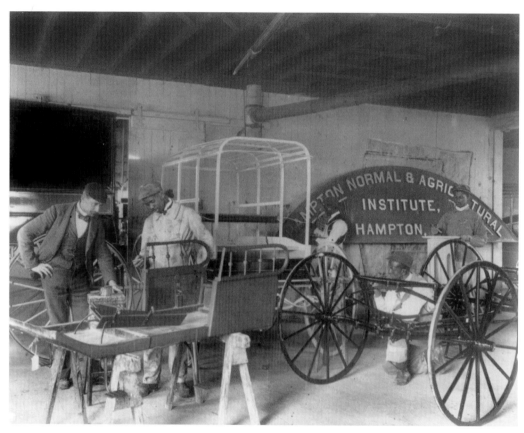

Begun in 1868 by General Samuel Chapman Armstrong, an agent of the Freedmen's Bureau, Hampton University was first known as Hampton Normal and Agricultural Institute and then as Hampton Institute. It was supported with monies from philanthropic and religious groups and with federal land-grant funds (1872–1920). The school's purpose was to prepare newly freed enslaved people for self-sufficient and productive lives. One of the classes taught there was in the Trade School shop, shown here in an 1899 photograph made by Frances Benjamin Johnston, where the students learned a trade and also how to teach that trade to others. In 1898 it had become a requirement for a young man who wished to enter the Trade School that he demonstrate an "aptitude for trade and . . . sufficient knowledge of English, mathematics, and physics to make his work intelligent."

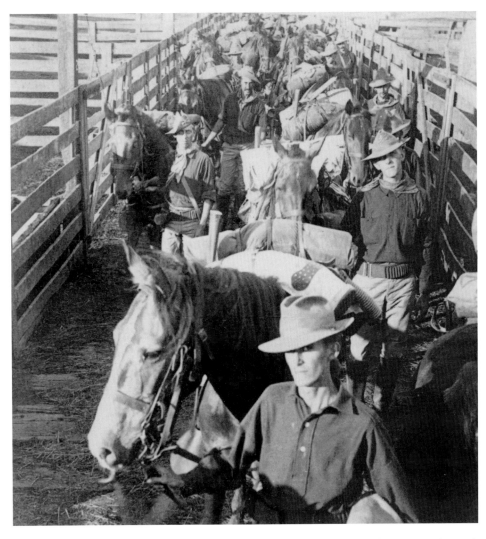

The American Stereoscopic Company, of New York City, made this image of the Pennsylvania Volunteer Cavalry in the stockyards at Newport News probably in July or August 1898. Newport News was one of several embarkation ports for soldiers bound for Puerto Rico to fight in the Spanish-American War. Pennsylvania sent three volunteer cavalry troops (companies): the First Troop, Philadelphia City Cavalry, which had been formed in 1774 and was the oldest military unit in continuous active duty at the time of the war; the Sheridan Troop, formed in 1871 and named for then–Lieutenant General Philip H. Sheridan of Civil War fame; and the Governor's Troop, which was attached to the corps headquarters of the Second Army Corps in Puerto Rico in August 1898. All three companies passed through Newport News in July and August 1898. A member of the Governor's Troop later wrote that when he and the other cavalrymen arrived in Newport News there were no transports available to send them on to Puerto Rico. Their horses were "very wild and vicious" and the men had much difficulty in breaking them. They were told that if a horse tried to break free, they were to "remember the mane." The troop left Newport News on August 5, 1898, with 800 men, 1,000 horses and mules, and 1,280 tons of supplies. The most important thing to remember while on board, they were told before embarking, was to "take care of the horses, because horses are scarce and hard to get, and men are plenty."

This picture was taken in 1892 on Queen Street in Hampton looking west with a trolley approaching and a horse and wagon trying to get out of the trolley's way. Trolley service had begun in Hampton in 1889 after James S. Darling, Sr., had organized the Hampton to Old Point Comfort Railway Company in February 1888. Beginning with a four-and-a-half-mile track, the trolley proved so popular that it led to a housing boom in the West End of Hampton for employees of the newly opened Chesapeake Dry Dock and Construction Company in nearby Newport News. The shipyard's name became Newport News Shipbuilding and Dry Dock Company on February 17, 1890.

One of the most popular clothing and men's furnishings stores in downtown Norfolk, the Hub opened about 1899 and was owned by H. Wurtzburger & Sons—Henrietta, Aaron, David, and Joseph Wurtzburger, of Baltimore, Maryland. In 1909, they sold the store to Charles and Louis Mansbach, also of Baltimore. Seen here in this Harry C. Mann photograph are perhaps the store's owners and employees, posing underneath a distinctive clock. In November 1924, the *Norfolk Ledger-Dispatch* would advertise for a new "Adam and Eve" to volunteer for a week in the woods near Cape Henry (now in First Landing State Park). The couple would have to make their own shelter and find their own food, thus proving whether a modern man and woman could survive like their original ancestors. Among the many applicants, one couple moved their wedding date forward so that they could go on their honeymoon under these unusual circumstances. They were married in the store window of the Hub and headed directly to the Cape Henry area. Every day for a week, a newspaper reporter checked on them and reported on their progress in the day's edition. A diet of persimmons and grapes kept them going, and despite being dressed in sleeveless summer clothes during a cold snap, they huddled beside a fire they built, holding out the whole week. "When they returned to civilization, they were feted at the Wells Theater, where they received a large array of wedding presents from local merchants."

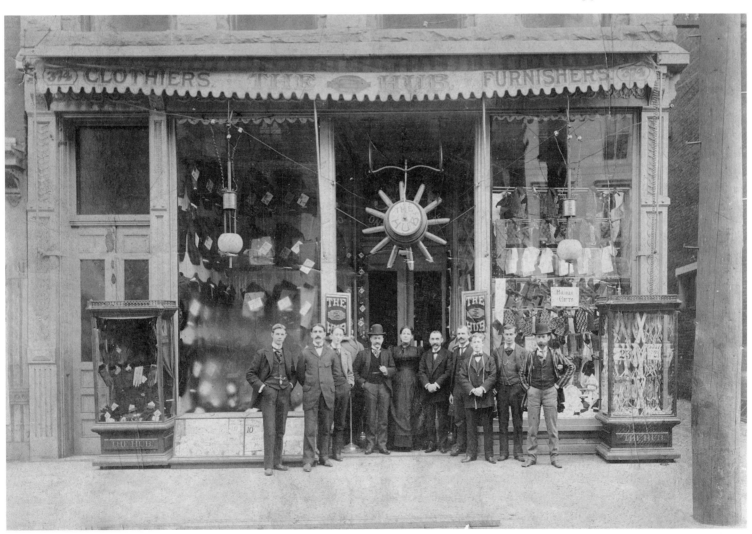

Photographed for the Detroit Publishing Company between 1890 and 1901, this postcard shows at the left the second Hygeia Hotel, which had been built in 1868, and two of the hotel's boat landings in the background. The first Hygeia had been constructed in 1822 next to Fort Monroe and torn down in 1862 because its location interfered with the guns at the fort. The second hotel was erected where Fort Monroe's bandstand and park are located. Harrison Phoebus, for whom the adjacent town was named in 1900, managed the new hotel until competition from the first Chamberlin Hotel proved too great for the second Hygeia, which was demolished in 1902.

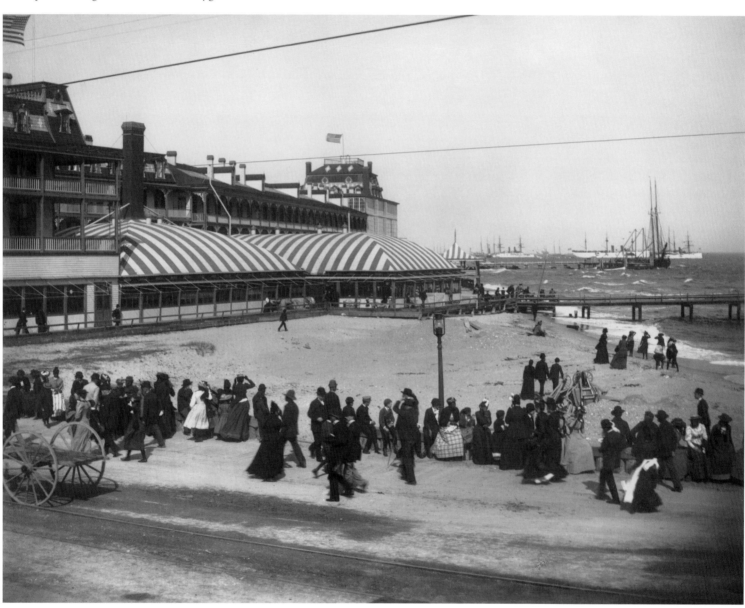

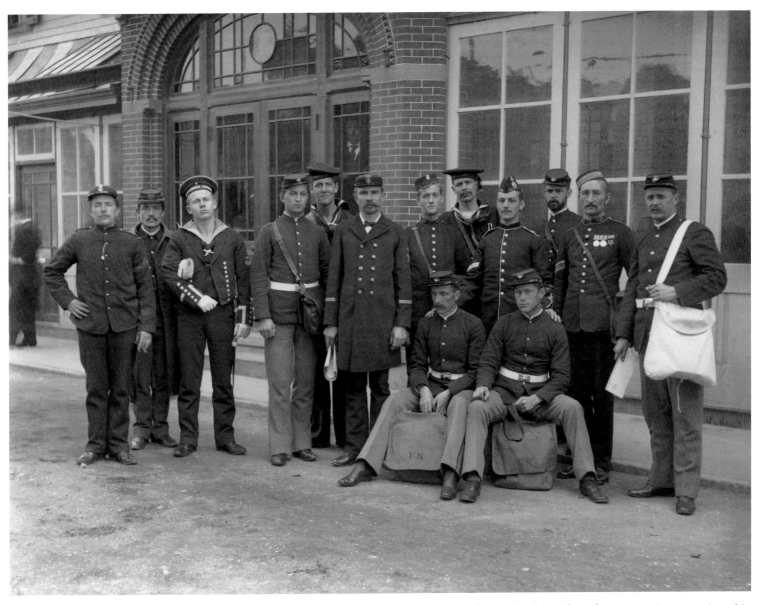

As part of the events planned for the 1893 World's Columbian Exposition in Chicago, thirty-eight ships of war from ten nations participated in the International Naval Rendezvous in Hampton Roads, April 17-24, 1893, before attending a similar event in New York. Among the nations that participated were Brazil, England, France, Holland, and Russia. Several other invitees had to decline because they had no vessels available and one—Haiti—for want of a navy. At least 50,000 spectators crowded the cities in Hampton Roads and prices rose precipitously. A shave now cost thirty cents and "only the wealthiest [were] able to afford a hair-cut." During the week's events, which included fireworks, boat races, military drills, and band concerts, the Detroit Publishing Company captured this image of "mail orderlies of all nations" posing for the camera.

The Whittier Primary School was the children's school at Hampton Institute. In 1898, enrollment consisted of 361 boys and girls from the surrounding neighborhoods. Photographed about 1899 or 1900 by Frances Benjamin Johnston, the children are saluting the American flag probably to start the school day. In 1887, the Whittier School, named for New England poet John Greenleaf Whittier, had replaced the Butler School built by Major General Benjamin F. Butler in 1863 to educate newly freed African American children. In 1868 the Butler School became a student teacher–training institution as part of Hampton Institute, and in 1871, when universal public education began in Virginia, a public elementary school as well. Elizabeth City County financed both the Butler and the Whittier schools. The Whittier School closed about 1930.

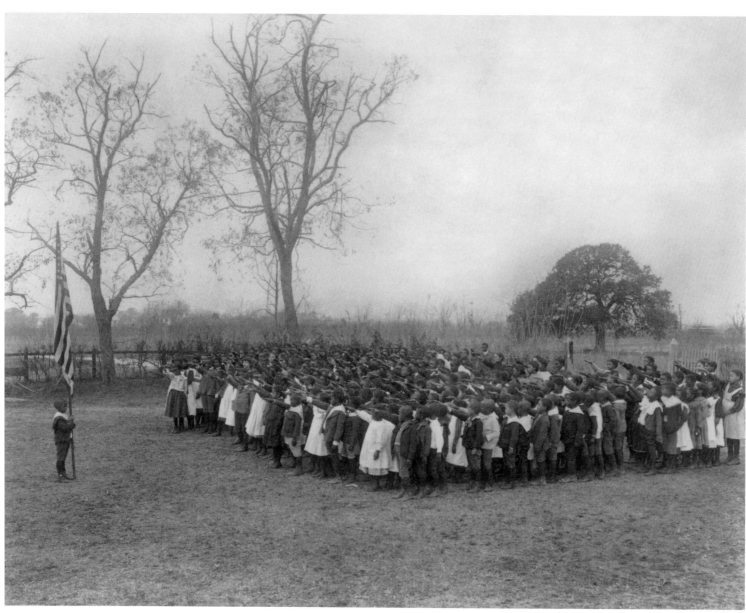

A group of passengers prepare to board one of the launches pulled up at the dock near the second Hygeia Hotel. The scene was photographed between 1890 and 1901. One Hampton resident born in 1895 recalled that because there was no bridge-tunnel in the late 1800s and early 1900s, boats took a circuitous route around Hampton Roads. They first went from Norfolk to the Hampton Wharf, then to the dock at the Hampton Institute, next to the Old Soldiers' Home, and at last to the main dock at Old Point Comfort, site of Fort Monroe and the Hygeia, before heading back to Norfolk. He believed that the trip from Hampton to the Hygeia took at least an hour.

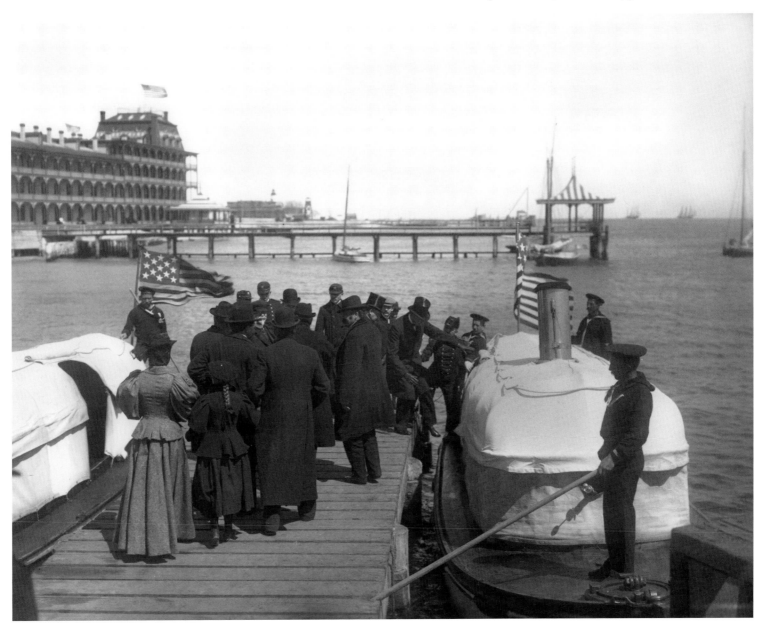

After a group of Native Americans from the Indian Territory had been sent to Florida in 1875 following a war with U.S. forces, the officer in charge, Captain R. H. Pratt, began to educate the Indians in his custody including the study of native art and handiwork. After three years, Hampton was asked to take some of the Indians for further education and accepted seventeen of them in April 1878. Thereafter, Indians were recruited from the Dakotas, and the federal government underwrote the students' tuition. When the experiment proved successful, Indian parents in the West "pressed their requests, until Captain Pratt remarked, 'he could have brought a thousand.'" Between 1878 and 1923 when the program ended, more than thirteen thousand Indians from sixty-five separate tribes received an education at Hampton in the Indian Department. Shown here in this 1899–1900 Frances Benjamin Johnston photograph is Louis Firetail, a Sioux, Crow, and Creek Indian, wearing his tribal clothing in an American history class at Hampton.

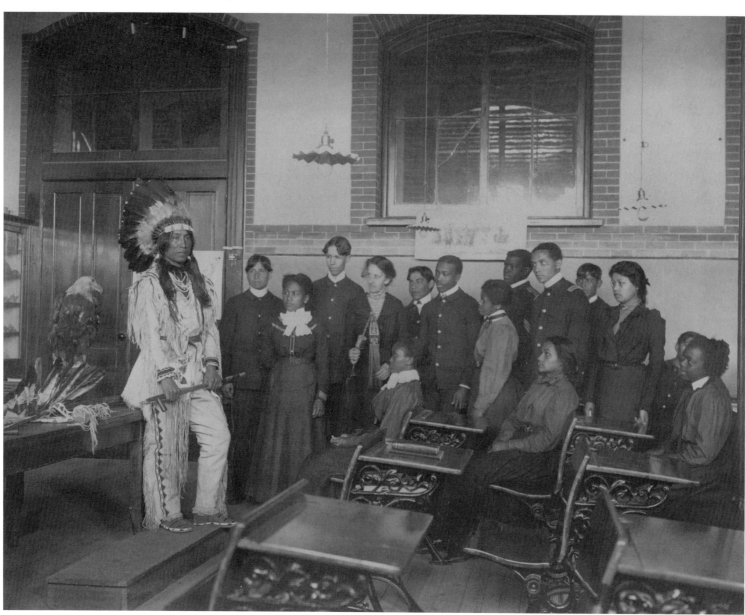

Frances Benjamin Johnston (1864–1952) was one of the first American women photographers to gain fame in that field. She opened a studio in Washington, D.C., about 1890 and began a career in photojournalism and portrait photography. Among her subjects were the African American schools of higher education at Hampton, Virginia, and Tuskegee, Alabama. Early in December 1899, she visited Hampton Institute. This photograph captures a capillary physics class in progress. Capillary physics is the study of the "properties of fluids, such as surface tension and viscosity . . . using capillary tubes . . . very narrow, thick-walled tube[s], usually made of glass, such as in a thermometer."

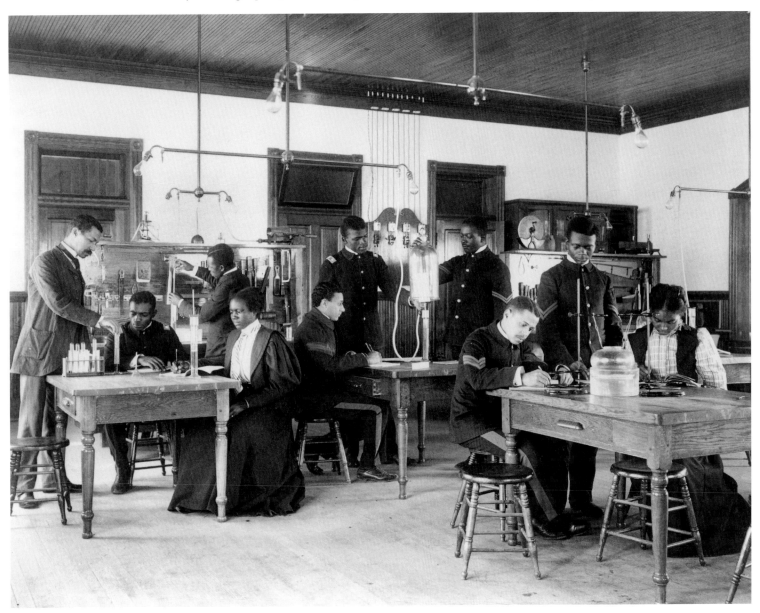

The first Chamberlin Hotel, located at Fort Monroe and seen here about 1900, was the inspiration of John Chamberlin, a restaurateur, gambling impresario, and luxury hotelier. Designed by the architects of the Library of Congress, Smithmeyer and Pelz, and built between 1890 and 1896, the Queen Anne structure featured the most up-to-date amenities: on-site ice and electrical plants, billiard rooms, shops, telegraph and railroad offices, laundry, and bowling alley. The dining room's large windows overlooked Hampton Roads, and the room contained a gallery for the dinner orchestra as well. The ballroom was a thousand square feet with a spring floor, and the hotel's south side housed an enclosed Palm Garden for afternoon tea. The Chamberlin cost about $5 million to build, had 554 rooms, 200 of them with private baths featuring hot and cold, fresh or salt water, and was six stories tall.

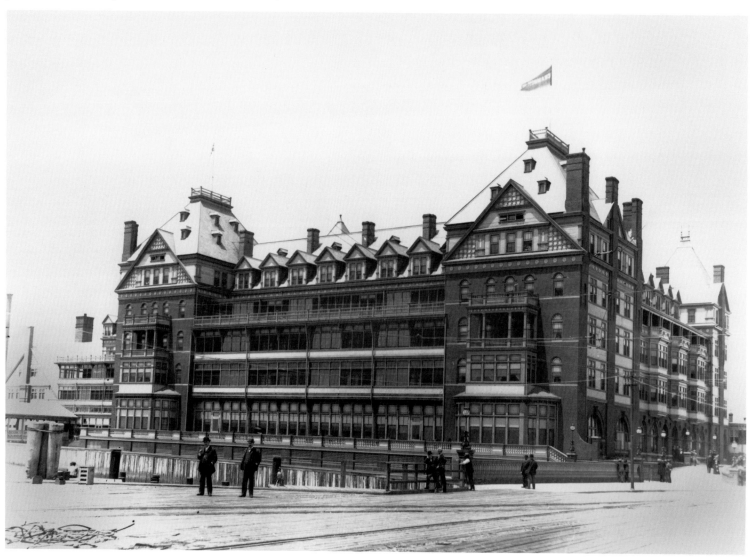

A group of seven small Indian children, several of them in native costume, is shown here in this Frances Benjamin Johnston photograph taken in 1899 or 1900, before they entered Hampton Institute. The curriculum for newly arriving Native American children consisted of teaching with objects—using toys, pictures, and other aids to help the youngsters learn English, including "all sorts of talking games" and "short dialogues, memorized and repeated daily."

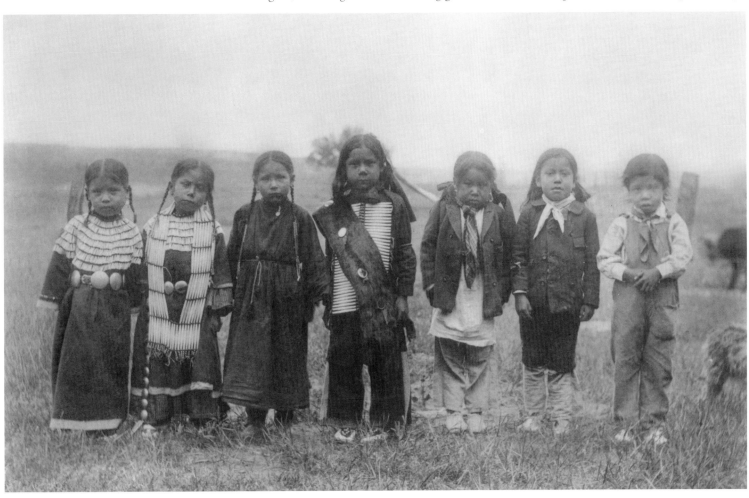

Christopher E. Cheyne took this photograph of Mellen Street in Phoebus in 1900. The waterfront community of Phoebus is located across a bridge from Fort Monroe. It was known variously throughout its history as Mill Creek, Camp Hamilton, and Chesapeake City, before being named Phoebus. Following its service as Camp Hamilton during the Civil War and Reconstruction in Virginia, the camp was laid out in building lots and advertised for sale. Streets were also laid out and named for prominent local citizens including Mellen. As the town grew, veterans, freed slaves, and new businessmen all made it their home. Incorporated in 1900, the town was named for its most prominent citizen, Harrison Phoebus, owner of the Hygeia Hotel (forerunner of the Chamberlin), who had been instrumental in getting the Chesapeake and Ohio Railway extended from Newport News to Chesapeake City.

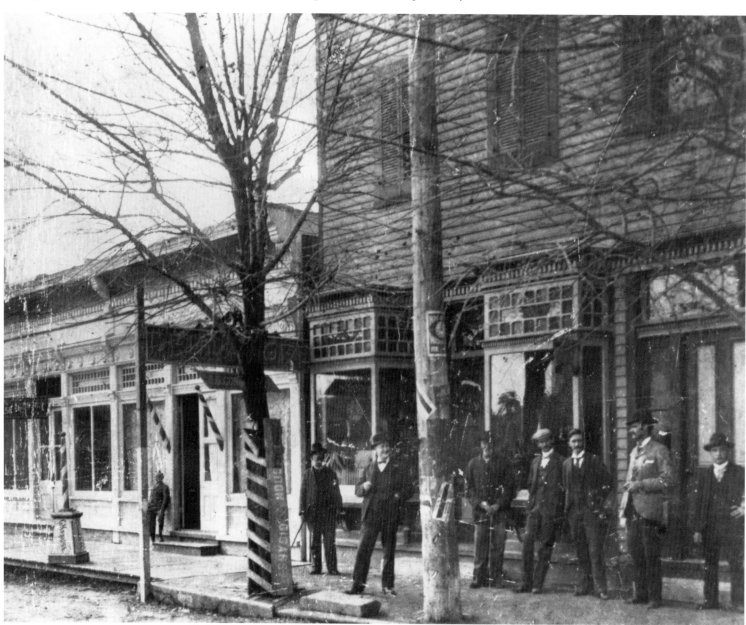

On April 9, 1884, a fire destroyed most of Hampton's commercial district including much of Queen Street. By 1900, when Christopher E. Cheyne photographed this area of King and Queen streets looking south, no evidence remained of the devastating fire sixteen years earlier.

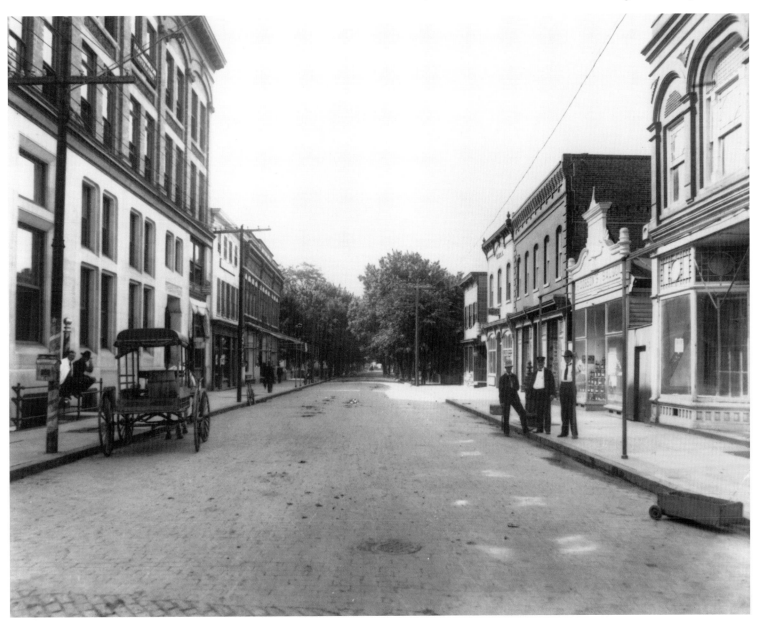

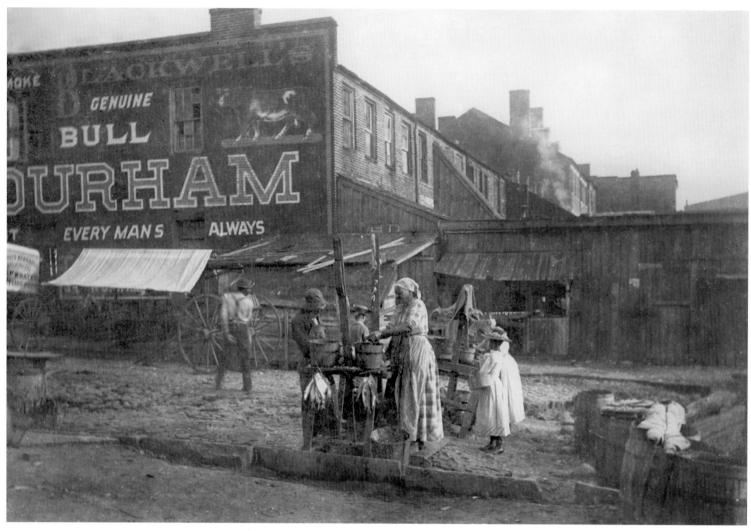

Women cleaning fish can be seen here at the "fish market" in the 100 block of County Street in Portsmouth in 1900, while a little girl waits with her basket. The Bull Durham brand of tobacco is prominently advertised on the side of the building opposite the fish market. The brand grew from an incident in Durham, North Carolina, at the end of the Civil War. Union and Confederate soldiers both raided a farmer's tobacco crop while awaiting the completion of a surrender negotiation. The soldiers were so impressed with the tobacco that once they got home they wrote to the farmer, John Green, asking for more. The farmer happily obliged. Named Bull Durham in 1868, the brand became the largest-selling tobacco in the world.

The Memorial Chapel at Hampton Institute, seen here, was designed by J. Cleveland Cady and built in 1886 in the Italian Romanesque Revival style. The bell tower, which rises 150 feet with a clock face on each of the four sides, contains twelve bells, the largest of which weighs 2,000 pounds. The chapel's oversized wooden doors were "built on a grand scale to welcome all those who entered the building." Student craftsmen created the woodwork and ironwork on the chapel's interior as well as the furniture. On the arches around the chapel can be seen the faces of the African American and Native American students for whom this church was constructed. The chapel is still used today as a nondenominational sanctuary.

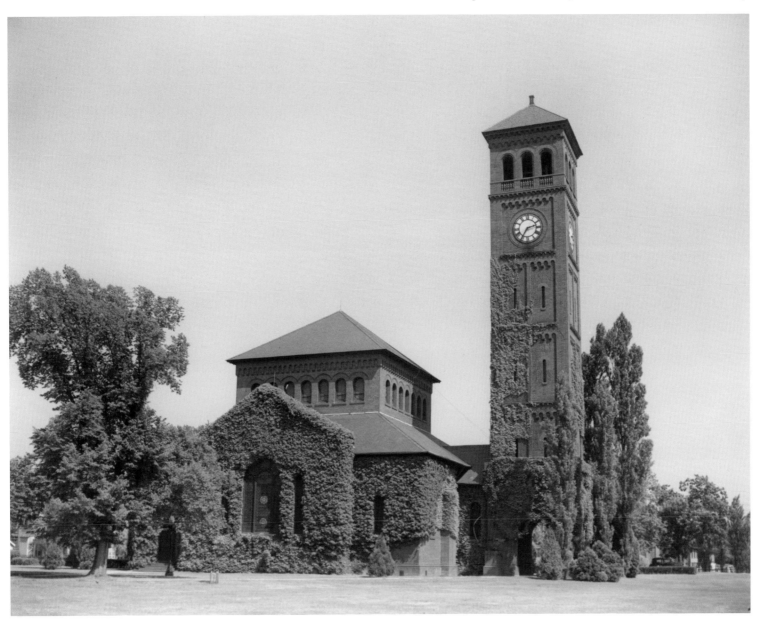

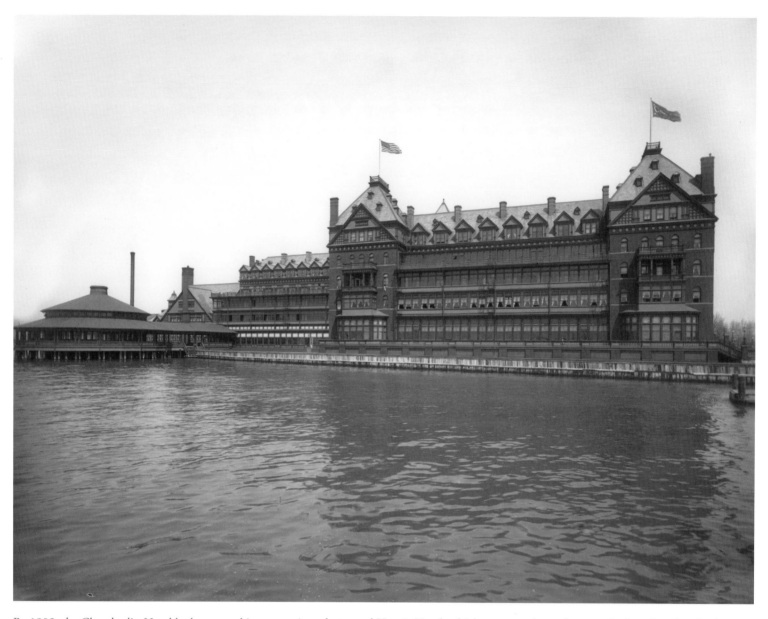

By 1902, the Chamberlin Hotel had surpassed its competitor, the second Hygeia Hotel, which was torn down that year. In fact, the Chamberlin had become one of the most popular resorts on the Atlantic Coast. The Old Point wharf can be seen at far-left. Among the many activities available for guests were dances, tennis, sailing, fishing, swimming in the sea pool, and listening to the orchestra. The hotel advertised its "good, wholesome, American food—like mother used to cook," especially Chesapeake oysters, terrapin, crabs, shad, Smithfield ham, and Virginia cornbread. The presence of so many U.S. Army and Navy men also provided dance partners for "the debutante [who] never lacks for attention— she must divide her dances and she finds herself in a tangled maze in her endeavors to pledge allegiance to both Army and Navy."

Photographed by Christopher E. Cheyne in 1900, the Phoebus Fire Department was organized in 1893. The men are shown here demonstrating their technique for pulling the hose reel.

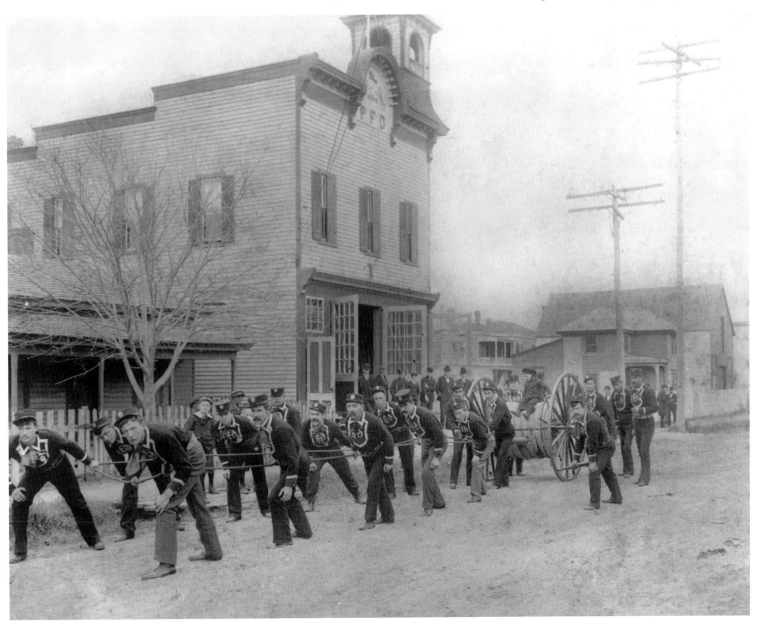

The Hotel Roache in Virginia Beach, photographed by Harry C. Mann early in the 1900s. Among its inducements to patrons were "ladies and gentlemen dining rooms," with the menu propped at the base of the sign, and Budweiser beer, which Adolphus Busch had introduced to America in 1876.

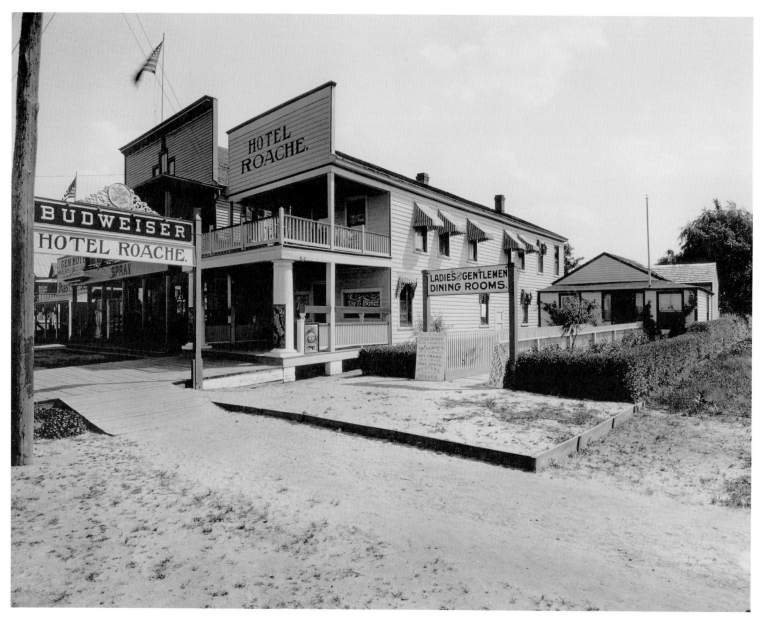

Shown here about 1902 is the National Home for Disabled Volunteer Soldiers, Southern Branch, popularly known as the Soldiers' Home, at Hampton. Originally, it had been the Chesapeake Female College, which Major General Benjamin F. Butler took over in May 1861 and converted to the Chesapeake Military Hospital. After the war, Butler bought the main college building and sold it to the federal government for the soldiers' home, which opened in 1870. It served former Union soldiers until 1946, when Private Charles Woodcock of New York, the last veteran there, died. The Veterans Administration was created in 1930 and took over administration of the Hampton Soldiers' Home and established the Hampton Veterans Administration Medical Center, which still serves more than 160,000 United States veterans today.

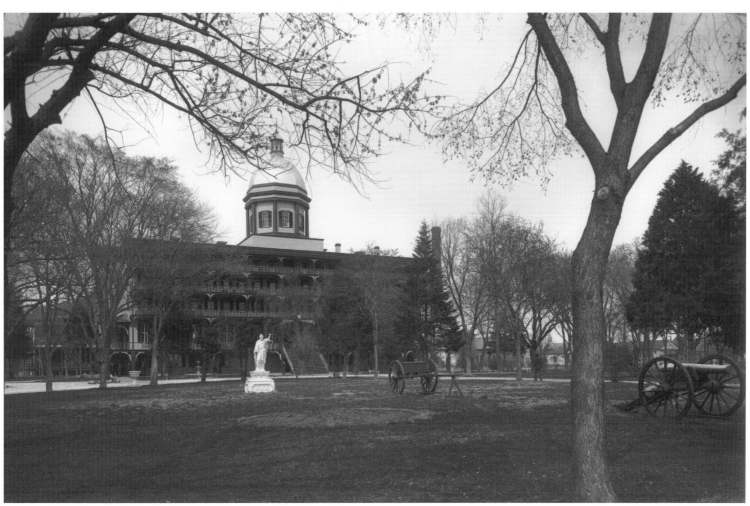

Shown here is the Monticello Hotel in Norfolk, in 1902, on Granby Street at City Hall Avenue. Built between 1896 and 1898, the Monticello exemplified the Richardsonian Romanesque Revival style of architecture with its walls of arched and heavy masonry. Considered to be the finest hotel in the city at that time, the Monticello hosted the important guests for the Jamestown Ter-Centennial Exposition in 1907, and Woodrow Wilson announced his candidacy there for the United States presidency. The hotel was completely gutted in a fire on New Year's Day 1918, but was restored a year later with two new stories and the latest amenities including a telephone in each room and electric lighting from the hotel's own power plant. It was finally demolished in 1976 and replaced with a federal building.

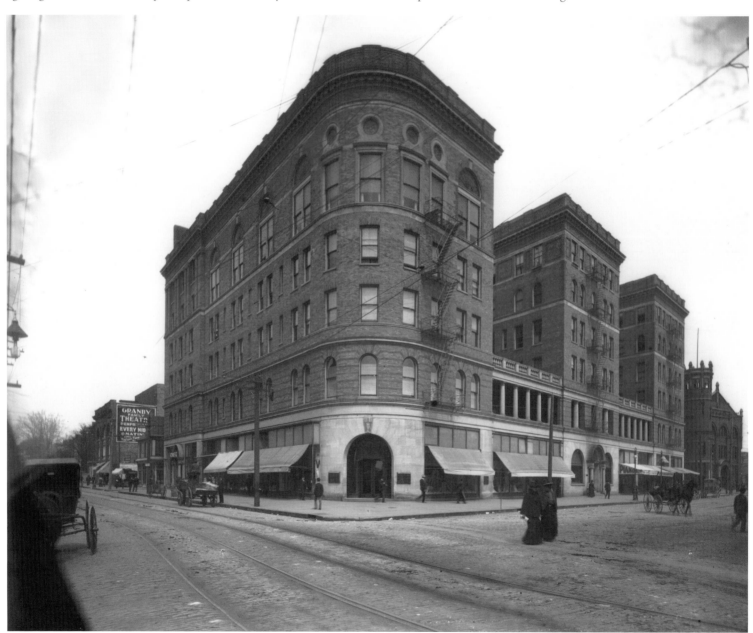

Norfolk photographer Harry C. Mann captured part of East Main Street in this image. At left is the facade of the Miller, Rhoads, and Swartz department store. Linton O. Miller, Webster S. Rhoads, and William G. Swartz had announced in 1896 that they proposed to open a new kind of store, "a strictly one-price establishment, with all goods marked in plain figures and sold at such prices." In addition, only "dependable merchandise would be offered," and "the salespeople" would be "educated with regard to this policy." Such was the growth of this new store that by 1900 it had moved to the newly constructed building on Main Street seen here near the Confederate monument at Commercial Place. The store had 45,000 square feet of floor space, which allowed it to add more and more varied merchandise in a greater variety of departments. Miller and Rhoads had originally opened their dry goods business in Richmond in 1885 with a partner, Simon Gerhart, who left the business in 1890 to open his own store in Lynchburg.

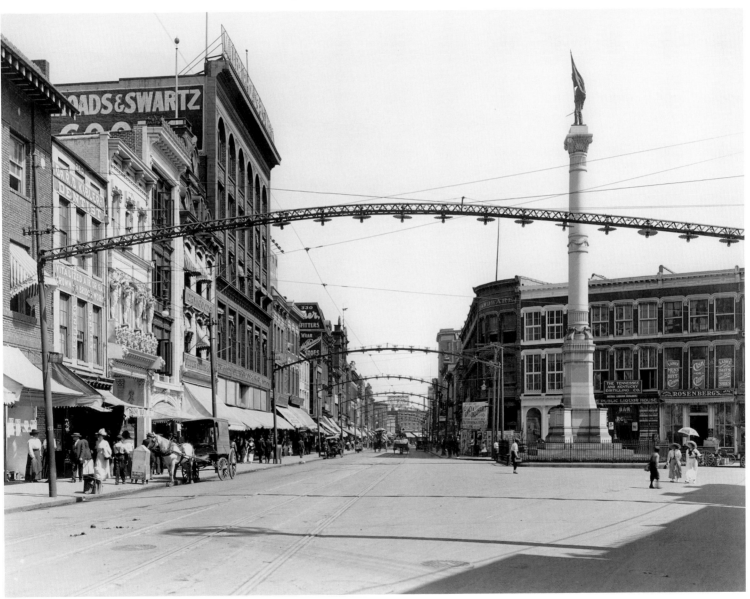

Collis P. Huntington's Old Dominion Land Company constructed the Hotel Warwick in Newport News in 1882, at a time when the community was made up of small farms. The hotel quickly became the hub of the area. Not only did the hotel house guests, but it also became the site of an early newspaper print shop for the *Wedge,* which began publication there on April 21, 1883. The organizational meeting of the Chesapeake Dry Dock and Construction Company (later the Newport News Shipbuilding and Dry Dock Company) took place there on June 24, 1886. The Bank of Newport News, chartered on December 1, 1888, conducted business from the hotel. For about four years, the Warwick County government maintained its county seat there after the courthouse was moved from Denbigh to Newport News after the June 1888 term of court ended. An act of the General Assembly of March 2, 1888, had authorized the relocation of the courthouse. This view of the lobby was recorded probably after the $75,000 remodeling and redecoration of the hotel in 1901.

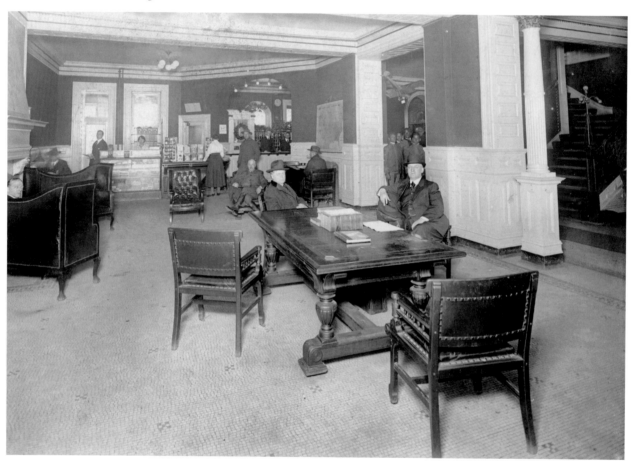

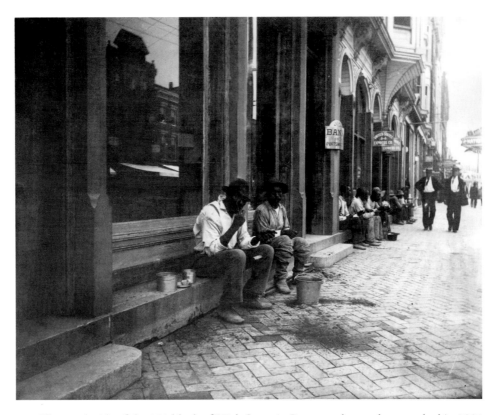

The south side of the 200 block of High Street in Portsmouth was photographed in 1901 looking west toward Crawford Street. Two workers who have stopped for lunch appear in the foreground. Behind them is the sign for the Bank of Portsmouth, which was established in 1867, and later became the American National Bank of Portsmouth. Beyond the bank, at 207 High Street, is the United States Express Company.

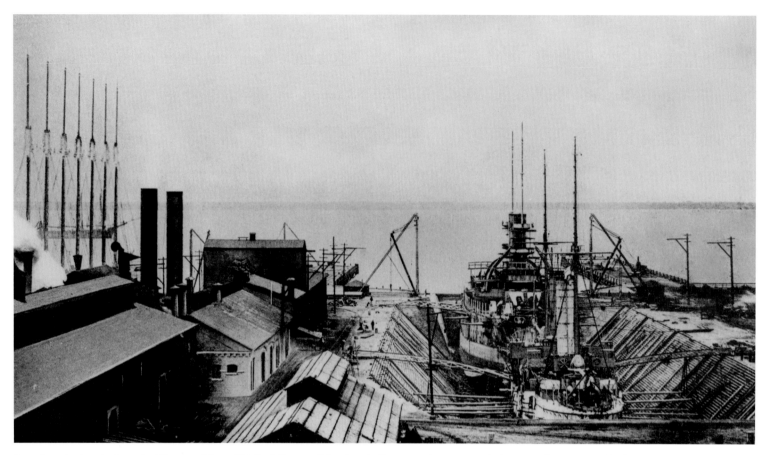

Seen here in dry dock at the Newport News Shipbuilding and Dry Dock Company in 1903 is the largest schooner ever built (and the only seven-masted one), the *Thomas W. Lawson,* with the battleship USS *Missouri* and the German cruiser SMS *Gazelle. Thomas Lawson* had been built in 1902 at Quincy, Massachusetts, and was here for repairs. The schooner was refitted, from a coal carrier to an oil carrier, at the dry dock company in 1906. On Friday, December 13, 1907, carrying a load of oil to London, England, *Lawson* was caught in a storm off the Scilly Islands and wrecked on Hellweather Reef with the loss of fifteen of the seventeen-member crew. USS *Missouri* had been laid down at Newport News Shipbuilding in 1900 and was completed there in December 1903. After service in World War I, *Missouri* was decommissioned in 1919, then broken up for scrap in 1921. SMS *Gazelle* was launched in 1900 and was extensively repaired at Newport News Shipbuilding between March 31 and June 4, 1903. *Gazelle* returned on July 7 for more work before sailing from there on July 29, 1903, for Halifax, Nova Scotia. The ship was scrapped in 1920.

Shown here is a gigantic crane and two vessels at a Newport News Shipbuilding and Dry Dock Company pier early in the twentieth century. The company was a logical extension of Collis P. Huntington's Chesapeake and Ohio Railroad terminal at Newport News, from where West Virginia smokeless coal would be shipped around the world. Huntington envisioned a ship-repair facility to handle the needs of vessels calling at the port, and thus established the Chesapeake Dry Dock and Construction Company in 1886. The dry dock opened three years later and proved immediately popular. When increasingly damaged ships arrived for repair, the logical next step was to add full-scale shipbuilding to the repair facility. In 1890, the Newport News Shipbuilding and Dry Dock Company was formed.

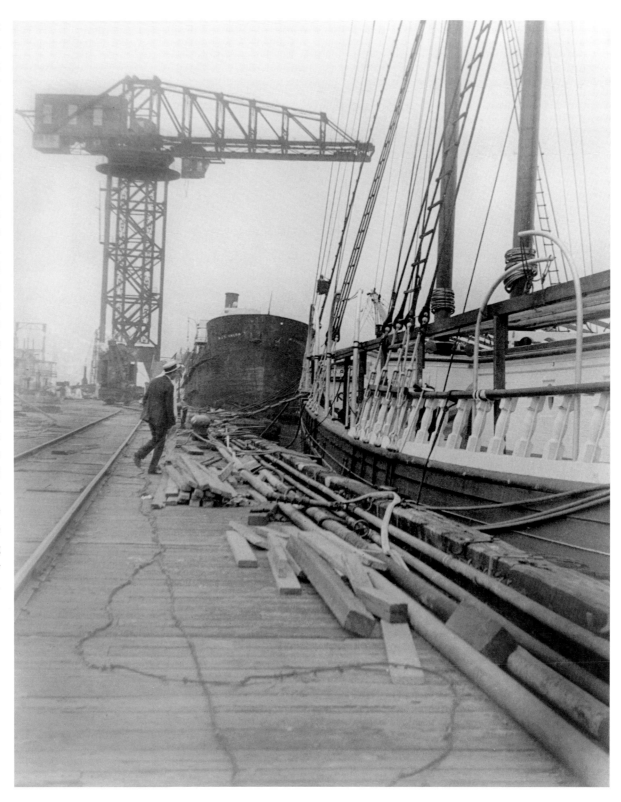

The Silsby Building with its distinctive tower appears on the right in this early-twentieth-century postcard view of Newport News. A group of boys stand in the street, men jaywalk, a trolley approaches, and a wagon is parked at the curb. The Silsby Building was constructed in 1904 and torn down in 1963. Eventually, it became known as the Leaning Tower of Newport News because, like the Leaning Tower of Pisa, it began to lean away from its neighboring building. The home of many Newport News lawyers, it was also nicknamed the Law Building.

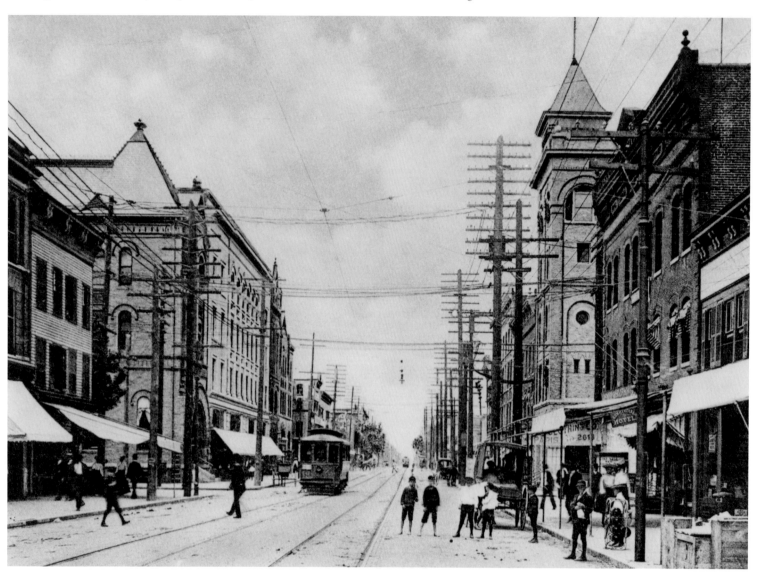

On July 25, 1903, the Newport News Shipbuilding and Dry Dock Company paid 6,082 men their wages in only twenty-four minutes, as seen here in this view of the event. Such a scene was typical every Friday afternoon until July 1946, when employees began to receive paychecks instead of cash.

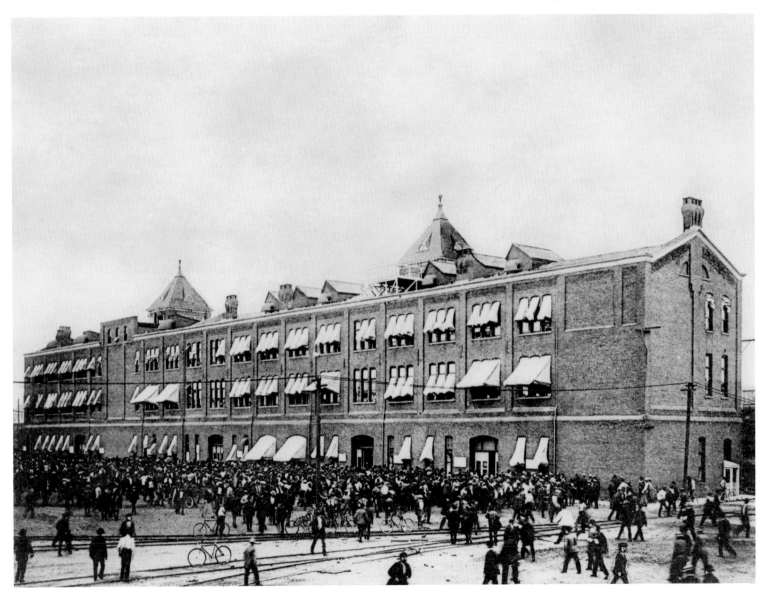

The first post office in Newport News may have opened about 1851 and operated until 1854. A second one in 1859 closed soon thereafter, then a third in 1870 that closed in 1872, and finally a fourth one opened in 1880. In 1904, this Neoclassical Revival building on 25th Street and West Avenue opened for business and included the post office and custom house. It was enlarged with a temporary addition during World War I. At the beginning of World War II, the post office was remodeled again and its size doubled to accommodate "the nearly overwhelming increase of postal business caused by the influx of war activity."

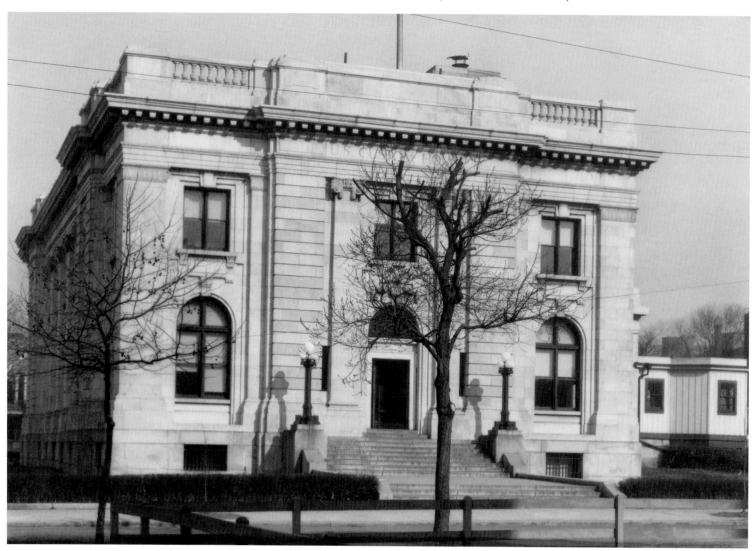

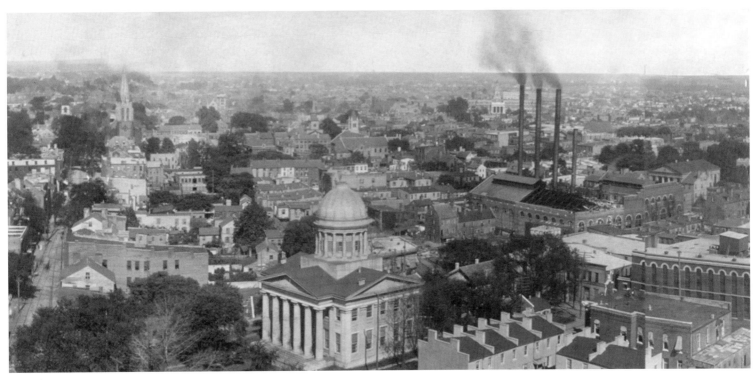

This view of downtown Norfolk, taken in 1905, shows the former Norfolk City Hall, the domed structure in the center foreground. The building was completed in 1850. It is now one of four structures constituting the MacArthur Memorial, a tribute to and the last resting place of both General of the Army Douglas MacArthur and his widow, Jean Faircloth MacArthur. Exhibits in the complex cover the general's life and career, and one of the buildings houses a library and archives.

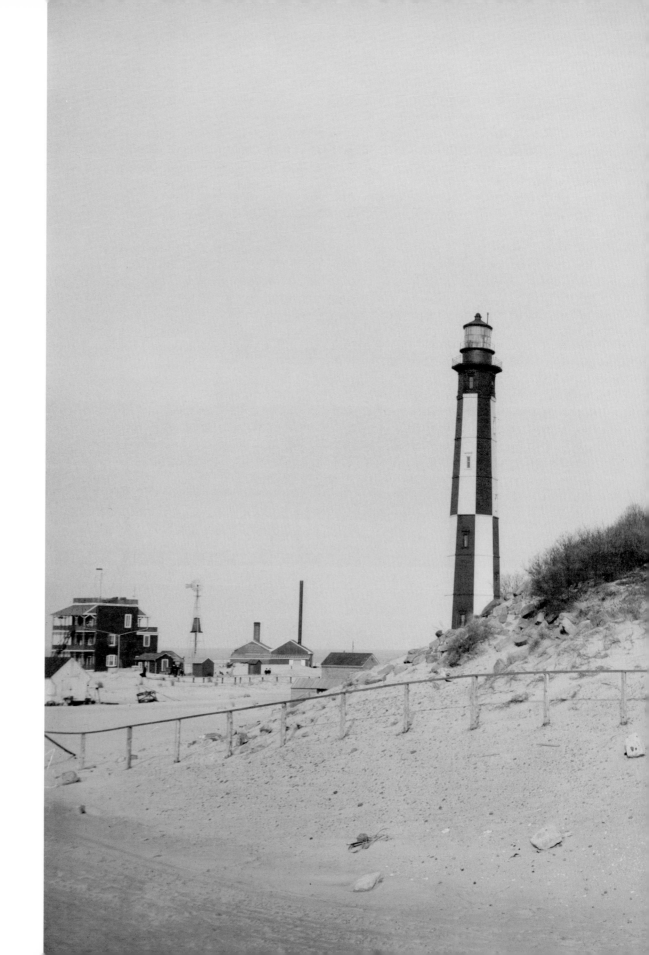

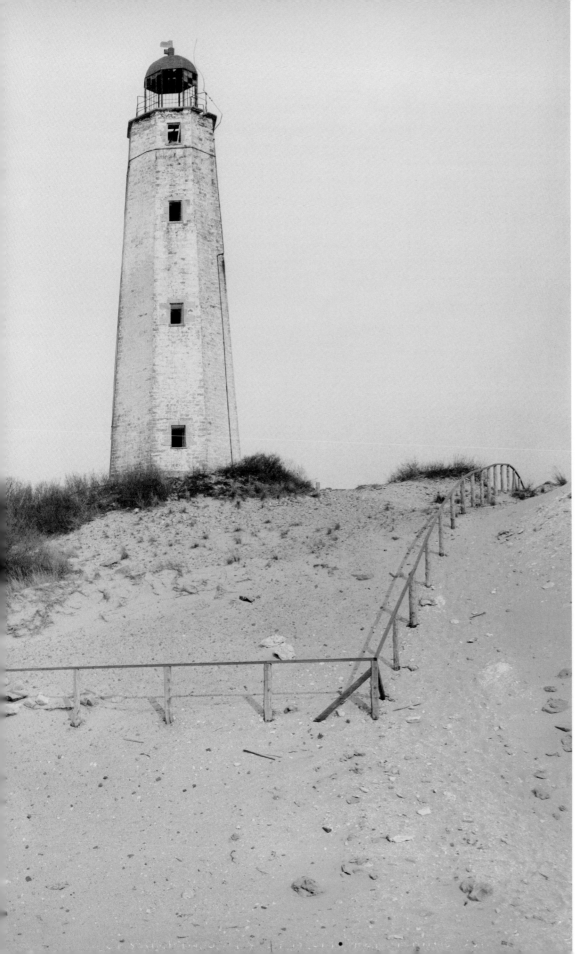

The "old" (right) and "new" (left) Cape Henry lighthouses are shown here about 1905. The old lighthouse was constructed in 1792, one of the first such structures authorized by the new United States government. When cracks were discovered in the masonry of the "old" lighthouse in 1872, the newer lighthouse was built. It was completed in December 1881. Today, the old lighthouse is a National Historic Landmark. The towers and lights illuminate the southern entrance to the Chesapeake Bay and James River at Cape Henry, the place where the English colonists who settled at Jamestown first came ashore on April 26, 1607, after their long voyage.

On February 27, 1906, the "even-keel submarine boat" *Simon Lake XV* was built and launched at Newport News Shipbuilding and Dry Dock Company as a vessel for the Russian navy. Its developer, the inventor and entrepreneur Simon Lake (1866–1954), had been fascinated with submarines from boyhood, ever since he read Jules Verne's 1870 novel *Twenty Thousand Leagues Under the Sea*. When the U.S. Navy announced a submarine design competition in 1893, Lake began work in earnest on his concept for the vessel, which featured hydroplanes amidships for "level diving" and hull-mounted wheels for crawling along the ocean floor. Lake had many failures and occasional successes with his submarines, and for years had better fortune selling them to the Russian navy than to the American. Lake also made prefabricated housing from concrete panels in the 1920s, an endeavor in which he was years ahead of his time.

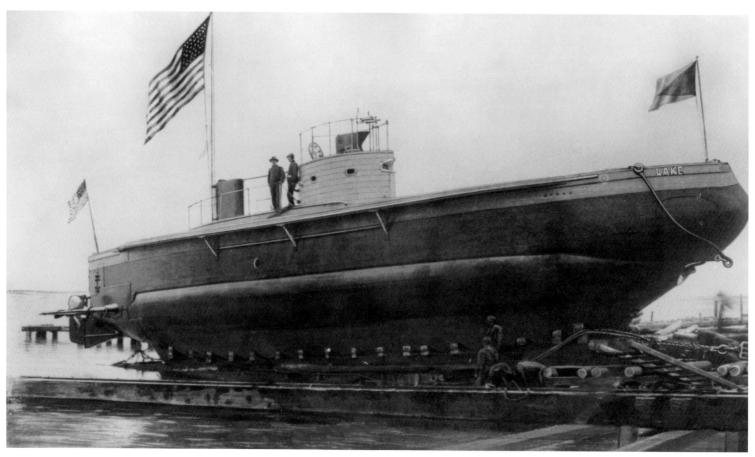

The Hampton Roads Yacht Club, located on Willoughby Bay in present-day Norfolk, was formed in 1901. Harry C. Mann photographed the bungalow-style clubhouse, which had been constructed by 1903.

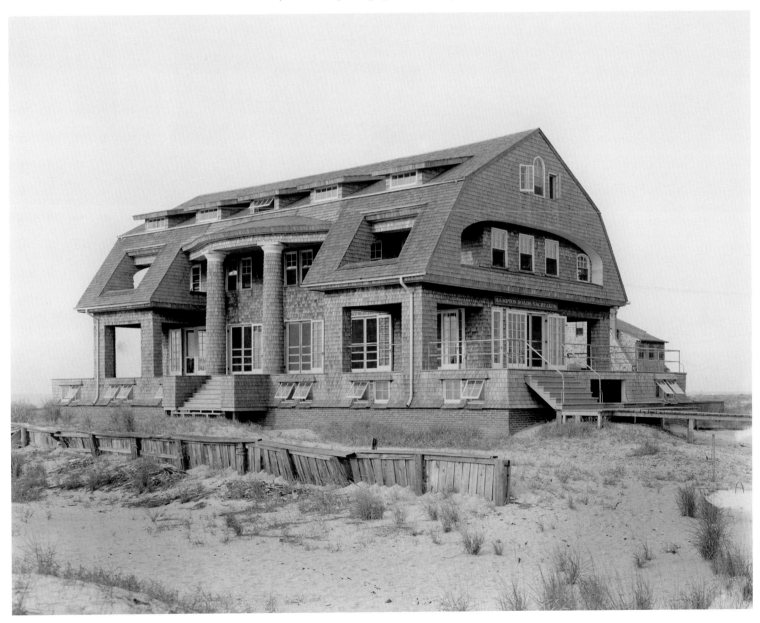

Christopher E. Cheyne (1867–1943) was a native of Brampton, Canada, who moved to Hampton in 1894 and opened a photographic studio. He took this picture of his studio in 1903 after relocating the business to this building in 1900. Cheyne's son William E. "Happy" Cheyne (1896–1976) also became a photographer and recorded many images of Hampton. Cheyne's studio closed in the 1960s.

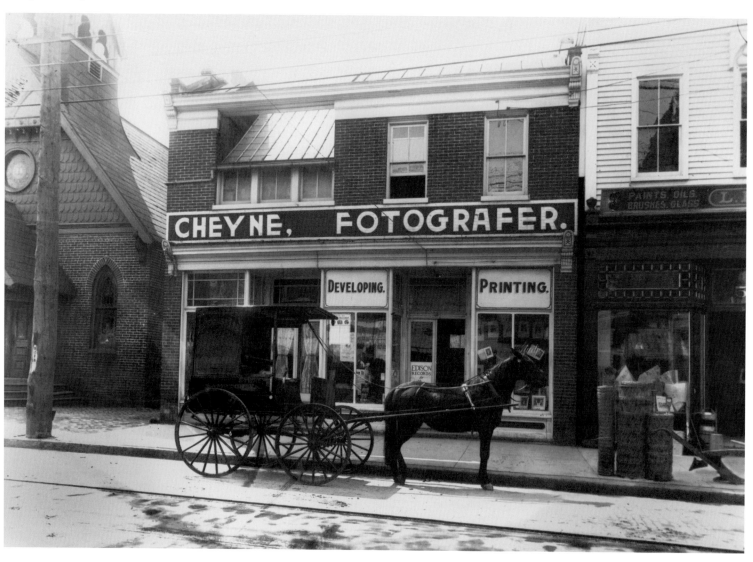

Harry C. Mann photographed the Newport News post office building in 1906. The handsome Neoclassical Revival–style structure was formerly a federal custom house. Located on Warwick Boulevard, the building is still used as a post office.

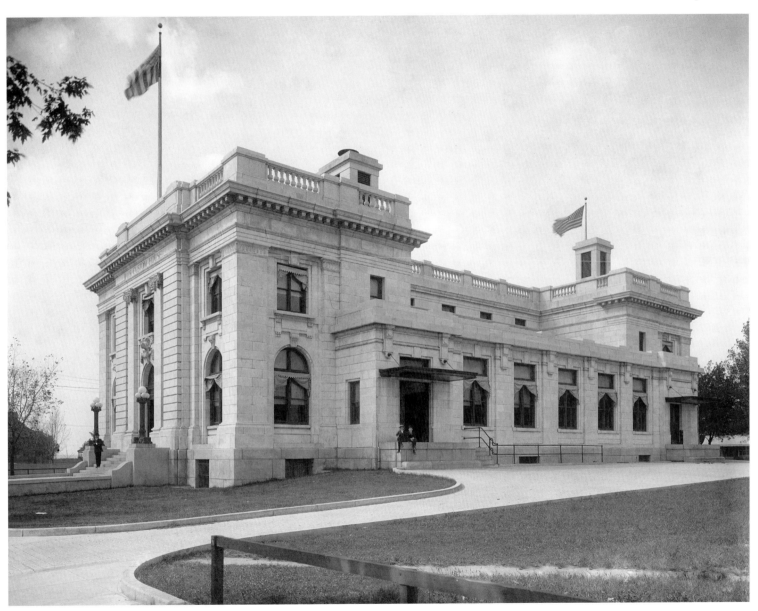

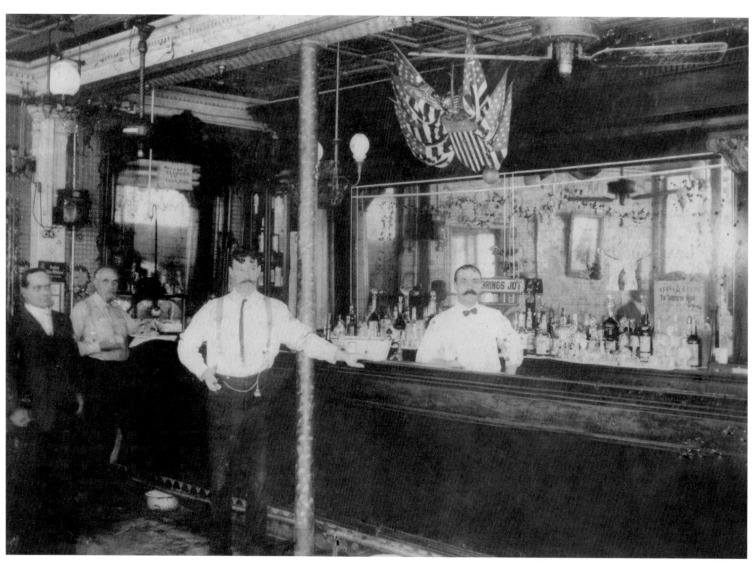

This photograph, taken by Christopher E. Cheyne in 1905, shows the Richelieu saloon and hotel at 2 East Mellen Street in Phoebus during its heyday. Years later, when Prohibition became law, William E. Lancer, the owner, converted the bar to a confectionery. The building was constructed in 1882 and still stands in the Phoebus Historic District.

Deep Creek, shown here in Harry C. Mann's photograph, is a small community located at the head of the Dismal Swamp Canal, a twenty-two-mile-long channel that connects the creek (a tributary of the Elizabeth River near Hampton Roads) with the Pasquotank River in North Carolina. Construction of the waterway began in 1793. The canal, now part of the Intracoastal Waterway, is a National Historic Civil Engineering Landmark. Several early-twentieth-century locks, drawbridges, and spillways at Deep Creek were listed in the National Register of Historic Places in 1988.

Recorded about 1905, this image shows children frolicking in the water and on the beach at Hampton, while adults wade or watch from the deck overlooking the beach.

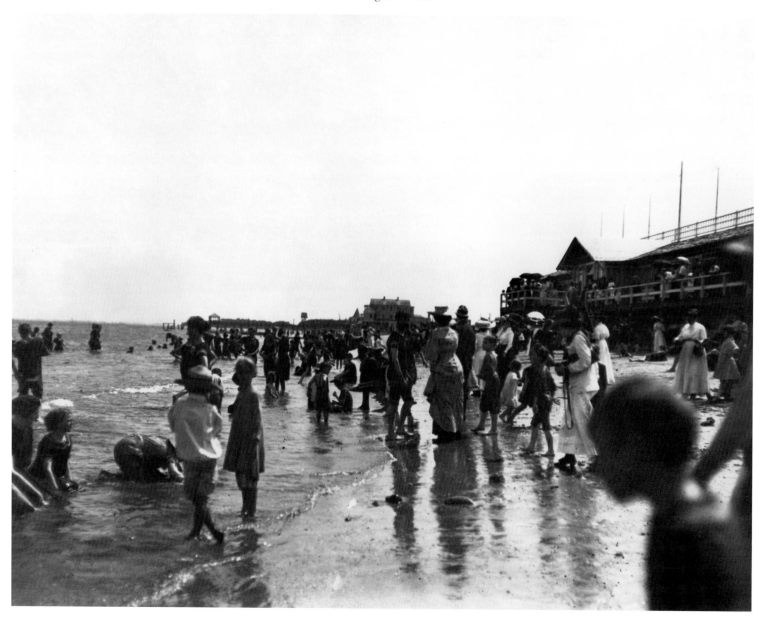

This picture was taken at the naval review on opening day of the Jamestown Ter-Centennial Exposition, April 26, 1907. In the background are some of the "Great War Ships in Hampton Roads" that had gathered for the occasion. Covered launches, such as the one in the foreground, ferried passengers to and from the ships and around the Roads.

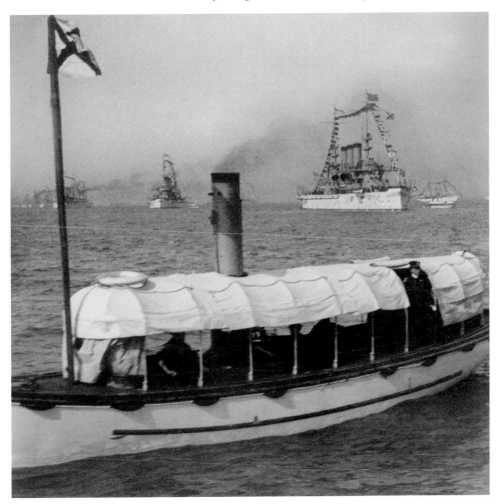

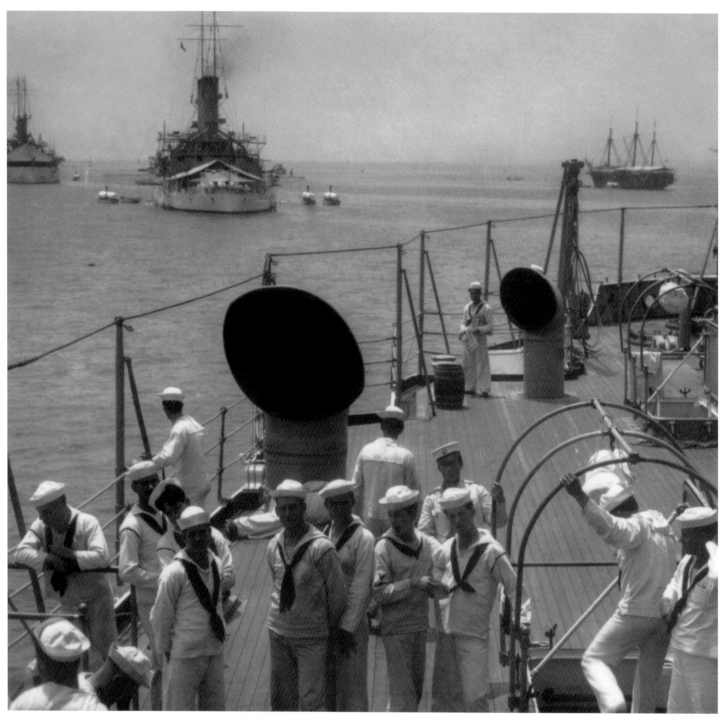

As U.S. Navy warships steam through Hampton Roads for the naval review at the opening of the Jamestown Ter-Centennial Exposition on April 26, 1907, sailors gather on the forecastle deck of the battleship USS *Ohio*. In the distance is the battleship USS *Maine*.

The Jamestown Exposition of 1907, formally entitled the Jamestown Ter-Centennial Exposition, was held at Sewell's Point in Norfolk. A large number of historically referential buildings were constructed to house a variety of exhibits. Shown here is the administration building (at center). The exposition opened on April 26, 1907, and closed on December 1. Although it was not a financial success, it called attention not only to the establishment of the first permanent English settlement in the New World, but also to the large tract of land at Sewell's Point. Several years later, in 1917, the site was purchased for a new naval base, today called Naval Station Norfolk, "the world's largest naval installation."

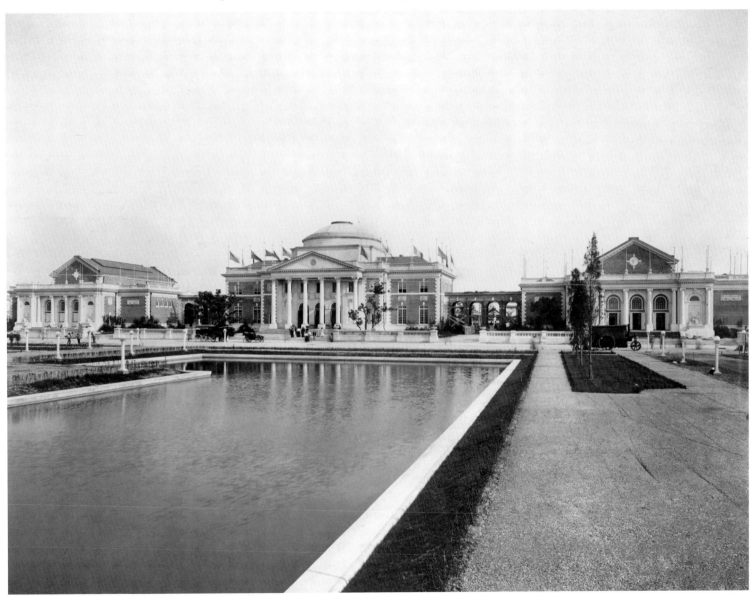

Each state participating in the Jamestown Ter-Centennial Exposition at Norfolk erected a building to represent its history and architecture, although most examples were remarkably grandiose compared with actual buildings of the architectural style modeled. Most were constructed on a colonial-mansion theme, while Kentucky built a version of a frontier fort. Nineteen of the exposition buildings survive, including thirteen of the state houses. This is the Virginia house, which has served recently as the residence of the supreme commander of NATO. It is an outstanding example of the Georgian Revival style.

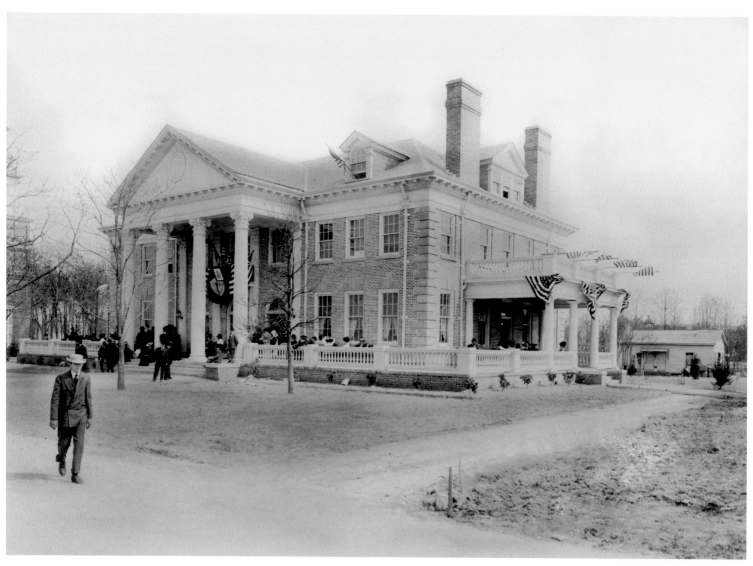

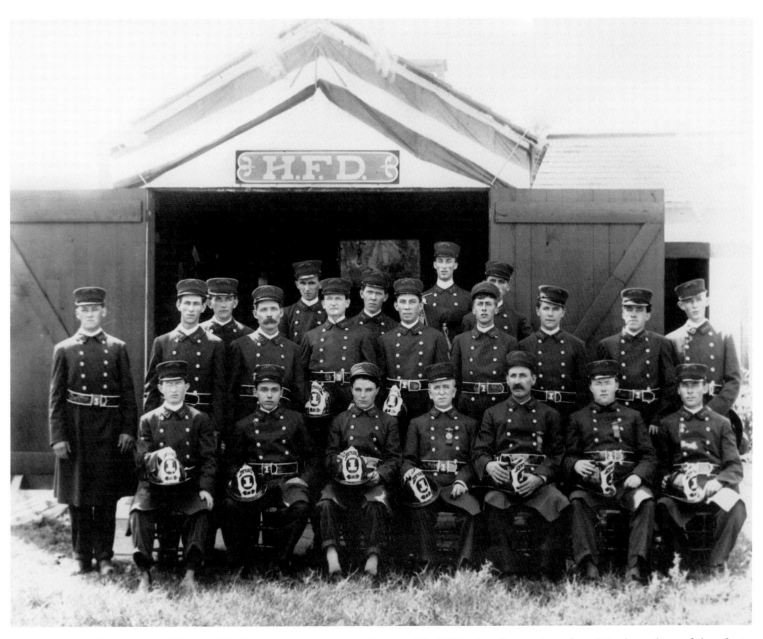

The Hampton Volunteer Fire Department was organized on April 9, 1884, when the town's residents joined together to fight a fire in the commercial district that destroyed about thirty-three stores and residences and most of the business section. The town acquired its first fire engine, a hand pump, that year, and in 1887 the town council authorized a well to be dug next to the courthouse. The fire department also received permission to erect a firehouse on the courthouse property. Hampton's first steamer fire engine arrived in February 1891. The West End Hose Company became full members of the Hampton Fire Department in July 1909. Christopher E. Cheyne photographed the firemen and the fire station seen here sometime during that year.

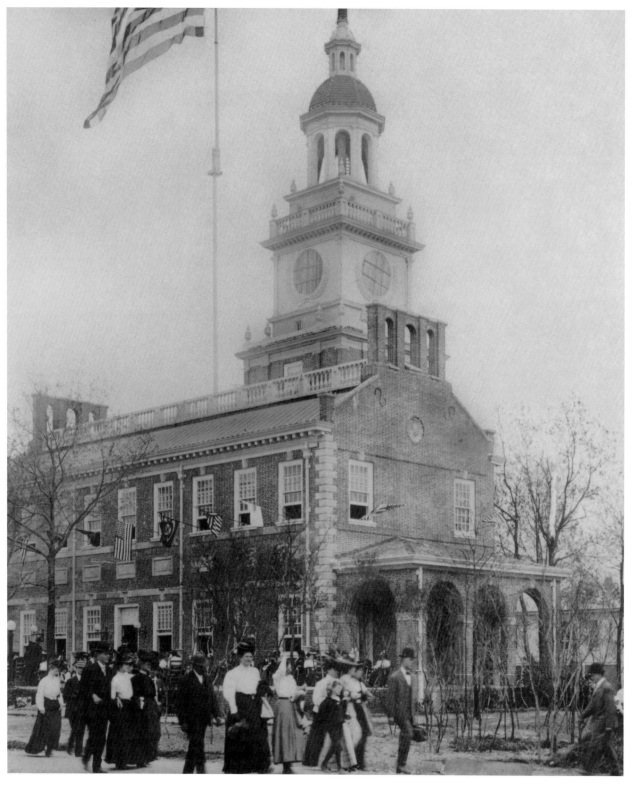

For the Jamestown Ter-Centennial Exposition at Sewell's Point in Norfolk in 1907, states erected buildings evocative of their history. The Pennsylvania State Building, a reproduction of Independence Hall, still stands along with several other buildings from the exposition. Now located on the Norfolk navy base, the structures are used for senior officers' quarters and are known as Admirals' Row.

A crowd has gathered at Old Point Comfort, with the Chamberlin Hotel in the background, to welcome home the Great White Fleet on February 23, 1909. Rainy weather did not deter people from jamming the dock in anticipation. President Theodore Roosevelt had conceived the fleet's excursion to the Far East to intimidate Japan, a nation with expansionist ideas. Sixteen battleships, all painted white, steamed out of Hampton Roads in 1907 after attending the opening ceremonies of the Jamestown Ter-Centennial Exposition. Fourteen months later, they returned to enthusiastic welcoming ceremonies that included Roosevelt himself, despite the gloomy weather. The president visited each ship to congratulate the officers and crew, and the communities of Hampton Roads entertained the sailors with dinners and parties.

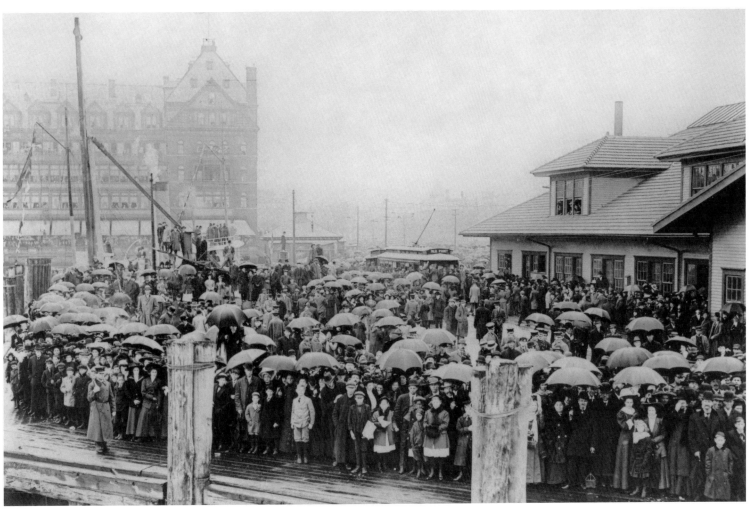

Harry C. Mann photographed the George Newton House sometime just before 1910. The house had been built in 1793 and in 1803 became the Branch Bank of the United States. In 1812, the Farmers Bank of Virginia took over the building. George Newton acquired it in 1826. In 1893, the Newton family sold the house to J. Wesley Fentress, a successful Norfolk businessman, who remodeled it for commercial use. Both the Norfolk Library Association and, after February 12, 1894, the Norfolk Public Library had offices and rooms in the house until the library moved to its new building in 1904. When Mann recorded the site, various businesses had quarters there including the Crystal Laundry and the Jim Huen Laundry, Expert Tailors, the J. Kuzboski shoe repair shop, Elkanah W. Stiff and Benjamin C. Tatum Decorators, and the Little Drug Store. In July 1910, the *Norfolk Virginian-Pilot* announced that the house would be torn down to make way for a new building.

Industry, the Navy, and the Beach

(1910–1929)

The Newport News Shipbuilding and Dry Dock Company, founded by Chesapeake and Ohio Railroad owner Collis P. Huntington, soon became the largest employer in Greater Hampton Roads. It became to private or corporate shipbuilding what the Norfolk Naval Shipyard in Portsmouth became to military vessels. Today, as part of Northrop Grumman Corporation, it is the largest nongovernmental employer in the state, with about 20,000 workers passing through the gates each day.

Although Kitty Hawk, North Carolina, is quite properly famous as the place where the Wright brothers inaugurated powered flight in 1903, Hampton Roads soon became an aviation center. The first flight from the deck of an "aircraft carrier" took place on November 14, 1910, from a temporary flight deck on USS *Birmingham* in Hampton Roads. In 1915, Glenn Curtiss opened a flying school nearby, and trained numerous pilots including Billy Mitchell. At the end of the next year, the federal government purchased a tract of land that became Langley Field, future home of the Air Force base of the same name.

In 1917, the former site of the Jamestown Ter-Centennial Exposition of 1907 was transformed into a naval base and training camp. About 34,000 enlisted men were posted there by the time hostilities ended in November 1918. The Norfolk Naval Operating Base, which continued to expand, is known today as Naval Station Norfolk, the largest naval station in the world. It is actually located in Norfolk, unlike the Norfolk Naval Shipyard down the Elizabeth River in Portsmouth.

The Suffolk peanut industry greatly expanded with the arrival of Amedeo Obici, an Italian immigrant who came there from Pennsylvania and constructed an enormous peanut-processing plant in the 1920s. He proved not only a benefactor to the local economy but also a philanthropist to the sick and needy, building a hospital in Suffolk to honor his late wife, Louise Obici.

As the naval and industrial centers of Greater Hampton Roads grew, so too did the resorts at Buckroe Beach and Virginia Beach. Great hotels—the Hygeia, Princess Anne, and Chamberlin—came and went and came again during the early part of the twentieth century, mostly destroyed in fires and then seemingly reincarnated in even grander style. Casinos, parks, and dance halls accompanied them, and the cottages and smaller hotels grew thicker along the coast in what would become Virginia Beach.

Prior to 1884, City Hall Avenue, seen here in Harry C. Mann's photograph from about 1910, had been Back Town Creek. About that time, A. A. McCullough had the creek turned into a ditch, filled the marsh there, and added more land to Norfolk's prospective business district. In 1884, the ditch was covered and City Hall Avenue was born. On the left is the Monticello Hotel, with City Hall in the background and the steeple of Saint Mary's Catholic Church to its left. Several modes of transportation are visible—horse-drawn carts, automobiles, streetcars, and people walking.

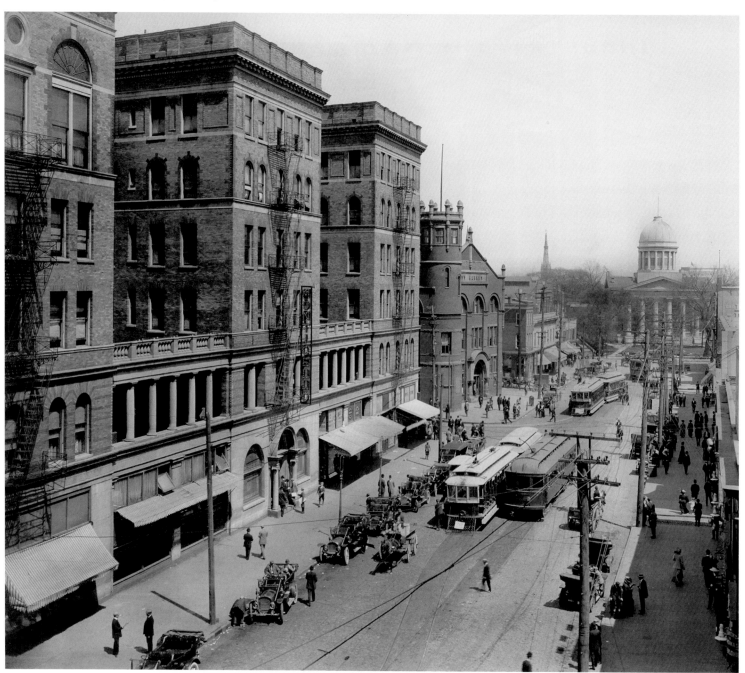

This picture shows the late-nineteenth-century Chesapeake and Ohio Railroad station at Newport News as it appeared about 1910. Located at the C&O piers on the James River, the train shed next to the station extended back to the water's edge. The station displays both Gothic Revival and half-timbered elements. The first C&O passenger train ran from the village of Newport News to Yorktown on October 19, 1881, on the one-hundredth anniversary of the British surrender at Yorktown, which effectively ended the Revolutionary War. At that time, the passenger depot was only a space alongside the track, without a ticket office or a waiting room.

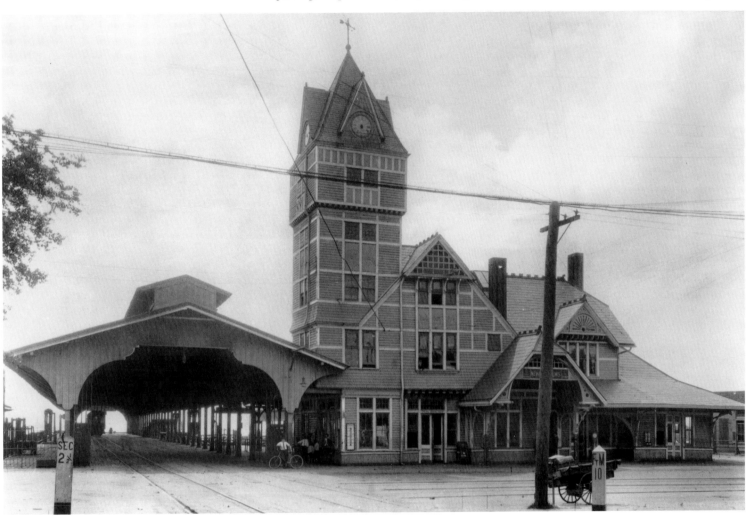

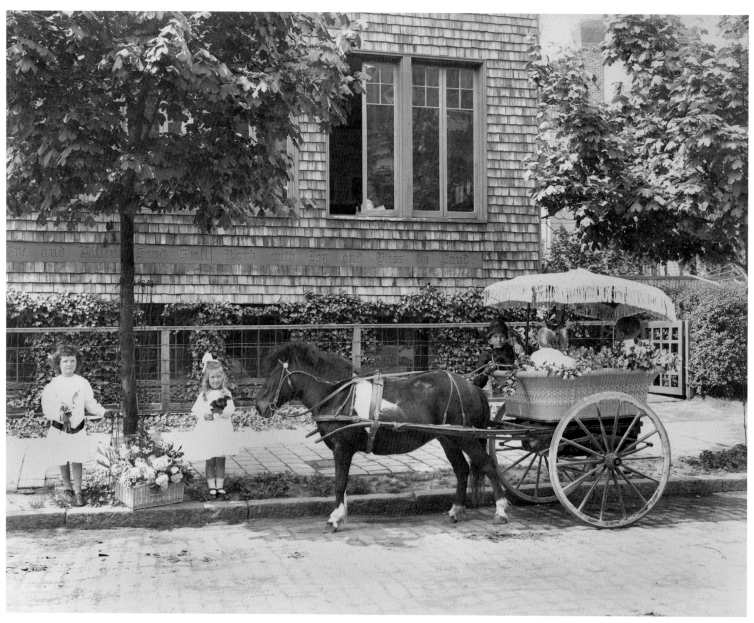

Saint George's Primary School, a private academy for boys and girls, opened about 1902. It was first located at 99 Bute Street in the new section of Norfolk known as Ghent, which had been named for the site in Belgium where the Treaty of Ghent was signed in 1817 to end the War of 1812. The area had been farmland until 1890, when a development company began laying it out as a residential suburban community. Harry C. Mann captured this delightful image of two little girls with baskets and a pony cart containing flowers standing at the curb next to the school about 1914. At that time, the school was located at 413 Boissevain Avenue.

Seen here about 1910 is the second Norfolk City Market, which was built about 1892 on City Hall Avenue between Brewer Street and Monticello Avenue. Known also as the Armory and the Municipal Building, the City Market also contained several city offices and provided quarters for some of the local militia companies. Its auditorium was used for militia drills, banquets, large meetings, and entertainments. The Norfolk Symphony presented its first concert there about 1920 and Will Rogers also appeared there. The market was torn down and replaced with the new Maritime Building in 1954.

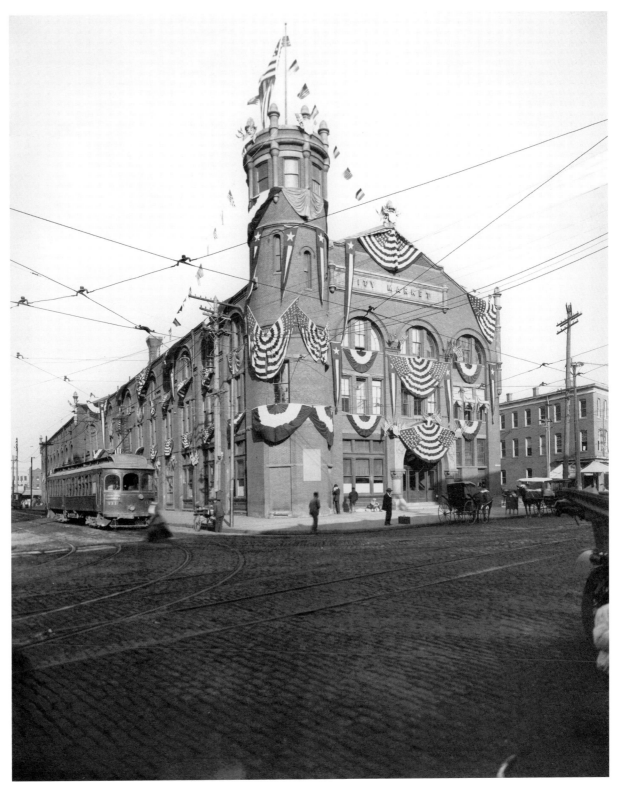

This Harry C. Mann image shows the Postal Telegraph-Cable Company's messenger boys with their bicycles about 1910. By 1914, a real estate office had replaced the Drs. Hamilton & Speer dentist office advertised in the window above the Postal Telegraph Commercial Cables sign above the door. The telegraph-cable company was located at the corner of Commerce and East Main streets. By 1919, the telegraph company had two branch offices, one at 700 Front Street and the other at the Southland Hotel (built early in the 1900s as the Lynnhaven at the corner of Granby and Freemason streets).

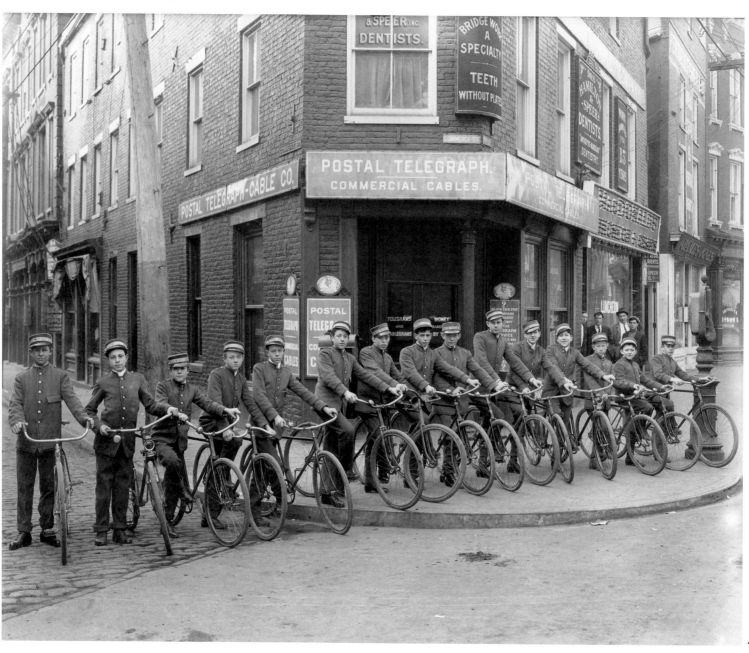

Harry C. Mann photographed the Palace Theatre, located at 830 Church Street in Norfolk, in 1914. Showing at the time was *The Robbery at Pine River,* starring fifty-three-year-old Charles Swickart and nineteen-year-old Betty Burbridge, in one of thirty movies she made that year. The second movie featured was *A Woman's Treachery,* which had been made in Russia and distributed in the United States with this English title. Contemporary reviews of the movie decried its lackadaisical direction and the fact that every scene went "on much too long for its own good." In it the villainess Sonia, acting as governess to Count Zachin's two children, plots to marry and then kill the count for his fabulous fortune. Despite wedding the count, however, she is thwarted in her schemes by the hero Ivan, a laborer in the count's employ, who disguises himself as a baron.

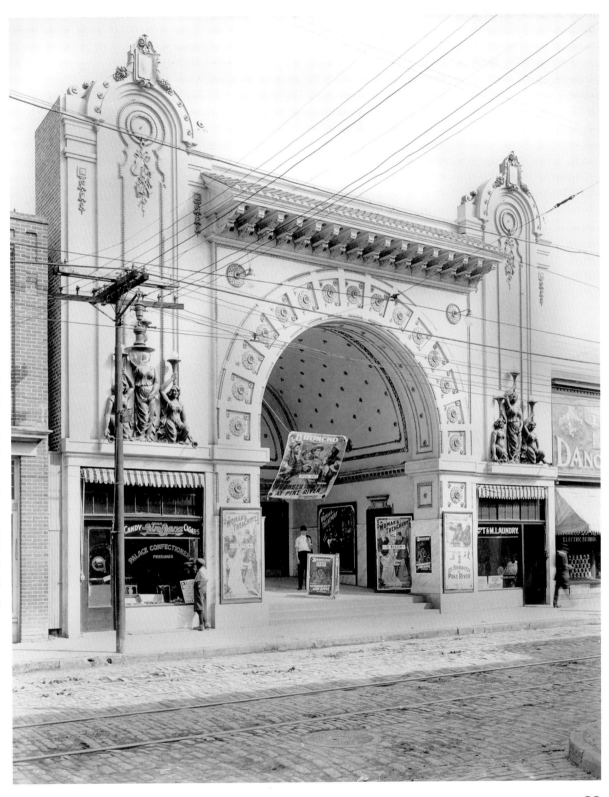

Among the many photographs Harry C. Mann took of scenes and buildings at Virginia Beach is this circa 1919 view of what would soon become the new Princess Anne Hotel. The Breakers Hotel, which had begun life as an early hunt club, is in the middle ground next to what was then the Tait house between 24th and 25th streets. Beyond the Breakers can be seen a small part of the 1903 Life-Saving Station. Sometime after April 1906, J. C. Tait, a Norfolk businessman, built his stone cottage at Virginia Beach, and in March 1921, his wife hosted 100 women who met there to form the Women's Municipal League. A year later, a group of Norfolk businessmen acquired the cottage, added wings, and under the management of the W. W. Sterling family, opened the new Princess Anne Hotel. The original Princess Anne Hotel had burned in 1907.

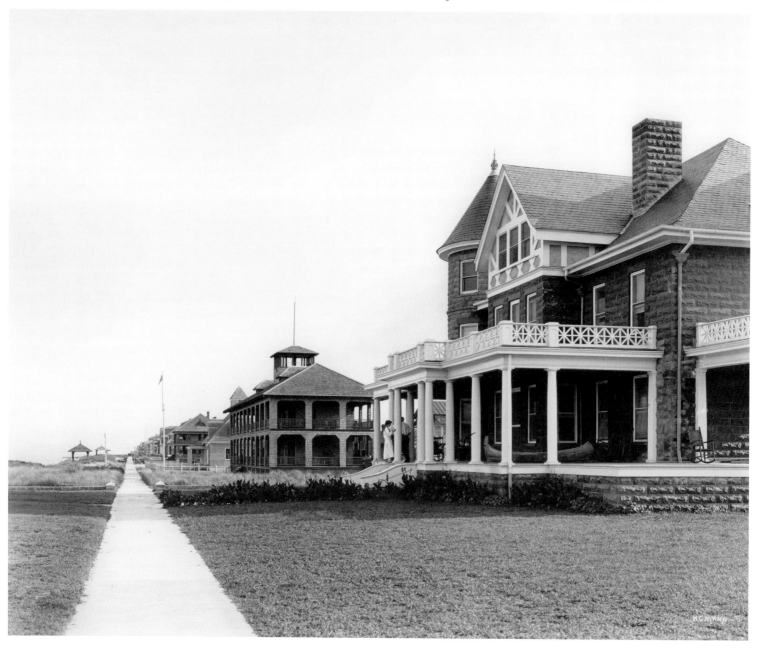

Harry C. Mann photographed the Seaside Park, which had been built by the Norfolk and Southern Railroad and opened in 1912 on a two-block section between 30th and 31st streets. In this view from about 1919, the park had been landscaped and a retaining wall built to protect the site from the ocean. The building behind the main structure is the famous Peacock Ballroom, where big-name bands played in the 1920s and 1930s. Excursion groups from Virginia and North Carolina came to the Seaside Park to picnic during the day and dance in the ballroom at night.

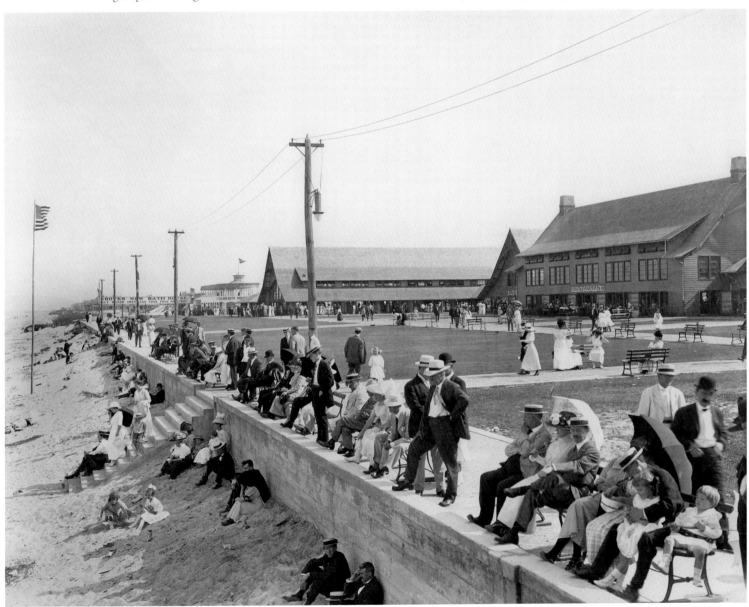

This monoplane, *Virginia 1,* was photographed at Virginia Beach in August 1910. The plane's builder and the two men posing on and with the monoplane have not been identified. During 1910, Glenn Curtiss's Flying Exhibition Team crossed the country giving flying demonstrations in various states, perhaps here at Virginia Beach in August. The Wright brothers also had an exhibition team touring the country. On November 14, 1910, Eugene Ely, a member of Curtiss's team, became the first man to fly an airplane from an "aircraft carrier" when he trundled his Curtiss Hudson Flyer off the newly built wooden flight deck on the U.S. Navy cruiser USS *Birmingham* in Hampton Roads. Ely landed safely on nearby Willoughby Spit.

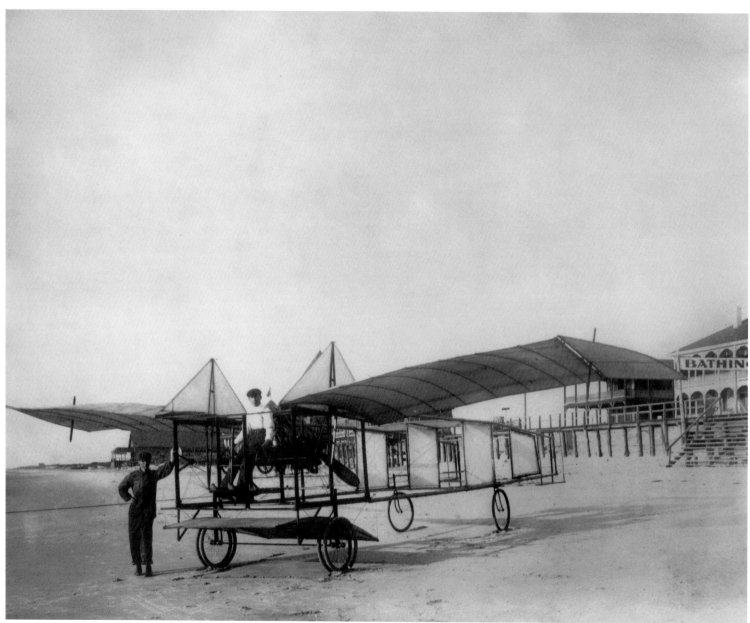

Norfolk's Taylor Building located at 153 Granby Street opened in 1908 as offices for doctors, dentists, and medical supply companies and remained at that address until 1912. Harry C. Mann made this photograph of the building about 1910. The building's address became 256 Granby Street in 1913 and continued to house offices for doctors and dentists until 1936. The Taylor Building entry remained in the Norfolk City Directory until 1946, but apparently none of the offices were in use. The building may have been demolished in 1947.

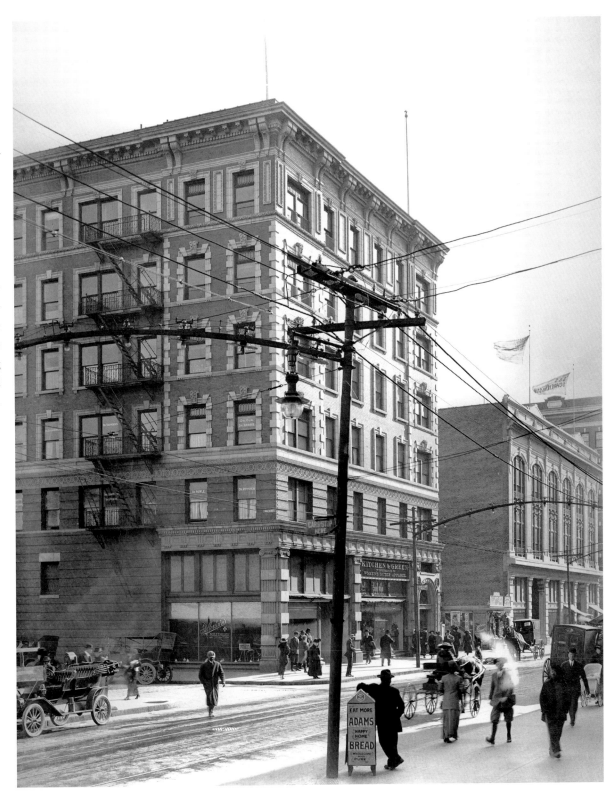

The Oaklette area of what is now the city of Chesapeake is located between Indian River and the Norfolk city line. Development of what had been farmland and wooded areas began in the 1850s. In the 1880s, the county built a one-room schoolhouse there. This view of the much larger, early-twentieth-century Oaklette School, photographed by Harry C. Mann in the 1910s, clearly shows the overgrown and brushy nature of the area at that time. Development of the area into a streetcar suburban community began in 1904 when the Mathew Hare farm there was divided into lots, and continued in 1905 when the Oaklette Realty Investment Corporation was formed. The Oaklette Historic District was listed in the National Register of Historic Places in 2003.

Lewis W. Hine, the investigative photographer for the National Child Labor Committee (NCLC), captured the image of these three adolescent spinners at the Suffolk Knitting Mills in June 1911. The mills, owned by Wilder E. Cobb, stood on Madison Street at the corner of Factory Street. Hine noted that one of the girls, age fourteen, had been working at the mill off and on for four years, and was then earning a dollar a day. The NCLC, a private nonprofit organization founded in 1903, still actively promotes "the rights, awareness, dignity, well-being and education of children and youth as they relate to work and working."

William Washington Gaines, pastor of the First Colored Church, founded Nansemond Collegiate Institute in 1890 as the Nansemond Normal and Industrial Institute to provide local African American children with an education. At that time, there were no free public schools for black children in the county. Local black churches of all faiths supported the school, along with tuition and contributions from patrons including some whites. No public dollars financed the school and no child was turned away for inability to pay. When a student did not have cash for tuition, payment could be made with livestock, vegetables, firewood, or labor for the school. Eventually the institute offered elementary, secondary, and normal school courses of instruction. In 1927, a public school for black scholars was opened, which led to competition for students. A series of fires forced the institute to close in 1939.

Facing south on King Street from the intersection with Queen Street, Christopher E. Cheyne captured this peaceful scene about 1910. The buggy on the left is parked beside the Bank of Hampton, and visible beyond it are the Barnes Hotel and the Kecoughtan Building. On the right, the sign for the YMCA can be seen in the distance. The Women's Christian Temperance Union presented to the city the drinking fountain at the curb, in front of the Powhatan Dining Room. The ghostly image on the far right is that of a man walking away from the camera; perhaps he was pondering whether to get a drink from the fountain, or to indulge in something stronger in the Powhatan.

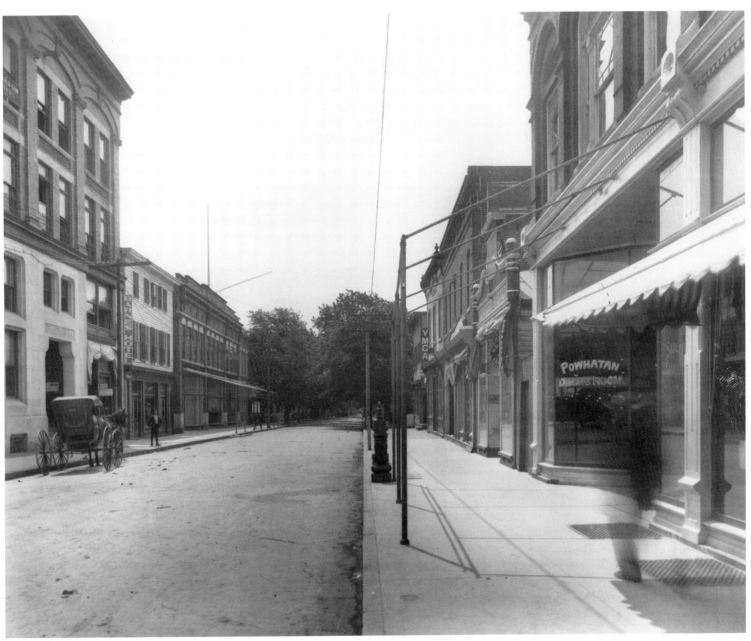

Lewis W. Hine, investigative photographer for the National Child Labor Committee, captured this image of five newsboys or "newsies" in Norfolk in June 1911. Hine commented that he had photographed the boys in "their environment," and that "many very small boys sell newspapers in the Virginia cities."

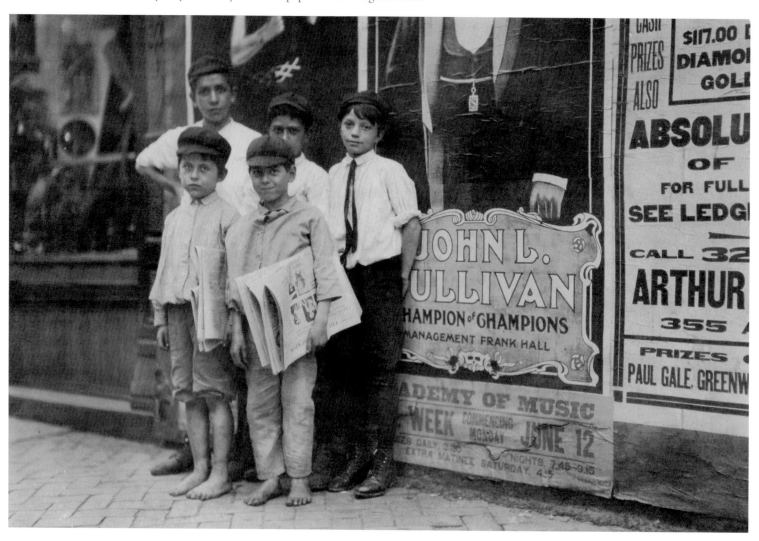

Harry C. Mann photographed this Norfolk Coal and Ice Company facility about 1912. The company had two places of business: at 545 Front Street and 128 Atlantic at the corner of East Plume. Mounds of coal can be seen behind the storage building in this image, while horse-drawn delivery wagons and a motorized dump truck await loading. Coal is being transferred from storage by way of a steam-powered crane with a clamshell bucket. The masts and bowsprit of a sailing vessel in the distance suggest that this photograph was probably taken at the Front Street facility, on the waterfront.

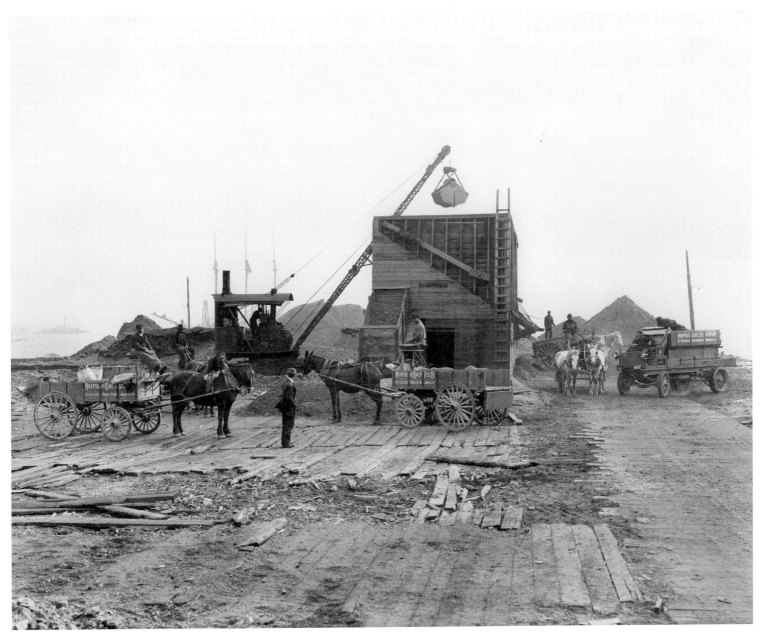

As Lewis Hine, investigative photographer for the National Child Labor Committee, made his way around the Hampton Roads area in June 1911, he recorded this image of a shift change "as the whistle blew at the Tidewater Knitting Mill, Portsmouth Va." Hine wrote, "I went through the mill several times while they were working and saw a number of boys and girls that were surely under 14." Under the administration (1913–1921) of Virginia-born president Woodrow Wilson, the Progressive Era ushered in child labor laws that ended the practice of sending young children to work instead of to school.

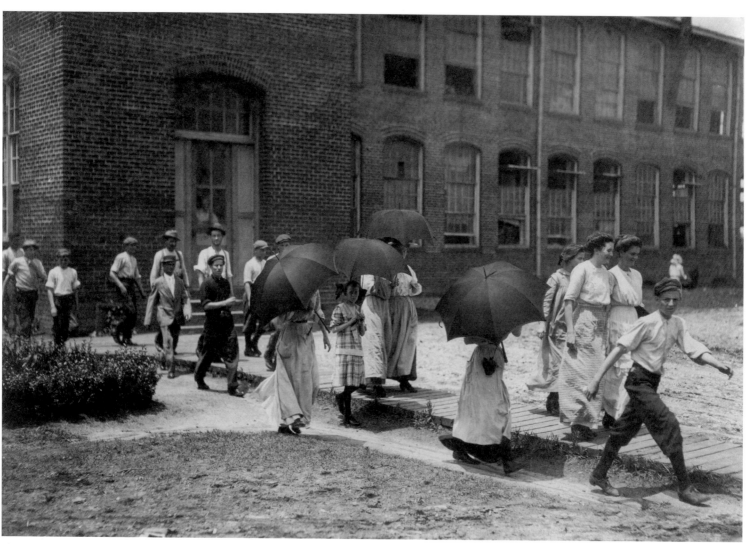

Harry C. Mann photographed the Furness, Withy and Company building at 2210 River Road in Newport News about 1921. Incorporated in 1891, this British company handled cargo for the many steamship lines that plied the waters of Hampton Roads, including coal, grain, flour, and "merchandise of every description." The Noland-Clifford Company, whose truck is shown parked, was founded in 1914 by L. U. Noland and T. B. Clifford. A plumbing and heating contracting firm, Noland-Clifford was the forerunner of the Noland Company, established in 1922.

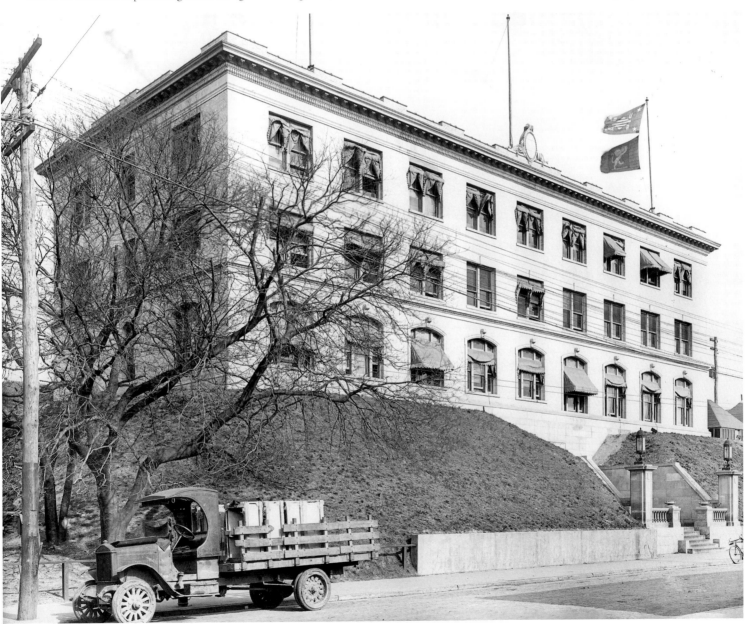

The G. R. Kinney Company sold shoes and boots at 73 Commercial Place in Norfolk. Harry C. Mann photographed the staff outside the store on January 15, 1915. The storefront advertised "Great Values" for 98¢ and "Nothing Over $1.98."

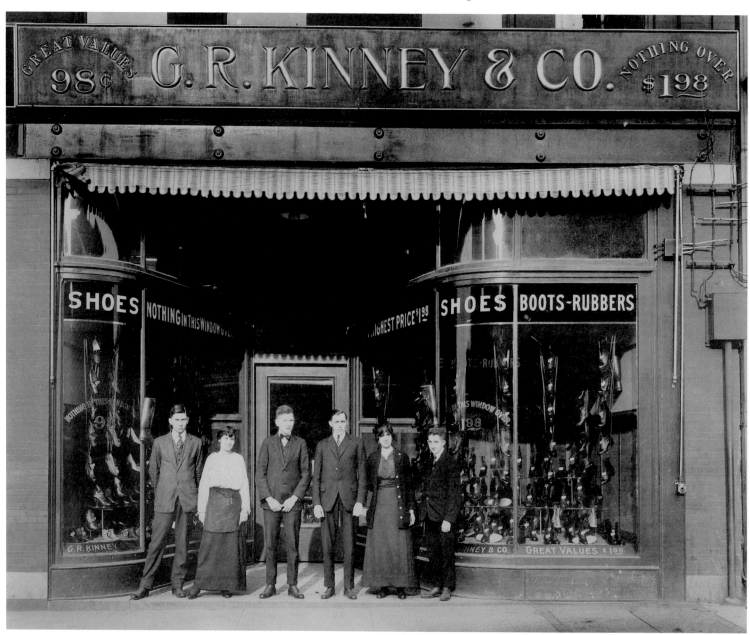

Christopher E. Cheyne took this photograph of Queen Street in Hampton, facing east, in 1915. An attorney, Samuel Gordon Cumming, is credited with designing the Bank of Hampton building on the right. Cumming had his office in the structure.

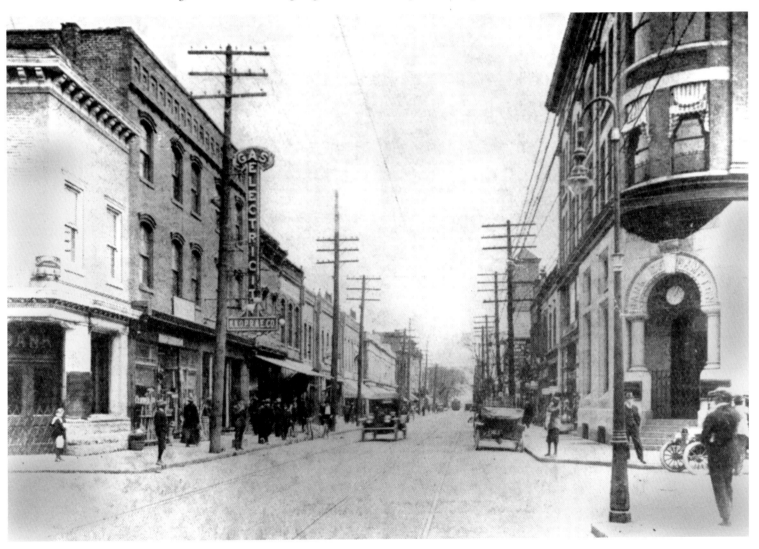

This Harry C. Mann image shows an unpaved street in Hampton, probably in the 1910s. Frame houses line both sides of the street, which has curbs and sidewalks if not paving, and a brick church can be seen halfway down on the left.

The Atlantic Coast Aeronautical Station, photographed by Christopher E. Cheyne in 1916, was also known as the Curtiss Flying School, opened by Glenn Curtiss in 1915 under the direction of Captain Thomas Scott Baldwin. The school was located near the Newport News–Sewells Point ferry slip. On December 29, 1915, the first two instructors made the initial flight from the school, taking up an early Curtiss tractor biplane and a hydroplane (flying boat) for a tour around the area. On January 26, 1916, several lucky locals got a ride in the flying boat, including the second Peninsula woman to go flying, Miss Elsie Rauch.

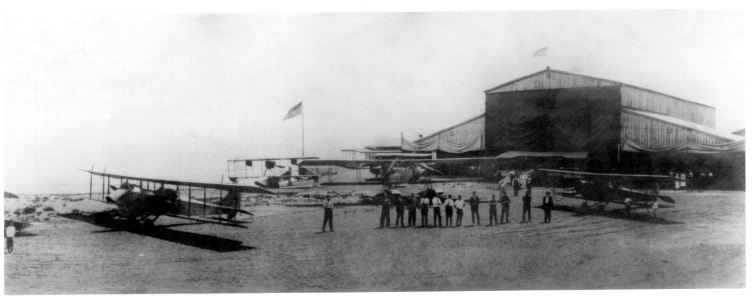

A worker loads crates of Planters Peanuts aboard a boxcar at the peanut factory in Suffolk. The picture was taken after 1916, when the character of Mr. Peanut was adopted as the company mascot. The image illustrates the manner in which boxcars, in this case belonging to the Central Railroad of New Jersey, could be loaded with goods directly at then-modern factories, eliminating the need to transport goods first to a central depot.

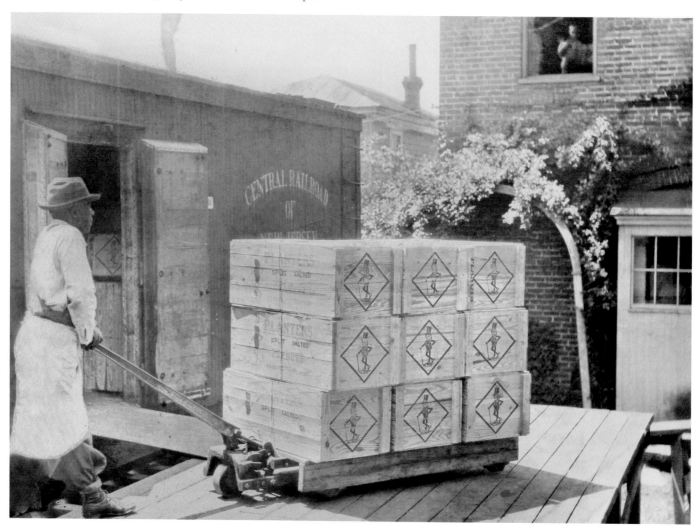

The old Nansemond County courthouse, now located in downtown Suffolk, was completed about 1840 to replace one lost in a fire in 1837. Its architecture is a provincial version of the Roman Revival style, with tall white Tuscan columns bearing a pediment, and a red-brick building to complete the courthouse "temple" first popularized by Thomas Jefferson and found in county seats throughout Virginia by the mid nineteenth century. The courtroom is on the second floor instead of the first, typical of the temple style. Currently, the building is undergoing rehabilitation for future use as a visitor center.

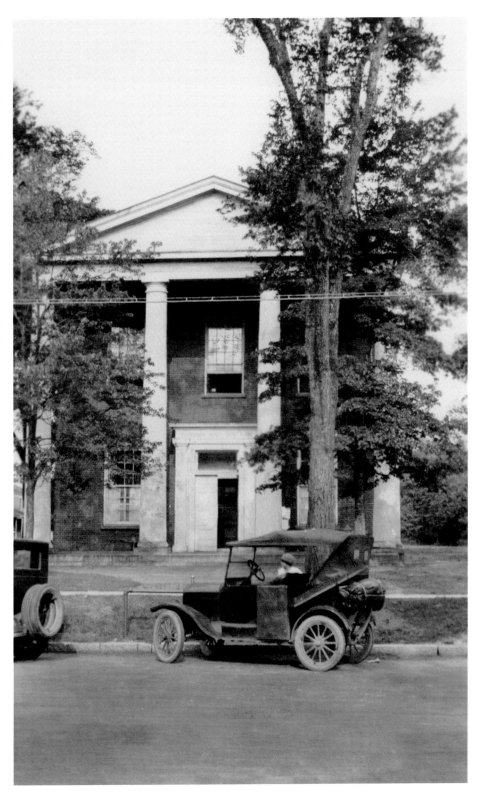

The three young women in this small art class at Saint George's School are drawing the younger girl posed at the table beside the wall. Harry C. Mann photographed the scene while making a series of pictures of the school and its activities. The image also shows plaster reproductions of classical sculptures on the walls and shelves to inspire the students and serve as examples. The school operated until 1929.

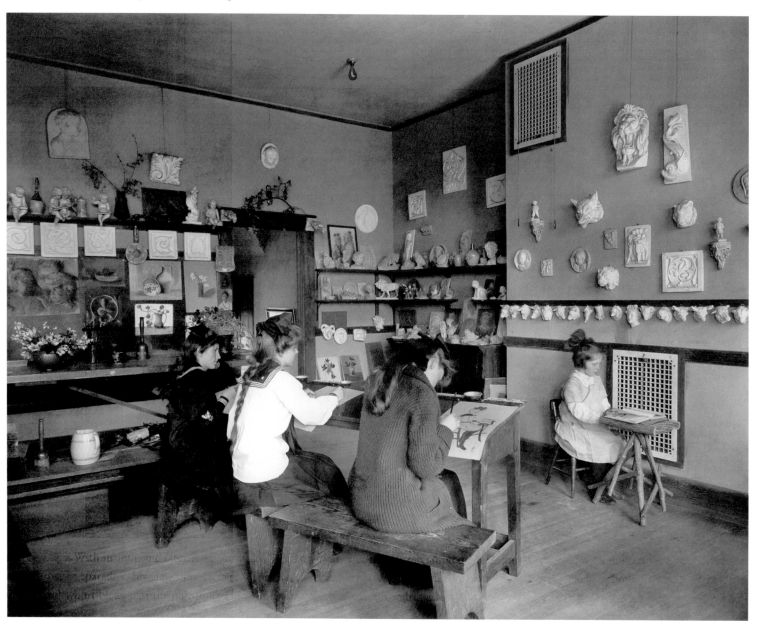

One of the premier hostelries in Norfolk, the Atlantic Hotel opened on the waterfront there in 1859 and served as a Confederate command post briefly in 1861. It burned in 1867 and was rebuilt in the Second Empire style "after the fashion of the French chateaux" with four stories and a mansard roof that raised it to six stories. Even in 1889, the hotel boasted space for almost 1,000 patrons and, after 1902, rooms for 1,000 guests exactly. Shown here about 1910 is the grandiose entrance to the hotel after its restoration from a 1902 fire. Early in the twentieth century, the hotel advertised its five staircases, three fire escapes, and electric lights throughout the building. As early as 1884 and thereafter, the Atlantic also offered electric bells in every room, elevators, and hot and cold baths. "Nothing will be left undone," according to an 1884 ad, "to render" the accommodations "comfortable" for patrons. It was demolished in 1976 as part of Norfolk's urban renewal.

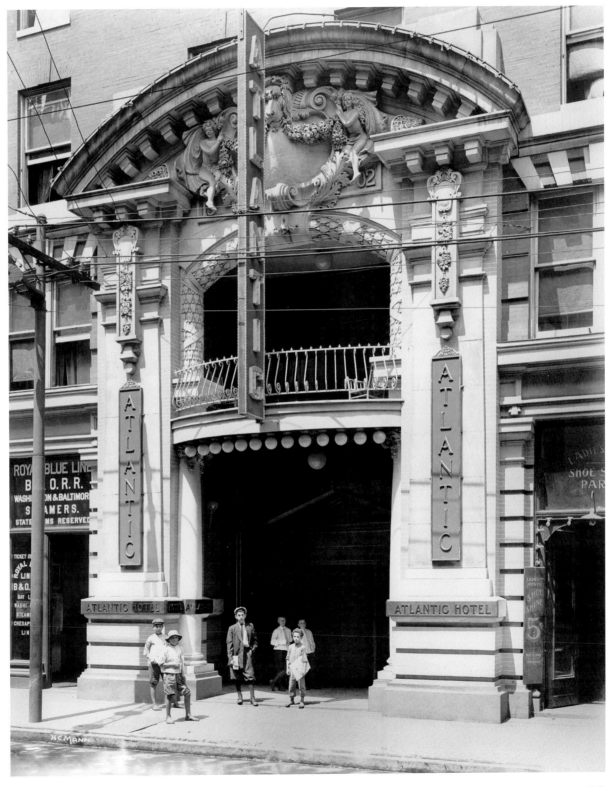

After the United States entered World War I in April 1917, the Secretary of the Navy bought 474 acres at Sewell's Point in Norfolk, the site of the Jamestown Ter-Centennial Exposition of 1907, for a naval base and training camp. The construction of the camp began in July 1917, and within thirty days housing was available for 7,500 men. By the time the armistice was signed in November 1918, 34,000 enlisted men were at the base, which included a training center, air station, submarine station, and hospital. The facility was officially designated the Norfolk Naval Operating Base. This training battalion was photographed there in December 1917.

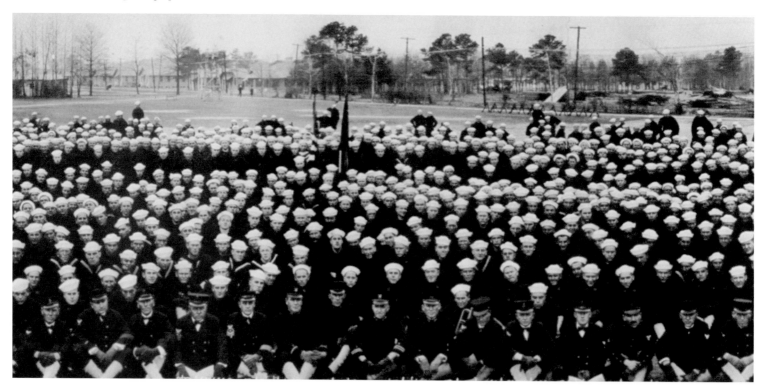

A January 1918 snowstorm in Portsmouth knocked the usually bustling High Street out of commission. This view was taken looking west from the ferry building.

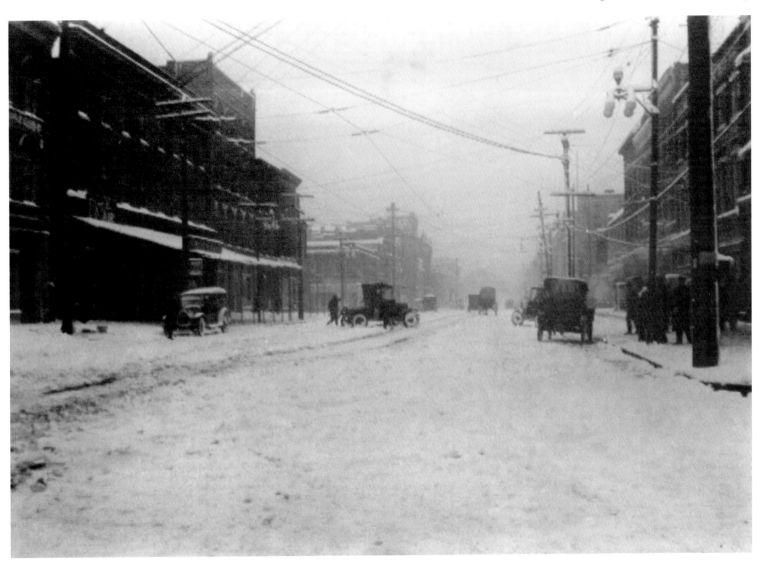

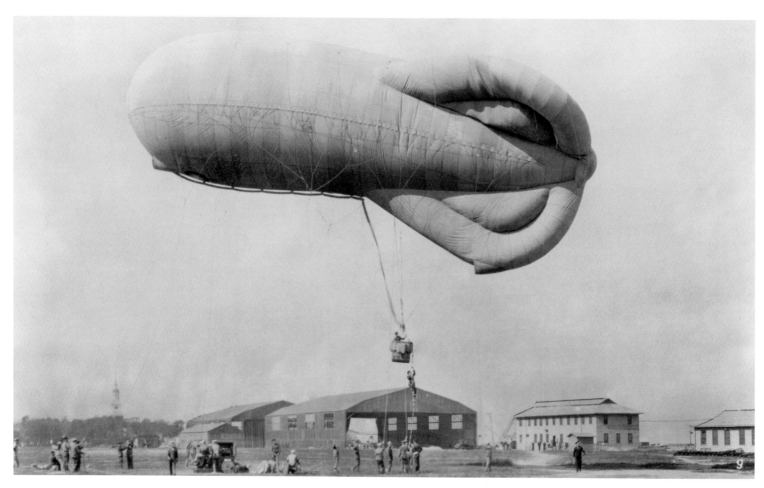

The Naval Air Station, Norfolk, evolved quickly once the federal government acquired the Jamestown Ter-Centennial Exposition site at Sewell's Point in 1917, when the nation entered World War I. Naval aviation training, which had been conducted in Newport News, was transferred to the Norfolk station later in the year. Training was given not only for fixed-wing aircraft, but also for balloons such as the one shown here. The pilot is climbing a rope to the basket or gondola suspended under this observation kite balloon in 1918.

On July 14, 1918, Bastille Day in France, the American Expeditionary Force under General John J. Pershing was in France helping to defeat the Germans and end World War I. The French had set aside July 4, 1918, to honor America's Independence Day "in true American style," so in return General Pershing ordered his troops to observe France's Independence Day. Almost 100 cities in the United States staged their own Bastille Day celebrations, including Norfolk, as shown in this Harry C. Mann photograph of the celebration at city hall. The nation hoped to "let the display of the tri-color be the most remarkable demonstration ever seen of a nation's appreciation of what another nation has done in the service of liberty."

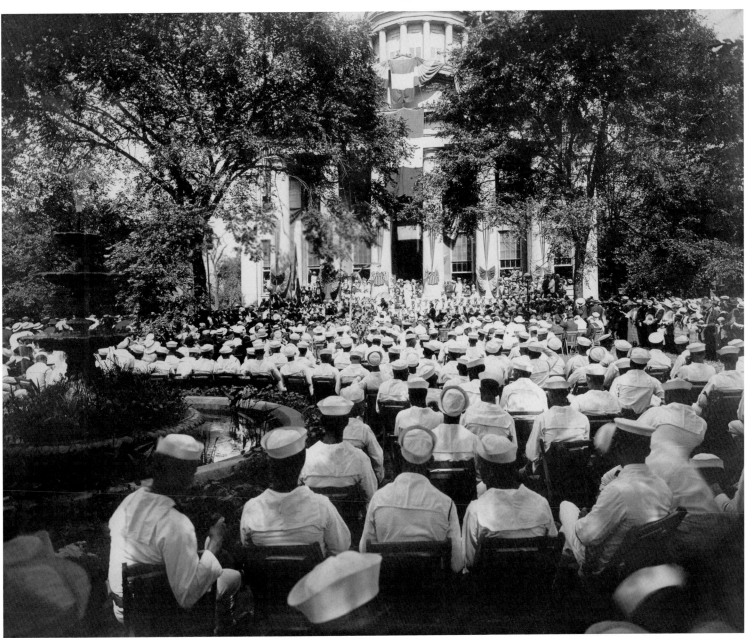

Before 1910, a thousand Baptists attended a Summer Encampment at Buckroe Beach in Hampton. Beginning in that year and continuing until 1932, they met instead in Virginia Beach, attending services and meetings in outdoor structures such as the "New Baptist Auditorium" shown here. It was also called the Chautauqua Building after the famous camp and lecture venue at Chautauqua, New York. On September 10, 1919, returning World War I veterans were welcomed home and entertained with speeches here, followed by dinner and dancing elsewhere.

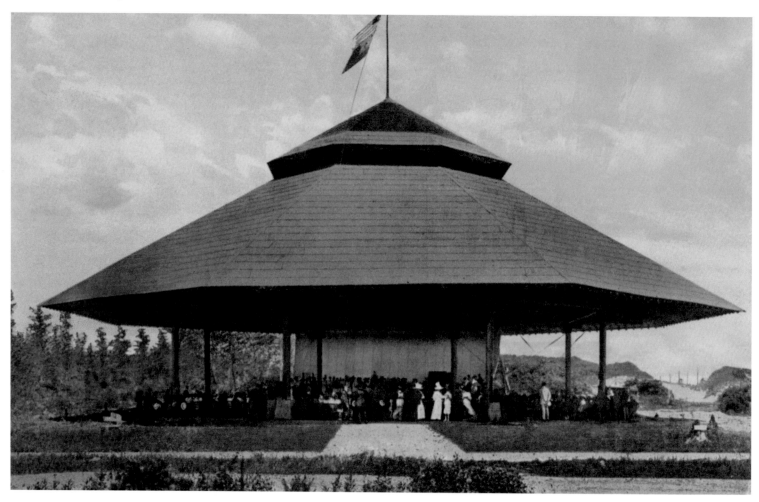

Housing was in short supply in Newport News for years before America's entry into World War I, because of the rapid expansion of the rail, coal, and shipbuilding industries there. When Hampton Roads became a wartime port of embarkation and orders for ships soared, the need for worker housing reached crisis proportions. Early in 1918, Homer L. Ferguson, president of the Newport News Shipbuilding and Dry Dock Company, obtained a congressional appropriation to construct houses—the Hilton Village project. By October 1918, thirty-two families were living in new houses there. Two years later, the project was largely completed and included four churches and several stores. The streets were paved, with curbs, gutters, and streetlights. This photograph shows the state of the project on February 1, 1919.

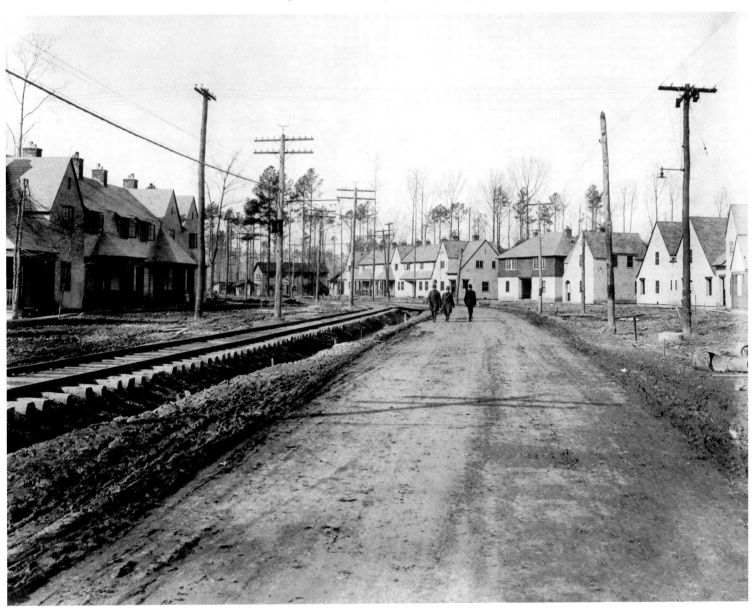

This Christopher E. Cheyne photograph of the interior of a soda shop in Hampton was made in 1919. The tidy shop and attentive staff appear ready for customers.

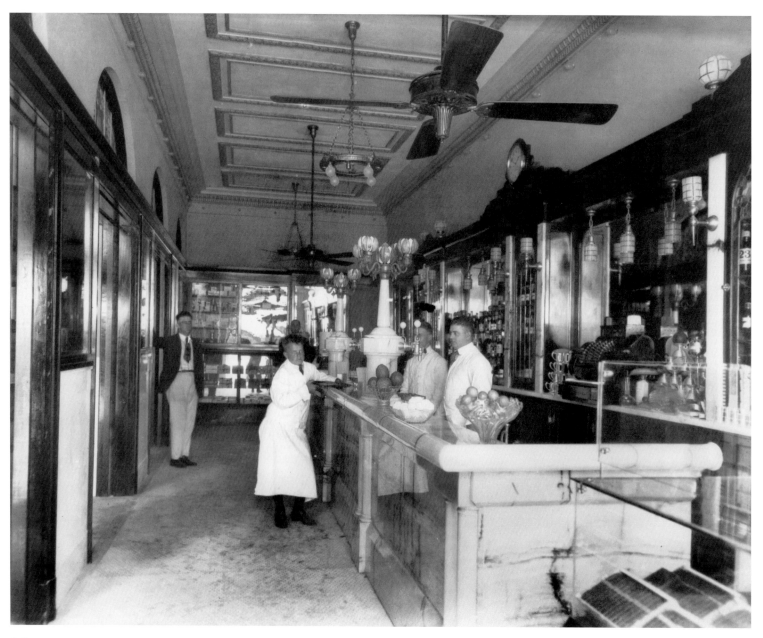

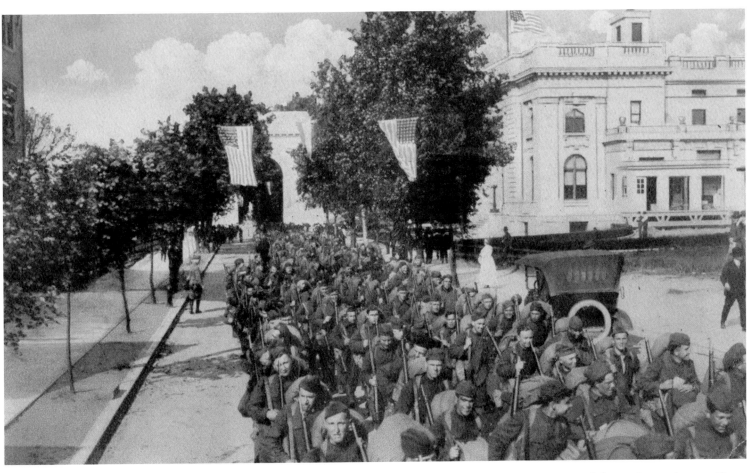

With its long and close association with both the army and the navy, Hampton Roads knows how to host a military parade. This view shows one of many that took place after World War I, as the returning troops marched through Newport News past the post office and custom house. Most parades ended at the end of 25th Street at the Victory Arch, which was dedicated April 13, 1919.

On February 24, 1888, entrepreneur James S. Darling, Sr., organized the Hampton and Old Point Railway Company, with himself as president. The line, with electric trolleys, was an immediate success, and Darling soon extended it to Newport News. There, Colonel C. M. Braxton founded the Newport News Street Railway Company in 1890, and extended his service to Hampton two years later. The two companies merged in 1896 to form the Newport News, Hampton and Old Point Railway Company. Only two years later, having acquired another streetcar company and upgraded its tracks and service, the company changed its name again, to the Newport News and Old Point Railway and Electric Company. This view shows one of the trolleys at the Chamberlin Hotel at Old Point Comfort about 1921.

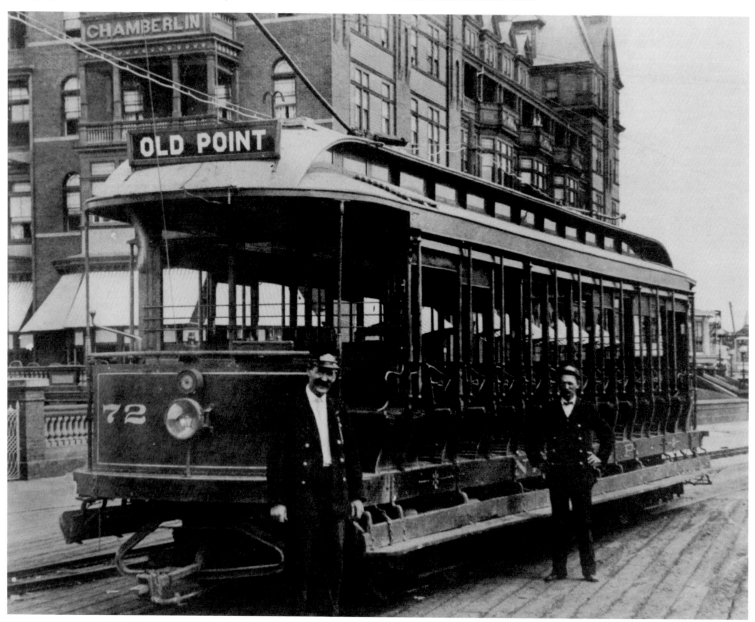

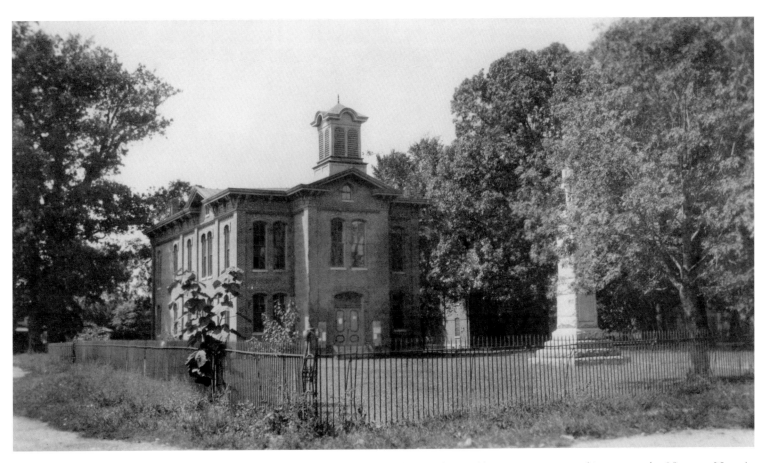

The former Warwick County courthouse, depicted here, was constructed in present-day Newport News in 1884, to coincide with the completion of the Chesapeake and Ohio Railroad line to the city. The building is considered an excellent example of High Victorian Italianate architecture, with tall windows, bracket cornice, and cupola typical of the style. It served the county until 1958, when the government was merged with that of the city of Newport News. The courthouse, with the adjacent 1810 courthouse that it succeeded, was listed in the National Register of Historic Places in 1988.

On March 7, 1920, a fire broke out on the third floor of the Chamberlin Hotel, and within a few hours the great structure was reduced to rubble. Fortunately, no one died in the conflagration, which caused an estimated $3 million in losses. Christopher E. Cheyne photographed the still-smoldering ruins shortly after the disaster. It would be eight years before another Chamberlin—the present building—was completed on the same site.

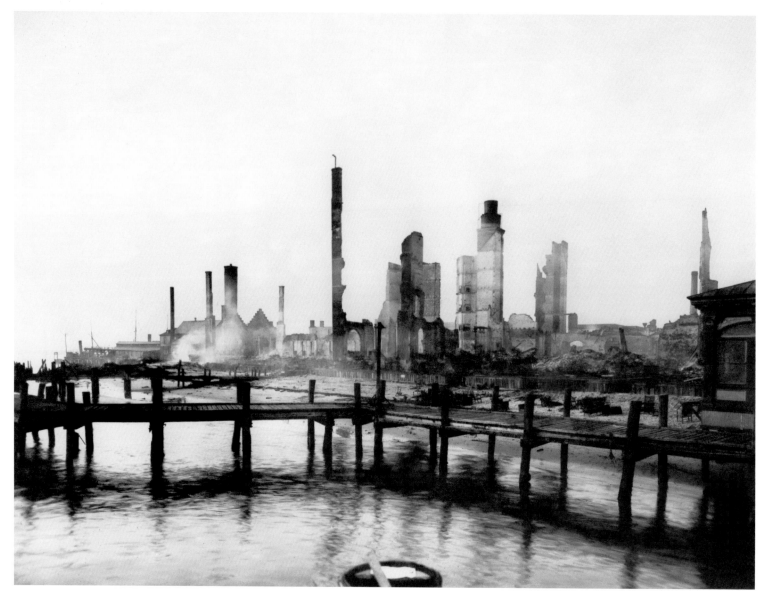

Reflecting the rise of the automobile, the York Tire Company was doing business in this former dwelling in Hampton by 1922, when this photograph was taken. As an inducement to customers, York Tire offered "Free Air" for inner tubes.

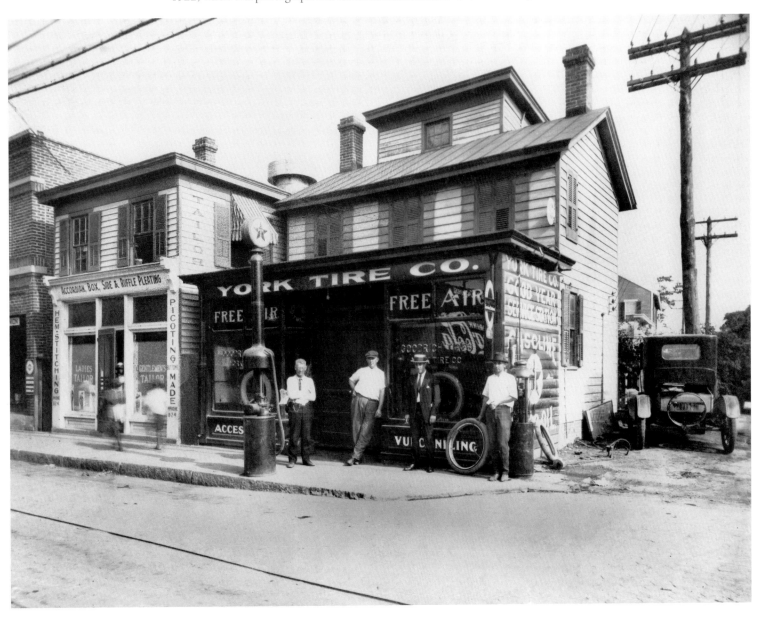

Seen here in this Virginia State Chamber of Commerce photograph is the garden at Roseland Manor, home of the second owner of the Hygeia Hotel, Harrison Phoebus. The massive edifice was built in 1886–1887 and burned in 1985. Located on the shore of Hampton Roads, the grandiose Queen Anne structure was designed by Arthur Crooks, an English immigrant who had established his practice in New York in 1869. It was equipped with intricate encircling verandas and surrounded by elaborate landscaping. The house site, called Strawberry Banks, provided spectacular views of Hampton Roads. Roseland Manor was one of a very small number of large-scale and highly ornamented residences built in Virginia after the Civil War.

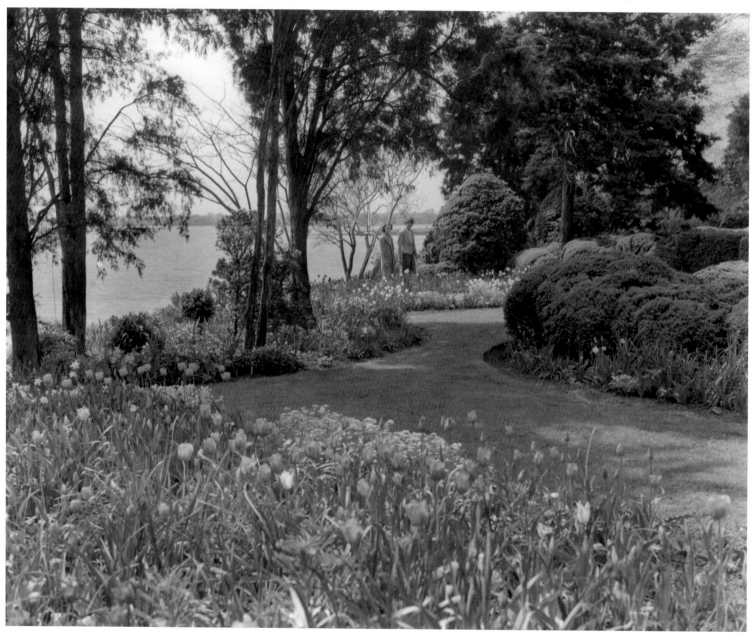

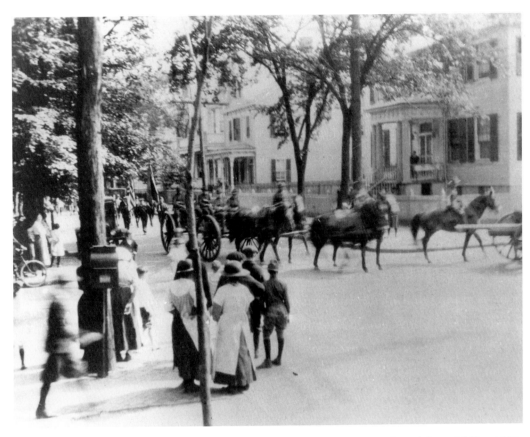

Recorded at the intersection of Middle and North streets in Portsmouth on Memorial Day 1922, this image shows part of the parade passing by. The house at right, on the northwestern corner of the intersection, was constructed about 1792 for Doctor William Leigh.

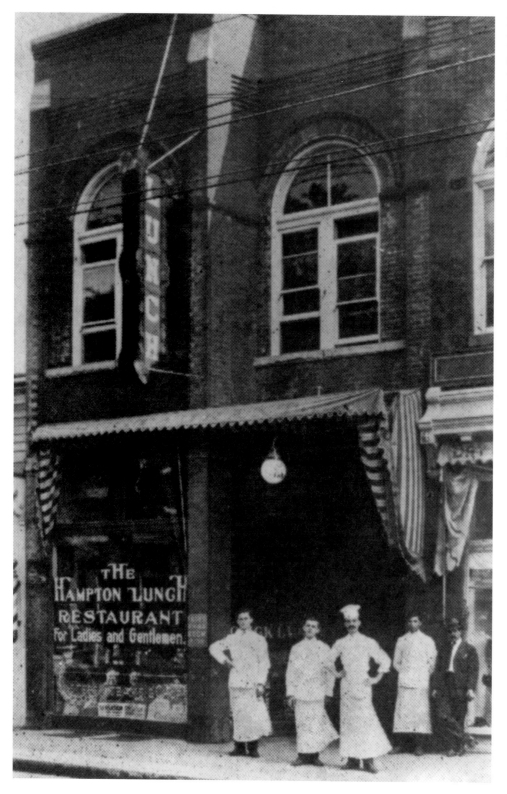

Local photographer Christopher E. Cheyne photographed the chef and waiters and perhaps the owner, William Loupes, standing in front of the Hampton Lunch Restaurant at 21 North King Street, probably in the mid 1920s. By 1929 the restaurant had gone out of business.

The Commonwealth of Virginia's Historic Highway Marker program began in 1926 to mark significant sites in the state for the education of its citizens and tourists. One of the first sites to receive a marker was this one on Waters Creek. The marker noted a 1624 patent of land here to Captain Edward Waters in what was then Warwick River County, now the city of Newport News. Although this plaque no longer exists, Virginia continues to erect highway markers, and more than twenty-two hundred are in place today.

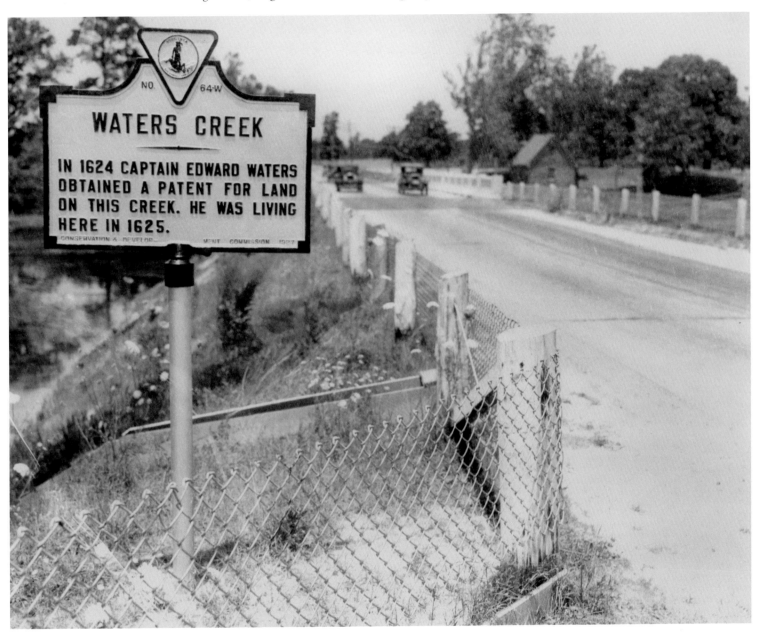

With all of the industry and commerce that exists in Hampton Roads and Tidewater today, it is easy to forget that fishing formed the basis for the early economy of the region and continues to be an important livelihood for many residents. In this view, a bucketful of fish is hauled up to the dock from a small fishing boat.

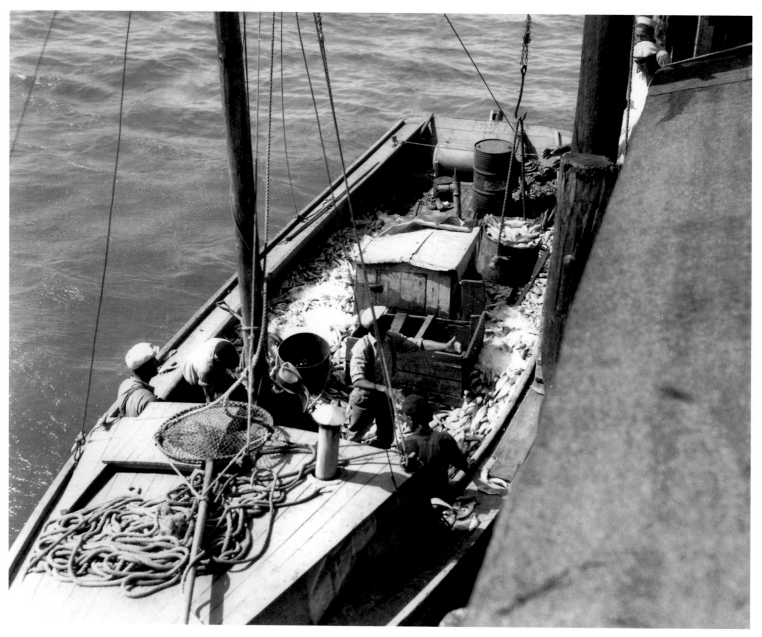

Part of the Suffolk Historic District listed on the National Register of Historic Places, the present Saint Paul's Episcopal Church is a Gothic Revival building built between 1892 and 1895. Profits from the sale of bricks from an earlier parish church that ceased to exist by 1820 went into a fund for a new church bell. Manufactured in 1860, the bell hangs in the tower of Saint Paul's, seen here early in the twentieth century.

The store window of the Ballard and Smith department store in downtown Suffolk about the time of World War I displays a variety of women's shoes. Walter Wood Ballard and Otis Smith began as dry goods merchants by 1884 and theirs became the leading store in Suffolk for carpets, clothes, hats, shoes, notions, and fine items.

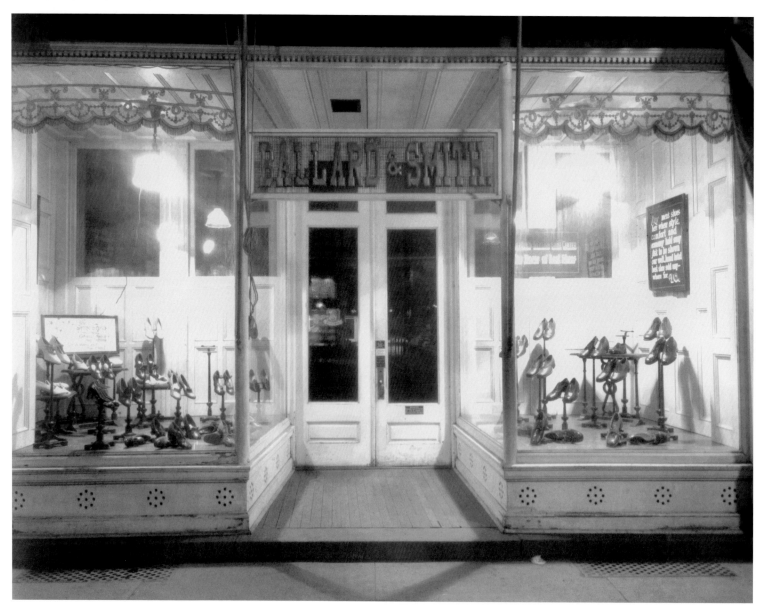

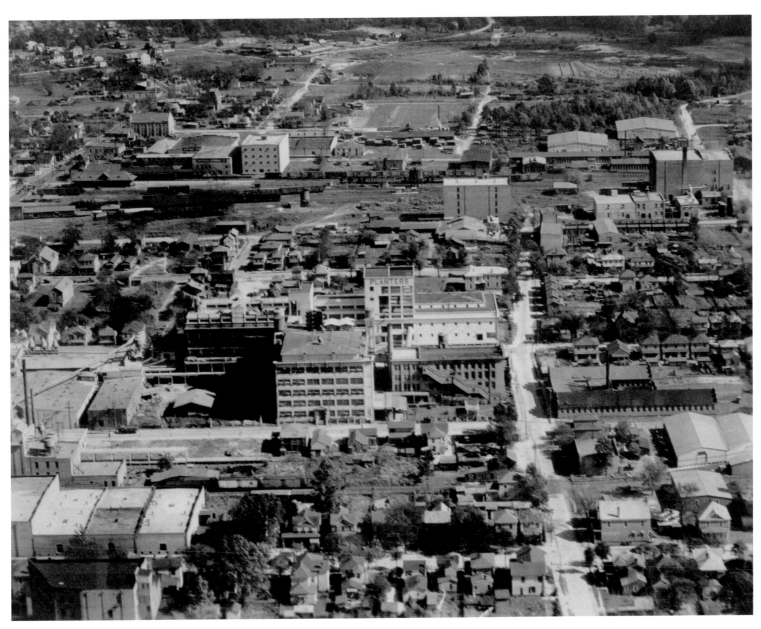

Much of the credit for laying the foundation of today's Newport News must go to Collis P. Huntington and the Chesapeake and Ohio Railroad. Amedeo Obici, founder of Planters, also deserves plaudits for constructing the Planters Nut and Chocolate Company factory in Suffolk. Obici, a native of Italy who came to America as a child, was renowned as much for his philanthropy as for his business acumen. The plant is shown here in an aerial photograph probably taken in the mid 1920s. Planters celebrated its 100th anniversary in 2006.

By 1912, the Methodist population of Virginia Beach had outgrown its first house of worship, Union Chapel at 18th Street and the oceanfront. The congregation purchased a lot on Pacific Avenue near 18th Street and completed a handsome Gothic Revival–style church there in 1913. In 1952, the church was demolished for a new sanctuary.

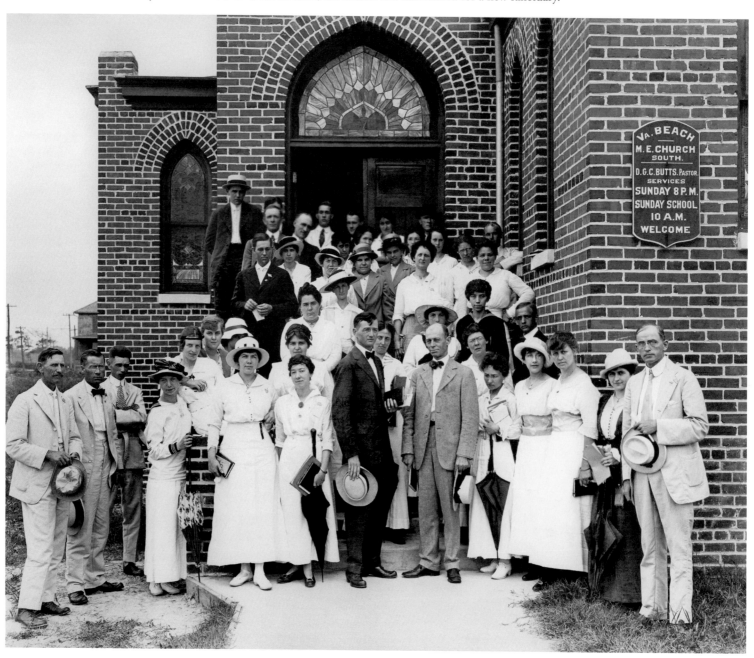

Langley Field in Hampton was established in 1916–1917 to train military aviators. In those early years of flight, there was almost as much interest in lighter-than-air craft such as zeppelins, dirigibles, and blimps as in airplanes. That interest may have begun to decline after the crash of the Langley-based dirigible *Roma* on February 21, 1922, when the ship lost altitude over the Norfolk Army Base. As it settled toward the ground, it struck high-tension wires that set it afire, killing all but eleven of the forty-five-man crew. A public funeral was held in Newport News three days later. Experiments continued for a few more years, although other lighter-than-air craft, such as the U.S. Army Air Service blimp TA-5 shown here, suffered wrecks. The blimp had made a forced landing in the water of Hampton Roads.

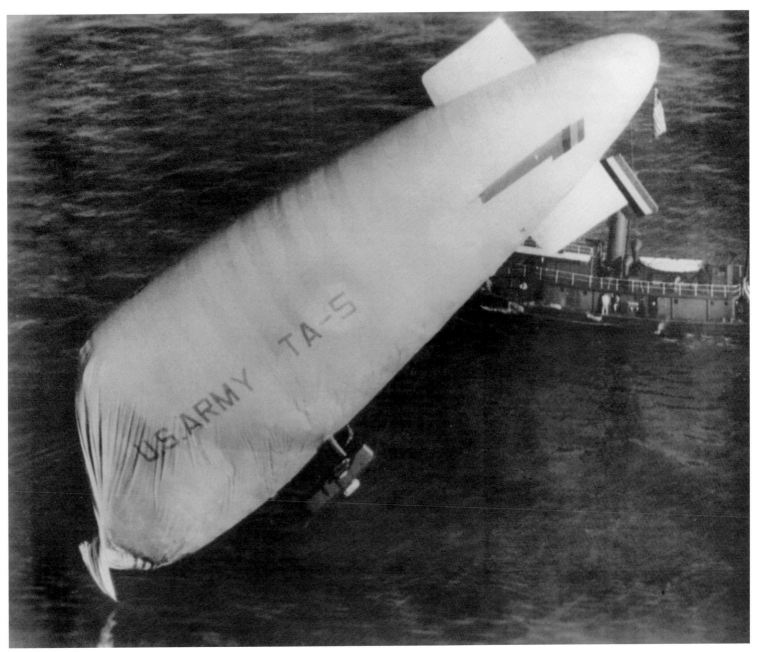

One of Hampton's post–Civil War entrepreneurs, James Sands Darling arrived there from New York in 1866 with his wife and year-old son, Frank W. Darling. J. S. Darling began with gristmills and sawmills and opened a fish oil factory on the Eastern Shore in 1879. Despite reversals in his lumber mill and the fish oil factory, he went into the oyster business in Hampton in 1881 operating as J. S. Darling and Sons, and built a street railway in 1888 with Henry and George Schmelz to connect Hampton with Old Point Comfort. His son Frank Darling continued the family fish business, as seen in this 1927 Christopher Cheyne photograph.

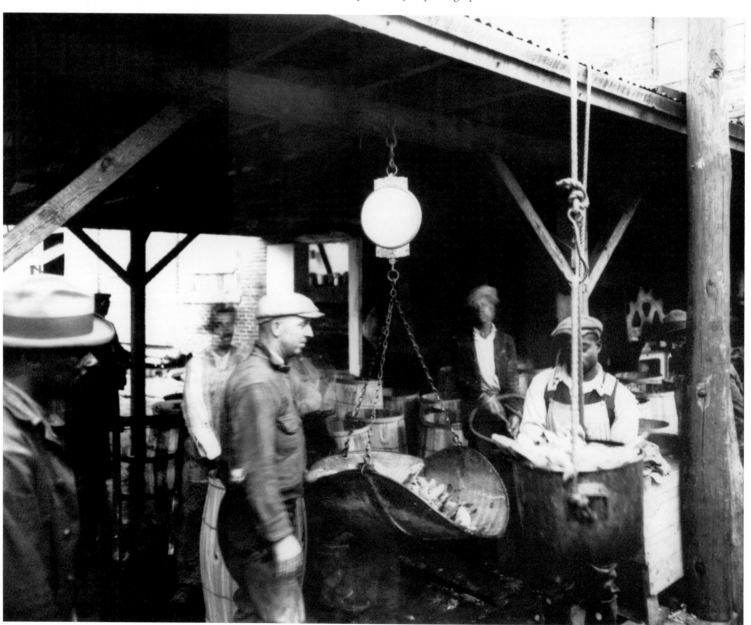

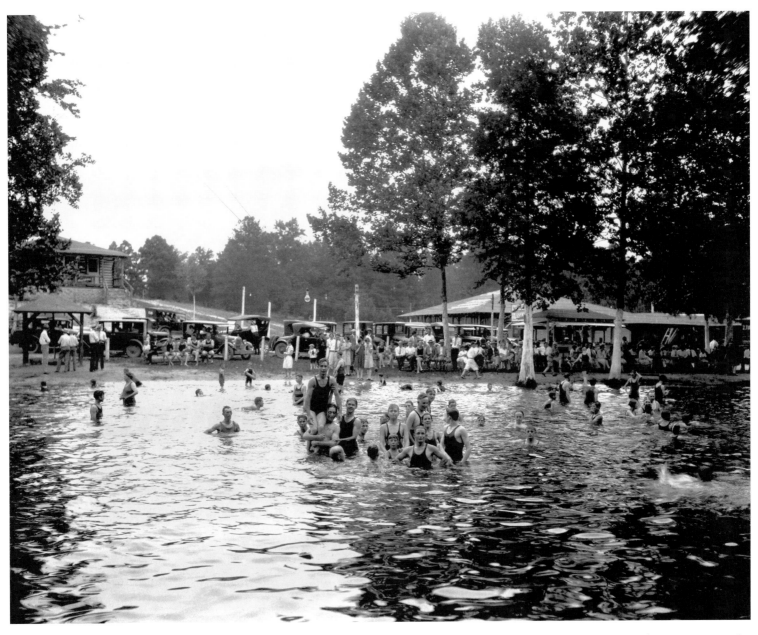

A popular recreational area, Conan Beach was located on the banks of Lake Meade at the upper end of the Nansemond River in present-day Suffolk (then Nansemond County). Shown here in June 1928, the swimming and picnicking area opened in the mid 1920s under the management of Baldwin Edward "Ballie" Parker and his son Binford E. Parker, later owners of Parker Peanut Company and other peanut-shelling operations in the area. Ballie Parker combined parts of the words Cohoon from Lake Cohoon and Nansemond from the name of the county to create the name Conan. Early in July 1928, Virginia Electric and Power Company brought floodlights on thirty-foot-tall poles to the site, the first beach in the area "to adopt that modern and highly satisfactory method of lighting." For twenty-five cents for adults and ten or fifteen cents for children, everyone could take a swim at night . . . without being in utter darkness." The beach closed in the mid 1940s after the danger of contracting polio at swimming sites became a public health issue.

Hampton photographer Christopher E. Cheyne, or his son William E. "Happy" Cheyne, photographed the Hampton Institute Band about 1929 as the members marched on campus. Music had always formed an important part of the school's curriculum. As early as the 1870s the school had a band, and in the 1890s the Hampton Singers helped "sing up" dormitories by touring Europe and the United States and performing for paying audiences. In 1924, the Royal Hamptonians orchestra was organized to play for student and faculty clubs. Five years later, the orchestra also began playing for community organizations and events. The Hampton Institute Band, the Crooning Syncopators, and the Hampton Institute Quartet and Sextette entertained audiences in the mid 1930s.

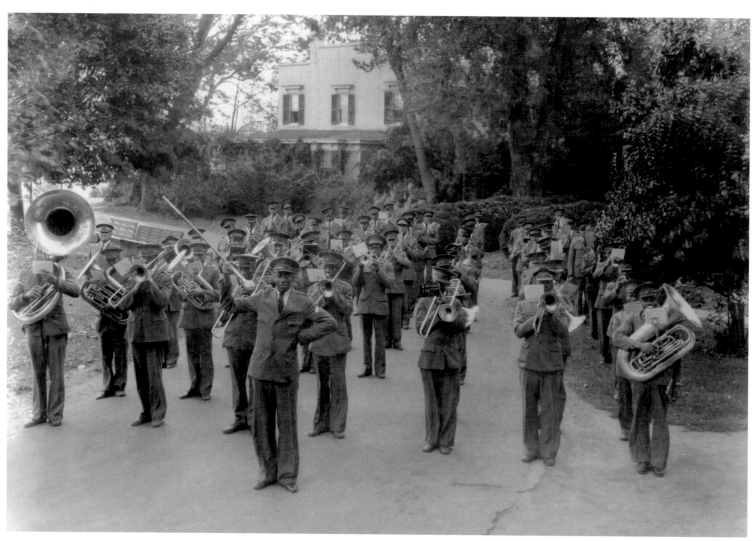

MILITARY CITIES

(1930–1949)

One of the strengths of the economy of Greater Hampton Roads has been that it is diversified. Although the largest employers may be in the military and the transportation sectors, the seafood industry, tourism, recreation, and small-business enterprises have also played leading roles.

During the Great Depression of the 1930s, it was this diversified economy that kept the cities and citizens of the area afloat. The lumberyards of Suffolk, the oyster boats of Hampton, and the beach clubs and beer halls and lunchrooms and movie theaters in all of the region's cities continued to furnish many residents with jobs and income.

As war approached, however, great changes were about to take place. The increased demand for ships from the Newport News Shipbuilding and Dry Dock Company strained the local housing market, which did not have enough housing for all the workers the company needed. A similar problem had been addressed during World War I with the construction of Hilton Village for white workers. In the 1930s, however, African American workers were especially challenged, for although they came in large numbers from the countryside to work at the shipyard, housing opportunities were limited given the racial segregation practices of the day. The solution was found on farmland west of the city, where Newport News Homesteads, later known as Aberdeen Gardens, was erected. Designed and constructed by blacks for black occupants, the project featured houses, not apartments, and eventually most residents owned their own homes. Aberdeen Gardens continues to be a vibrant community in Newport News.

World War II changed Greater Hampton Roads, of course, as it changed all of America. Women came into the workplace in greater—if temporary—numbers; the Great Depression ended; soldiers, sailors, and airmen went overseas and came back with a broadened knowledge of the world and a determination to build a better life in peacetime than they had known before the war. The result was a period of growth and prosperity without parallel in American history.

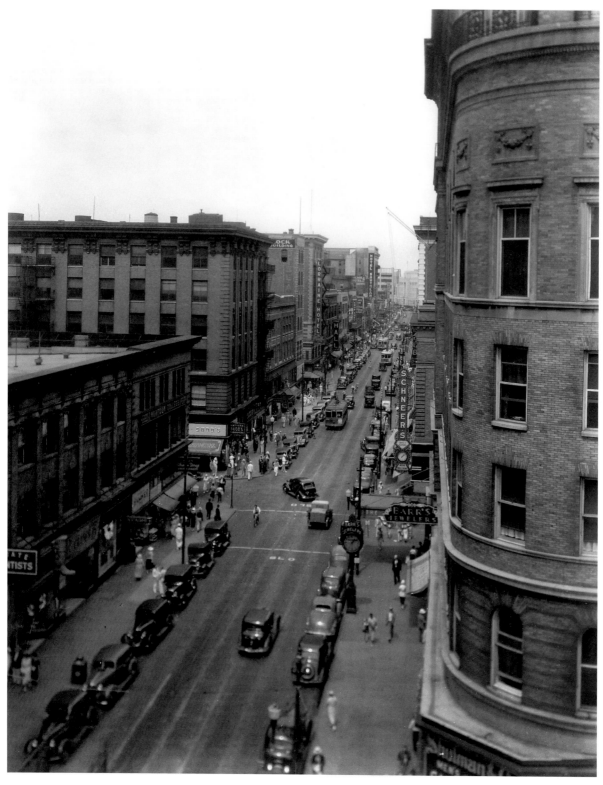

Taken about 1930, this bird's-eye view of Granby Street, the principal shopping street in Norfolk at the time, shows the signs of two popular stores. Shulman and Company was located in the building in the foreground on the right, at 200–204 Granby. It sold men's and boys' clothing. Up Granby Street, on the right at 218, is the sign for Schneer's, a dealer in jewelry, watches, and diamonds. The store extended credit; its slogan was "Wear While Paying."

William E. Lancer operated a saloon and hotel, the Richelieu, at 2 East Mellen Street until Prohibition, and then converted the bar to the confectionery shop shown here about 1930. The store, constructed in 1882, has been much altered but still stands in the Phoebus Historic District.

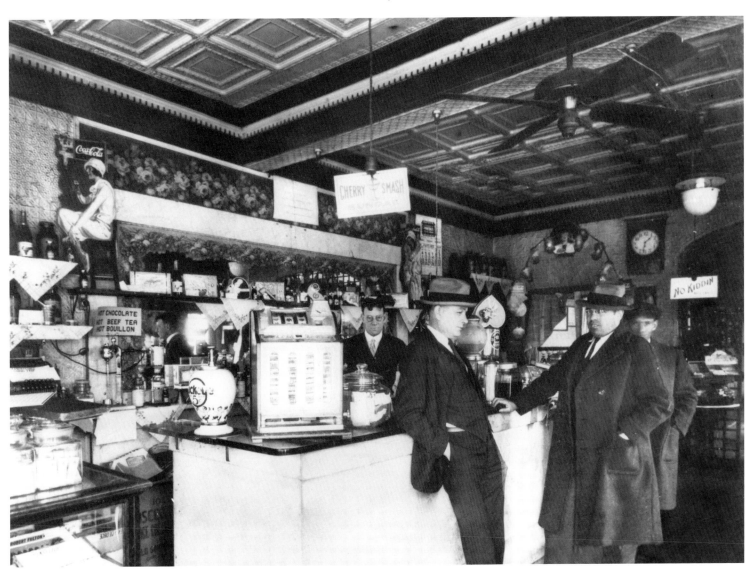

The Colonial Service Station on the right in this photograph, taken about 1930, was located at 800 High Street in Portsmouth. Electric streetcars replaced horse-drawn cars in 1901.

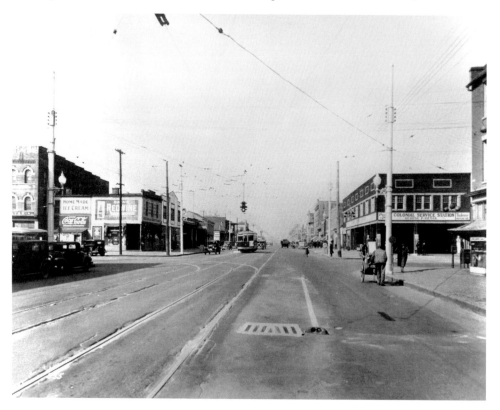

Although Suffolk is better known for its peanut-processing plants, it was long a center for the lumber industry. Large stands of hardwoods and the cypress found in the nearby Great Dismal Swamp made it a leading producer of logs, staves, shingles, laths, bobbins, and other timber products. Large quantities of lumber were shipped down the Nansemond River to the James River and Hampton Roads beginning in the seventeenth century. This photograph of the Doughty Wood Yard was taken in the 1930s.

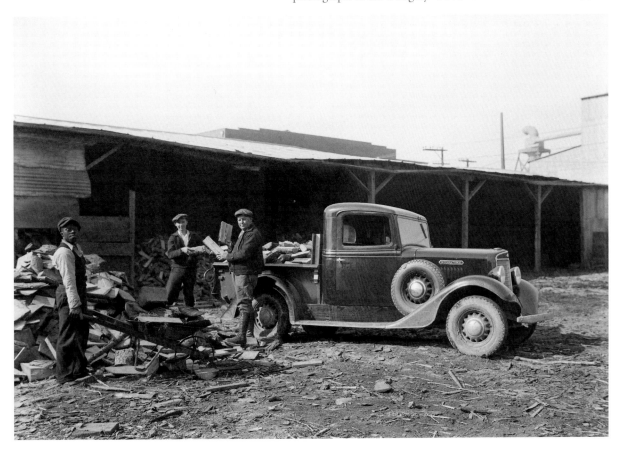

The Chamberlin Hotel at Fort Monroe on Old Point Comfort burned to the ground on March 7, 1920. In 1928, the Chamberlin-Vanderbilt Hotel, shown here as it appeared in 1930, replaced it. The cupolas were soon removed for security reasons and never replaced. Today, the hotel is undergoing restoration as part of a military retirement community with independent-living and assisted-living apartments.

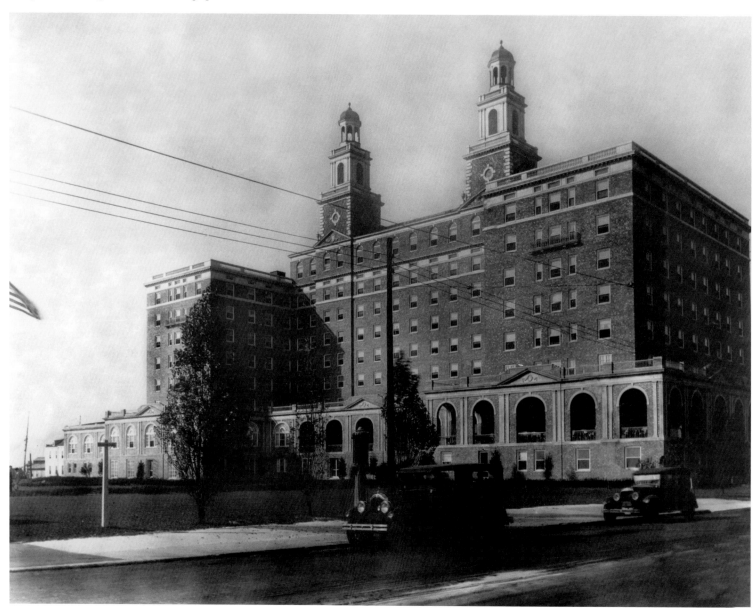

Reportedly home of the oldest golf museum in the world, the James River Country Club in Newport News built its museum in 1931–1932 at the behest of Archer Milton Huntington, principal owner of the Newport News Shipbuilding and Dry Dock Company. Huntington gave the city the Mariners' and other museums and offered the country club a golf museum as well. He sent his plant engineer, John Campbell, to Europe to acquire as many golf artifacts as possible, at a time when few people had begun to collect golf memorabilia. On September 6, 1932, Campbell returned from Scotland with "80 of the oldest golf clubs in existence. The youngest was made in 1895." He had also found two "feathery" golf balls, made from horse leather soaked in oil and filled with gull feathers. By 1936, Campbell had acquired for the museum a book with the first reference to golf in print, *The Book of the Black Acts,* published in Edinburgh, Scotland, in 1556. Today, the museum also boasts the "oldest identifiable golf putter in the world," dating from 1790, as well as a golf ball from that date, and the putter Horace Rawlins used in 1895 to win the first U.S. Open golf championship, among many other golf relics.

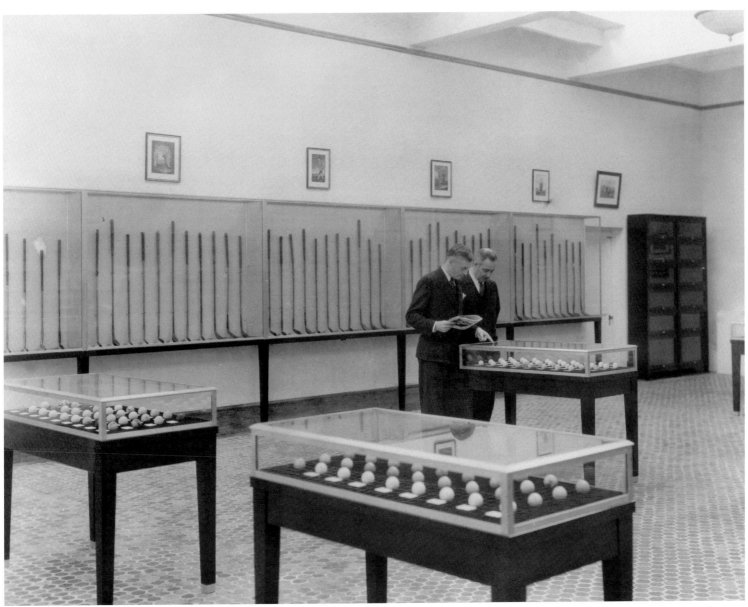

The James River Country Club was organized in 1931 and the golf course was laid out soon thereafter on the farm of C. J. Dietrich, a Newport News restaurateur. Lloyd U. "Casey" Noland, founder of the Noland Company (which began as a plumbing supply firm) was elected the first president. Although he did not play golf, he officiated at the opening of the course in 1932, gamely hitting the first drive from the first tee.

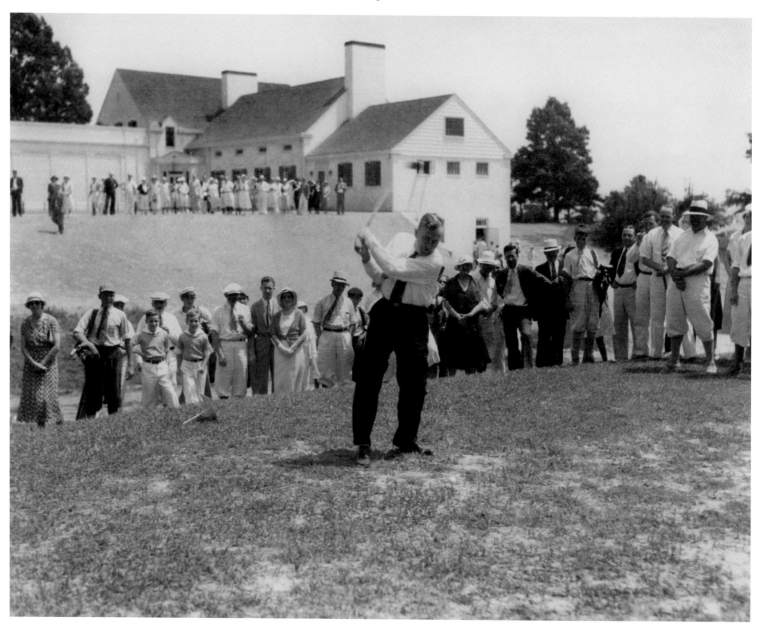

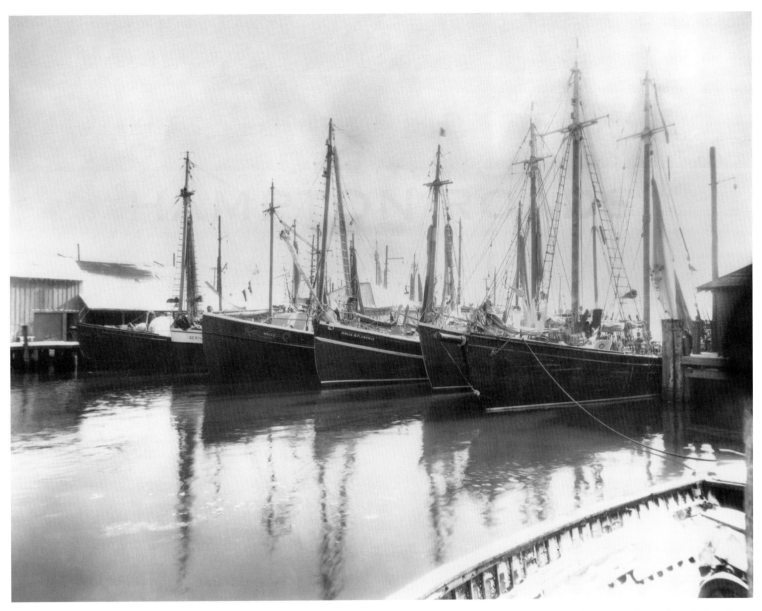

Leonard M. Newcomb, a fish dealer and oyster packer, operated a string of fishing and oystering boats from Water Street in Phoebus. Several of the vessels are depicted here in 1931.

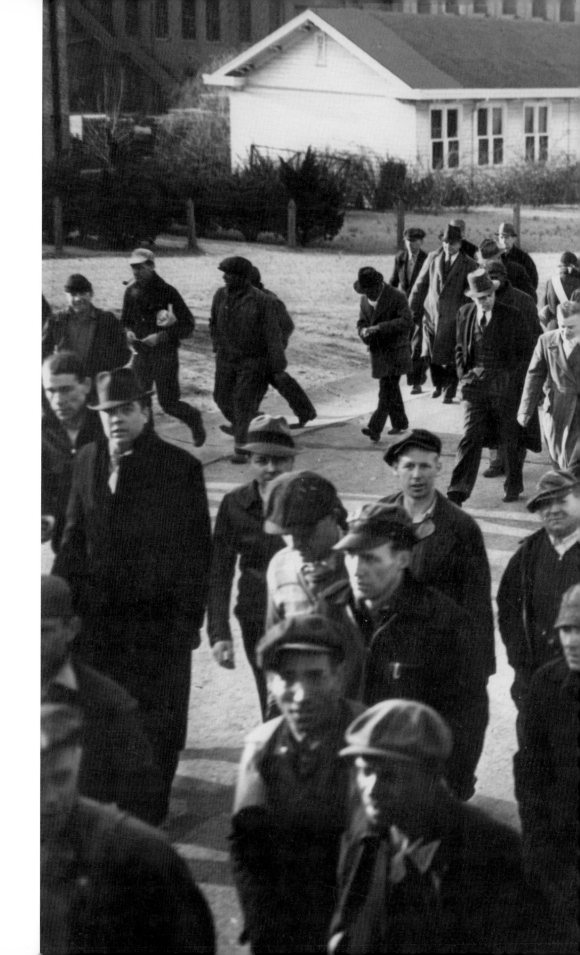

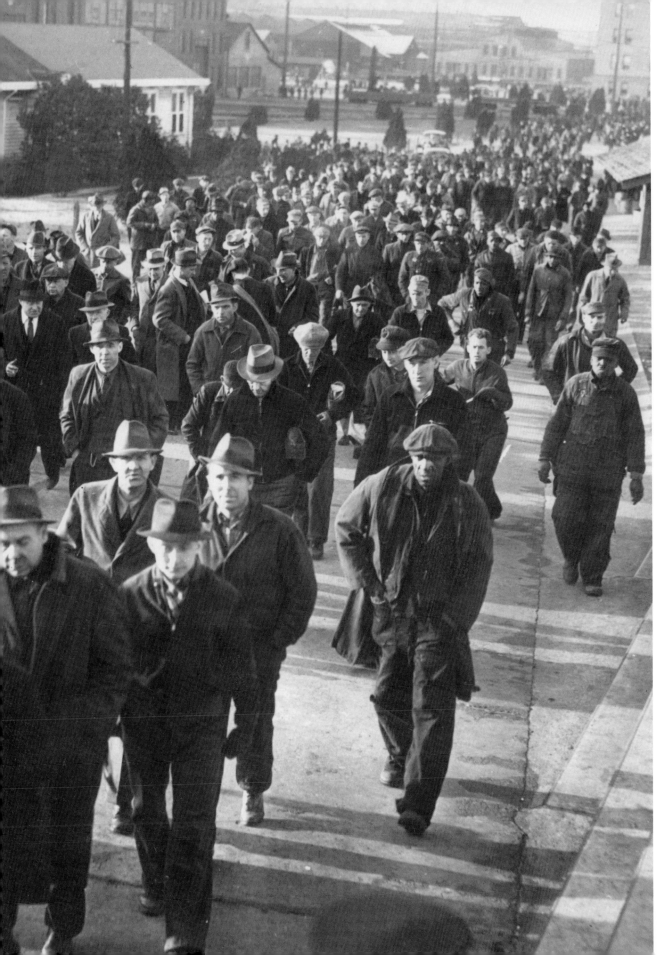

Employees of the Newport News Shipbuilding and Dry Dock Company are depicted leaving for home at the end of a long day.

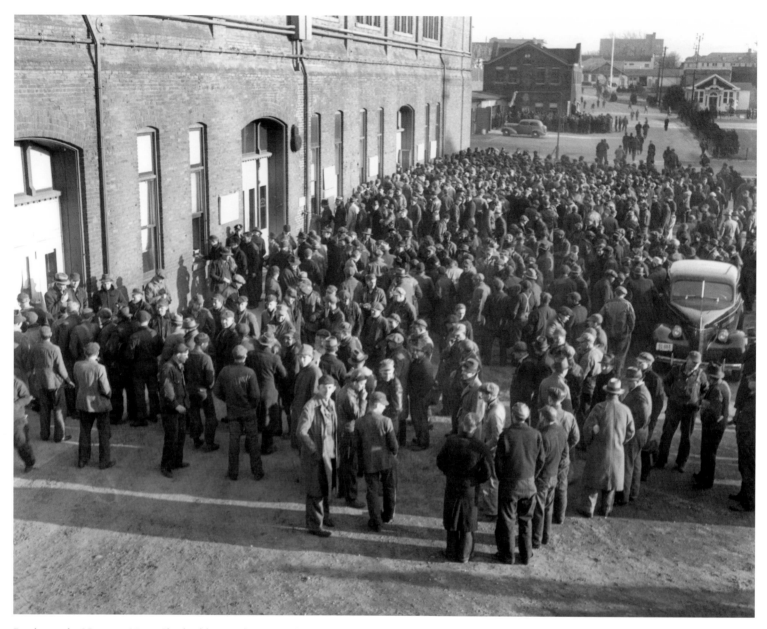

Payday at the Newport News Shipbuilding and Dry Dock Company was always a big event in the 1930s, when so many were unemployed in the dark days of the Great Depression. More than two hundred and fifty men are shown in this image awaiting their paychecks.

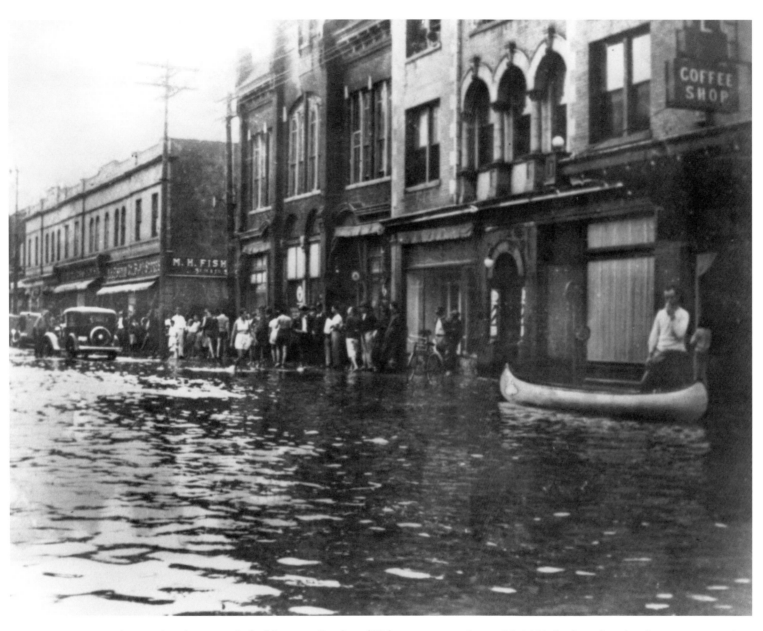

A severe hurricane struck the Hampton Roads and Tidewater area on August 23, 1933. In those days, hurricanes were not given names, but this storm needed no name for local residents to remember it for the rest of their lives. The hurricane came ashore at Virginia Beach, and the eye passed over Hampton, shown here, uprooting hundreds of trees and flooding streets. The water stood three feet deep on the parade ground inside Fort Monroe. Canoes are seldom seen floating in the streets nowadays.

Three people lost their lives in the hurricane that struck Hampton Roads and Tidewater on August 23, 1933. It caused massive damage throughout the region, as shown in this photograph taken in Hampton, and destroyed a bridge.

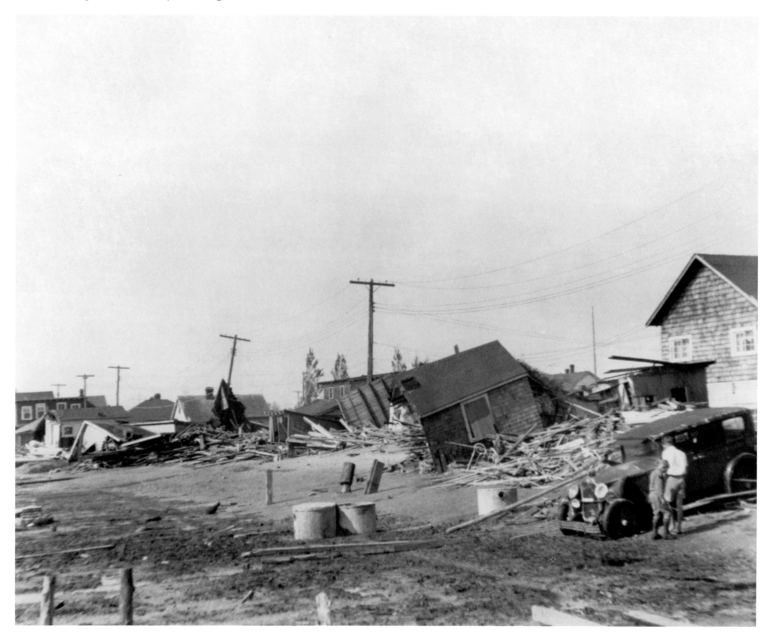

The Paradise Inn stood at Buckroe Beach, the resort community on the Chesapeake Bay at Hampton, until the hurricane of August 23, 1933, destroyed it.

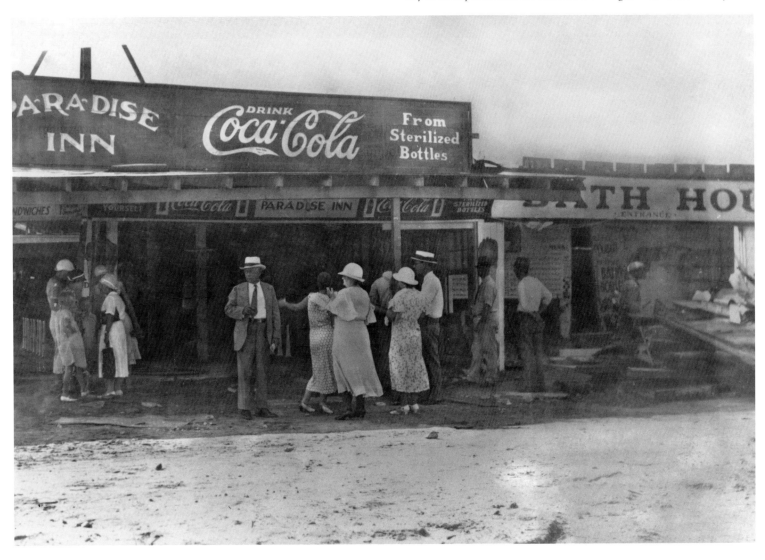

In 1930, Archer M. Huntington, principal owner of the Newport News Shipbuilding and Dry Dock Company, founded the Mariners' Museum, which opened in October 1933. Huntington and his wife, the sculptor Anna Hyatt Huntington, acquired 800 acres of land in Newport News and began a museum that today contains 61,000 square feet of exhibition galleries and more than 35,000 maritime artifacts from around the globe. Approximately one-third of the collection consists of paintings and two-thirds of three-dimensional objects, including the 3,000-pound gilt eagle figurehead from the U.S. Navy frigate *Lancaster*. The figurehead is seen here in a 1940s Virginia Chamber of Commerce photograph after it had been rescued from a chandler's shop in Boston; it was on display by April 1939.

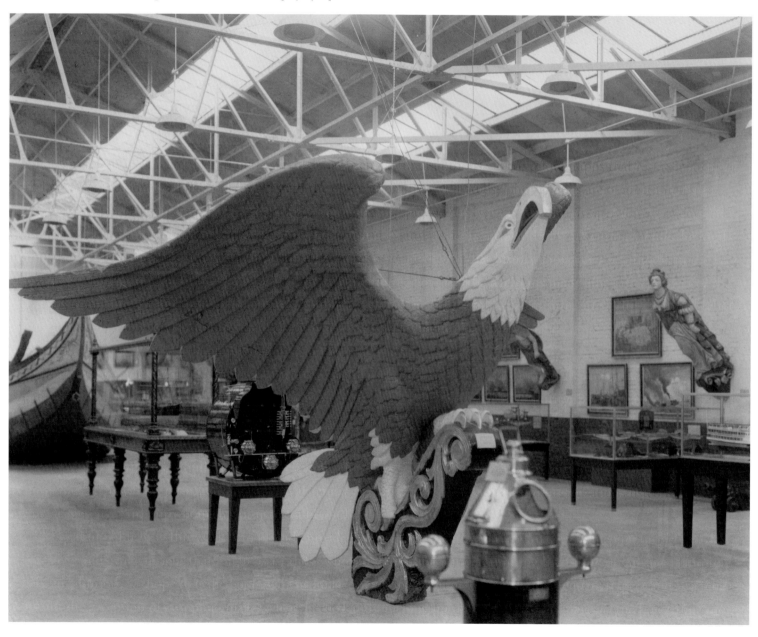

Conquering the Wild, a memorial to Collis P. Huntington sculptured by his daughter-in-law Anna Hyatt Huntington, stands in the Mariners' Museum park. Anna Huntington was the wife of Archer M. Huntington, who established the museum.

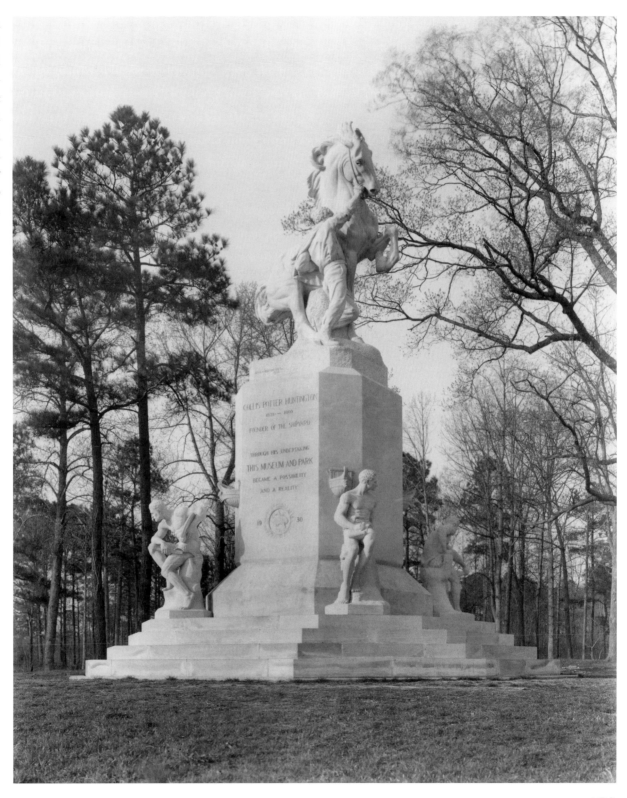

Snow and ice storms are rare in the Hampton and Tidewater region. This freeze occurred in Hampton in 1934.

Collis P. Huntington put Newport News on the map for the modern era in the 1880s with his rail terminal and coal yards for bituminous coal from the great Pocahontas Coal Field in West Virginia. He also established a shipyard near the terminal. In 1891, the Newport News Shipbuilding and Dry Dock Company delivered its first vessel, the tugboat *Dorothy*. Soon, the shipyard became a massive undertaking, and organized its own fire station to counter the dangers posed by fuel, other flammable materials, and welding equipment.

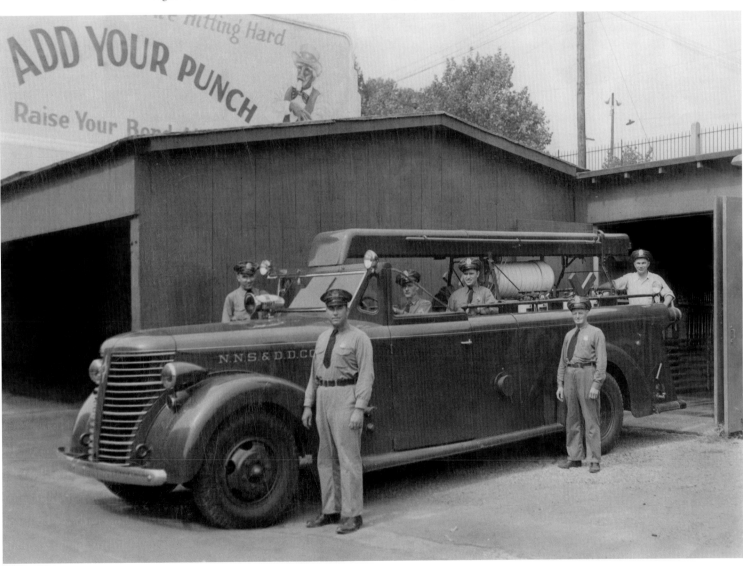

This view of Queen Street in Hampton shows the Langley Theater on the left. The motion picture playing there was *Sins of Man* (1936), starring Jean Hersholt and Don Ameche. The Langley, which was demolished in March 1968, opened in 1920 as the Scott Theater.

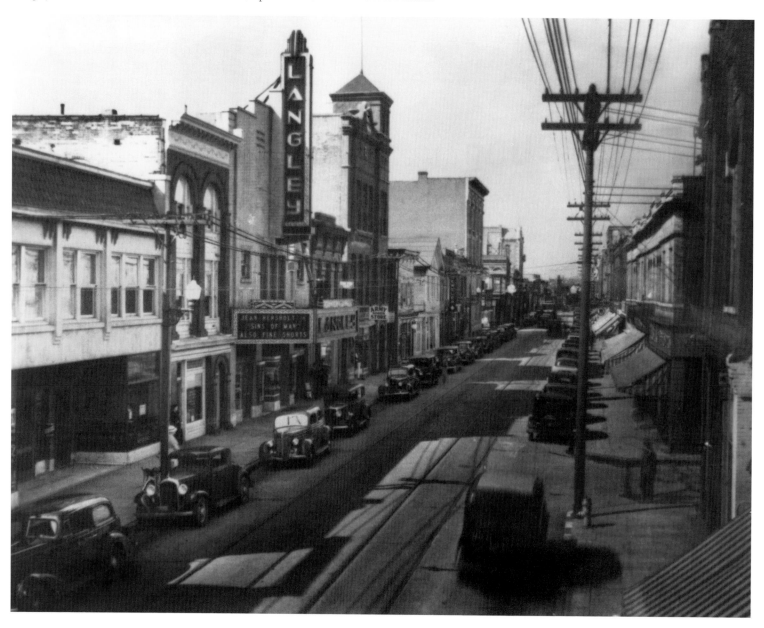

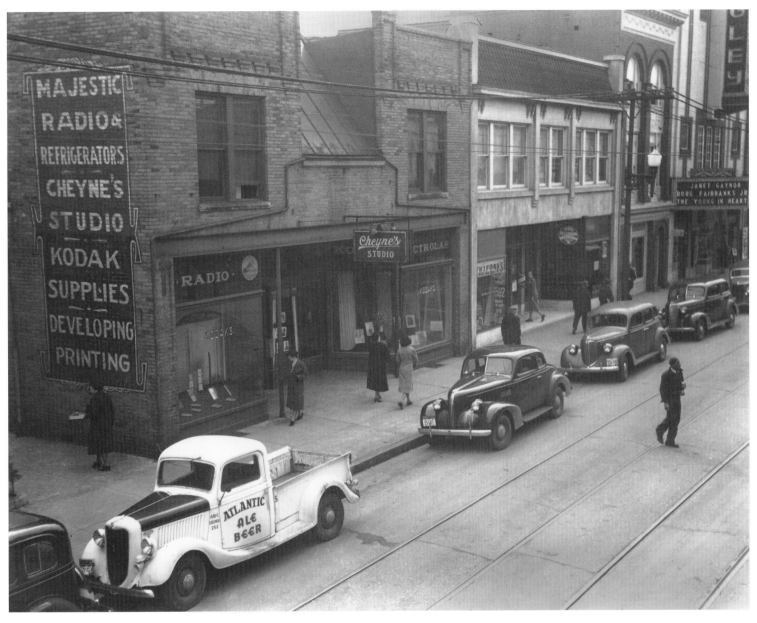

Christopher E. Cheyne (1867–1943), a native of Brampton, Canada, immigrated to Cincinnati, Ohio, and studied photography there. He moved to Hampton in 1894 and opened a photographic studio, and after several relocations, in about 1900 he settled his business in the building shown in this 1934 picture. Cheyne opened a second studio in Newport News in 1940.

Gasoline stations were constructed in a wide variety of architectural styles in the 1920s and 1930s. This Sinclair station in Hampton sported the Spanish Colonial Revival style.

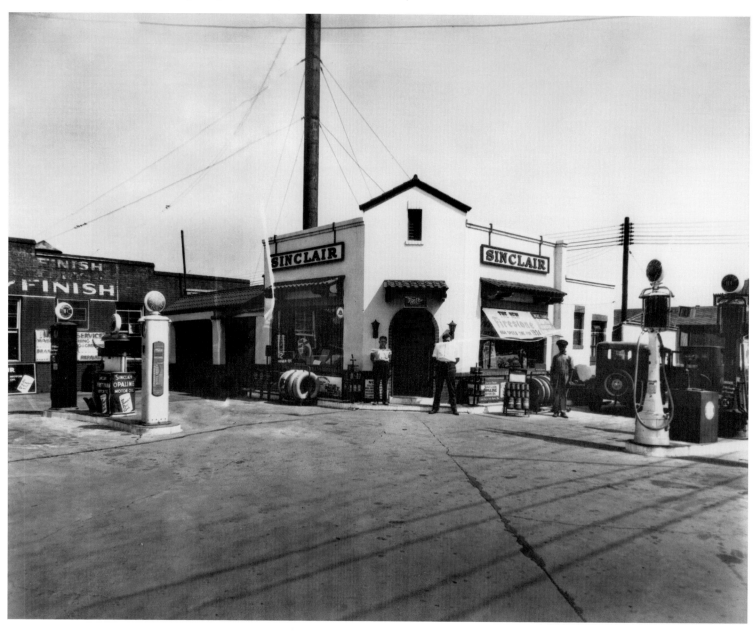

Hampton's First Methodist Church congregation was established in 1870 and purchased the lot on which the first, frame church was constructed two years later. In 1887, this church (shown here in 1936) was built on the site, at 110 East Queen Street. Although the building has been somewhat altered and expanded over the years, it still represents the Gothic Revival style of the original brick structure.

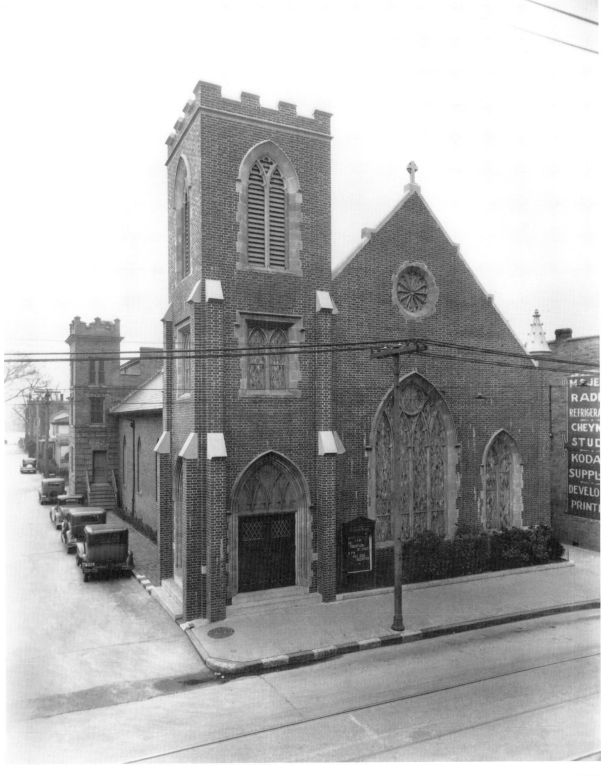

The Cavalier Beach Club, operated by the Cavalier Hotel, was located on the oceanfront and was one of several Virginia Beach venues to offer outdoor dancing during the Big Band era. According to the Cavalier, it hired more top-ranked bands than any other hotel in the world. The club opened on Memorial Day 1929 and operated for thirty years. This photograph was taken in 1936.

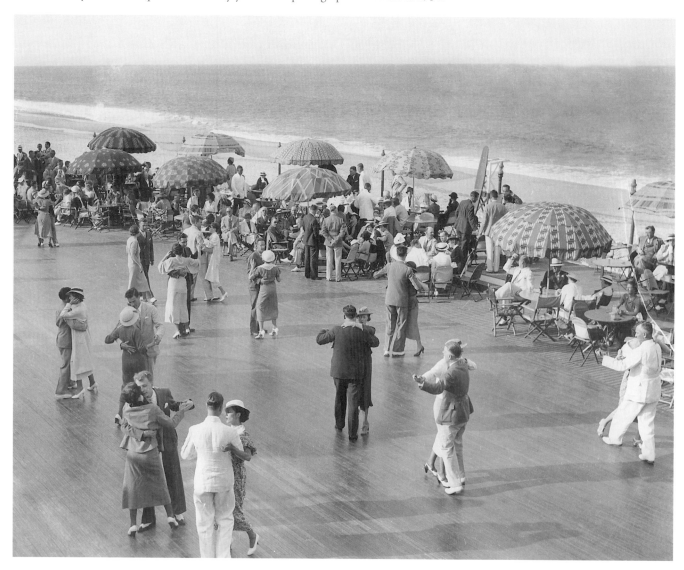

The American Theatre at 125 East Mellen Street was constructed in the Beaux Arts style in 1908. Stripped of much of its elaborate detailing, the theater still stands and is an important contributing resource in the Phoebus Historic District, which is listed in the National Register of Historic Places.

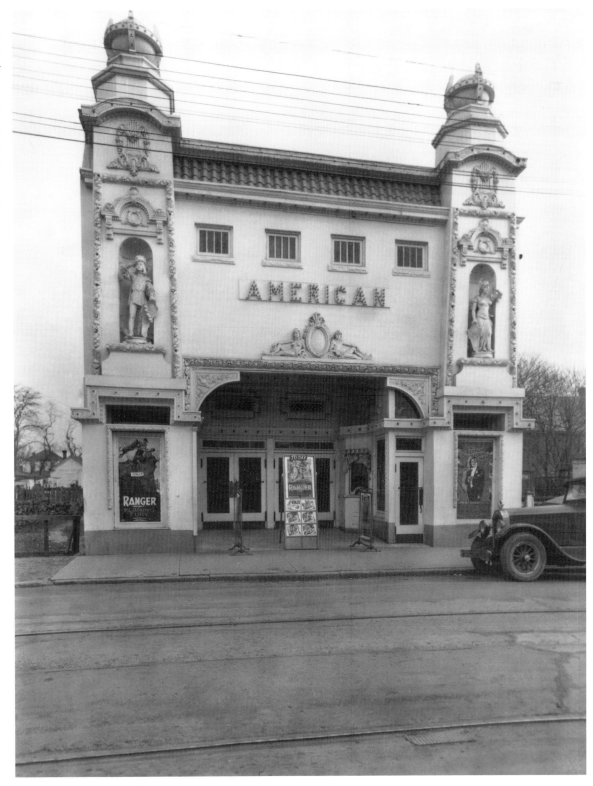

After World War I, the Newport News Shipbuilding and Dry Dock Company, under chairman of the board Henry E. Huntington, formed the Newport News Land Company and purchased Hilton Village from the federal government. In 1922, the company sold some of the houses to residents, and Hilton Village gradually became a community of private homeowners. The late novelist William Styron spent part of his childhood there. In 1969, it was listed in the National Register of Historic Places. The firehouse, located on Main Street at Warwick Avenue, was photographed in 1937. It no longer stands.

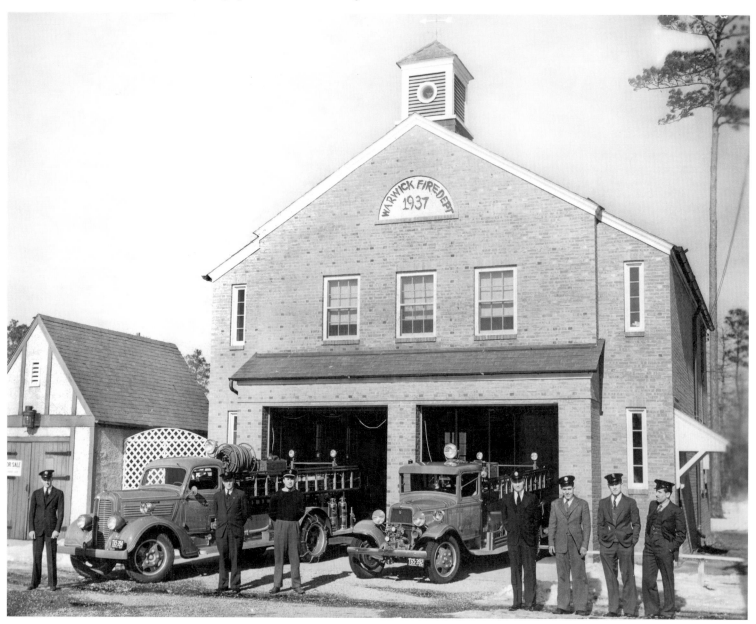

Merchants National Bank, located in this imposing if small building, occupied 1 East Queen Street in Hampton when it was photographed in 1937. It has since been demolished.

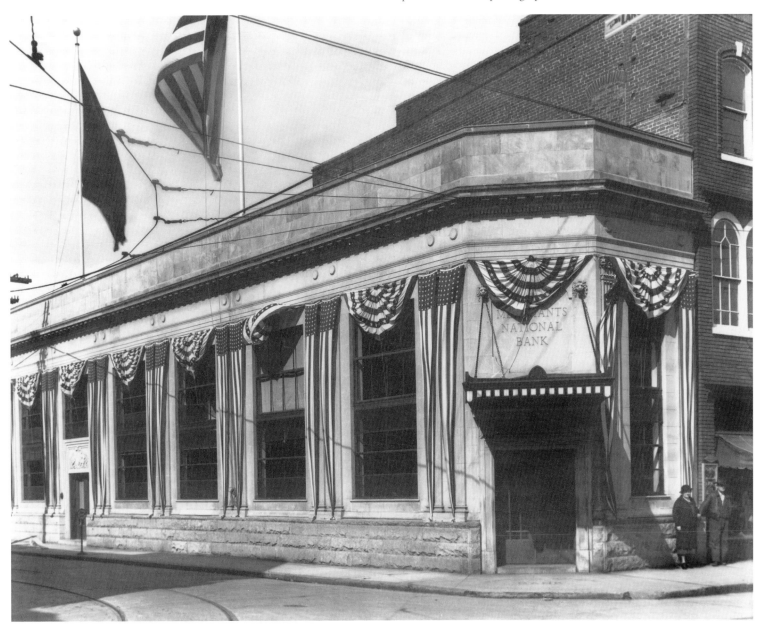

During the Great Depression, the Farm Security Administration hired photographers to fan out across the country, especially the South, and record the effects of the economic collapse on average Americans. Many emotionally wrenching images of bread lines and migrant workers were made during this period, and a few, such as Dorothea Lange's "Migrant Mother," have become iconic. John Vachon took many thousands of pictures around the nation, recording the scene in Newport News shown here in November 1937.

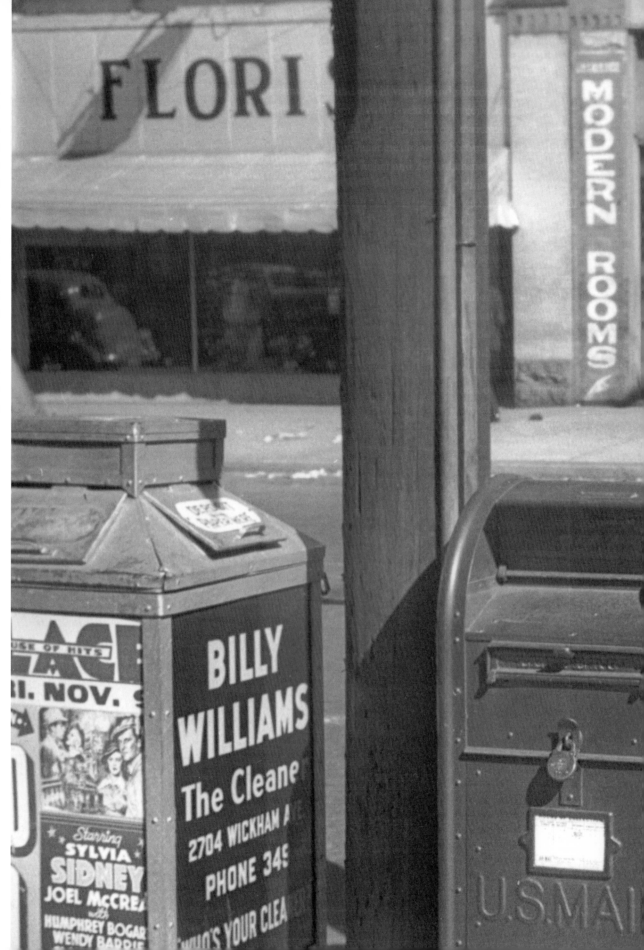

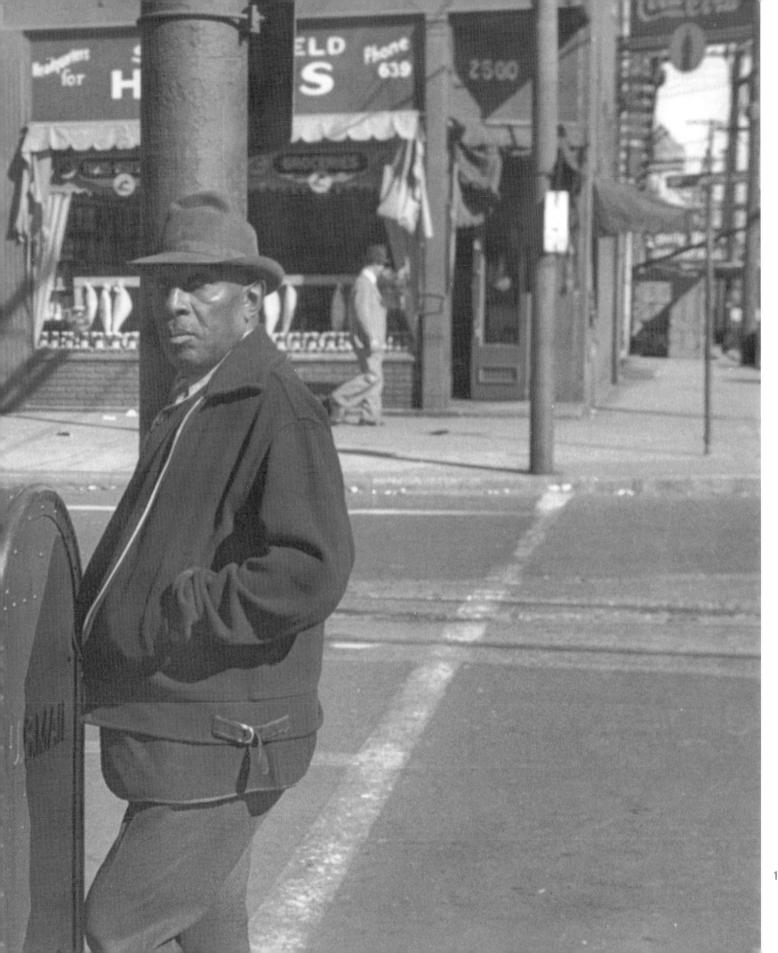

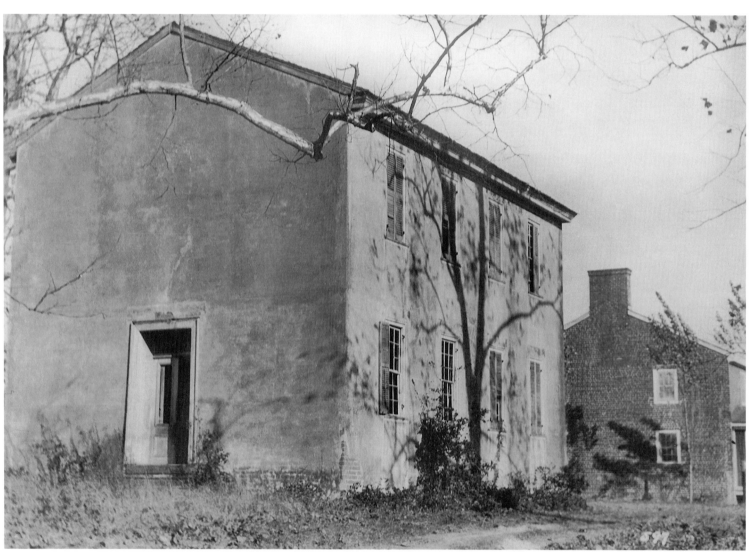

The Princess Anne County courthouse was completed and in use by 1787 at what was then Kempe's Landing, now Kempsville. The building, photographed in 1937, was constructed of handmade brick laid in Flemish bond and covered in stucco. After the county seat was moved to Princess Anne Court House in 1823, this building became the Kempsville Baptist Church and served in that capacity until 1911. Thereafter, it stood vacant, except for occasional Kempsville school group visits when they needed a room with a raised platform. By 1937, the windows had been boarded up. In November 1971, after unsuccessful efforts had been made to restore the structure, it was torn down.

Shown here in 1938, the York Tire Company and service station stood at 142 East Queen Street in Hampton. It no longer exists.

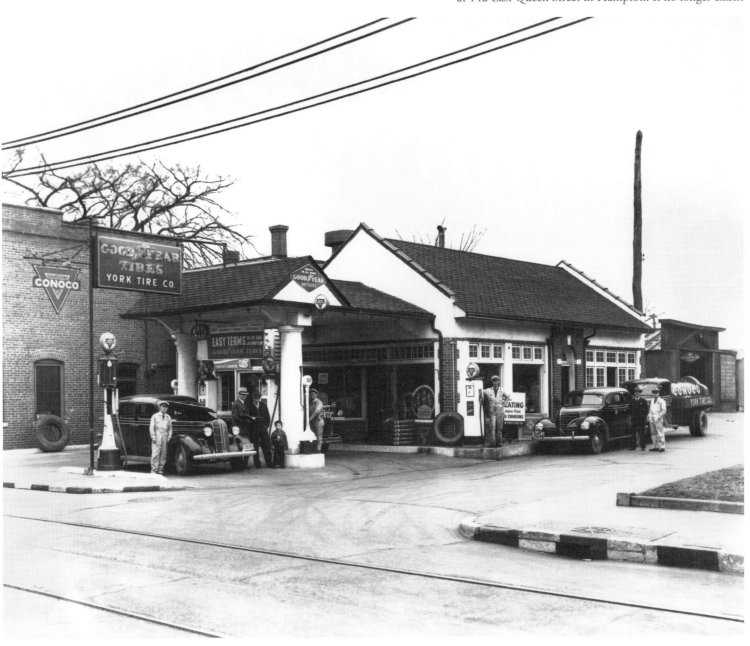

The Greyhound Bus station in the first block of High Street in Portsmouth leading southwest from the ferry terminal is visible at left here about 1940.

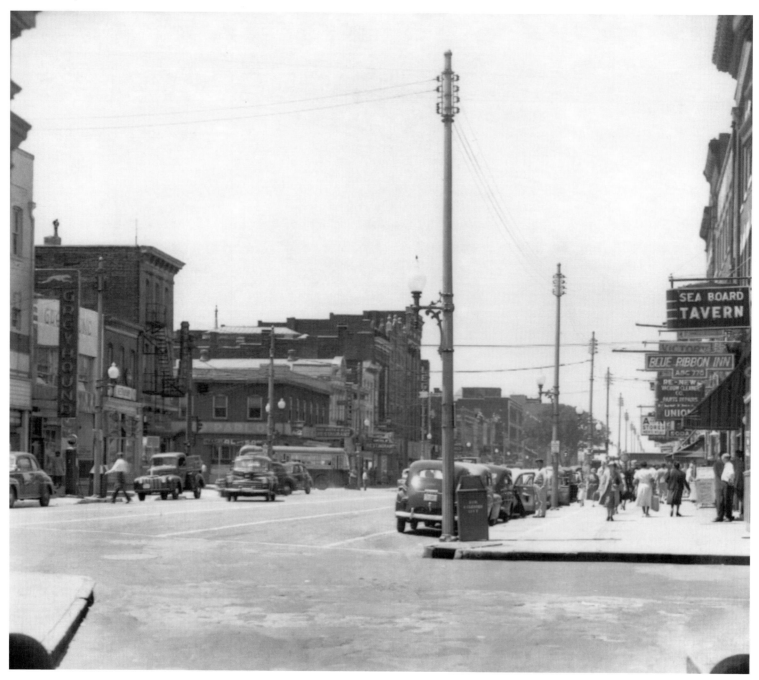

A small boy begins making a snowman in this photograph taken about 1940 during a rare snowstorm in Portsmouth. The Globe Buffet lunchroom, in the background, was located at 317 High Street between Court and Middle streets.

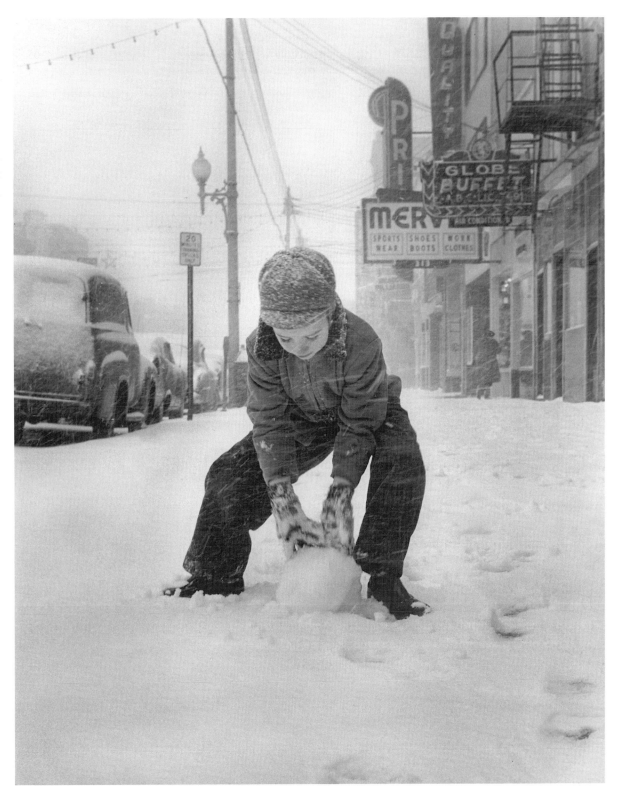

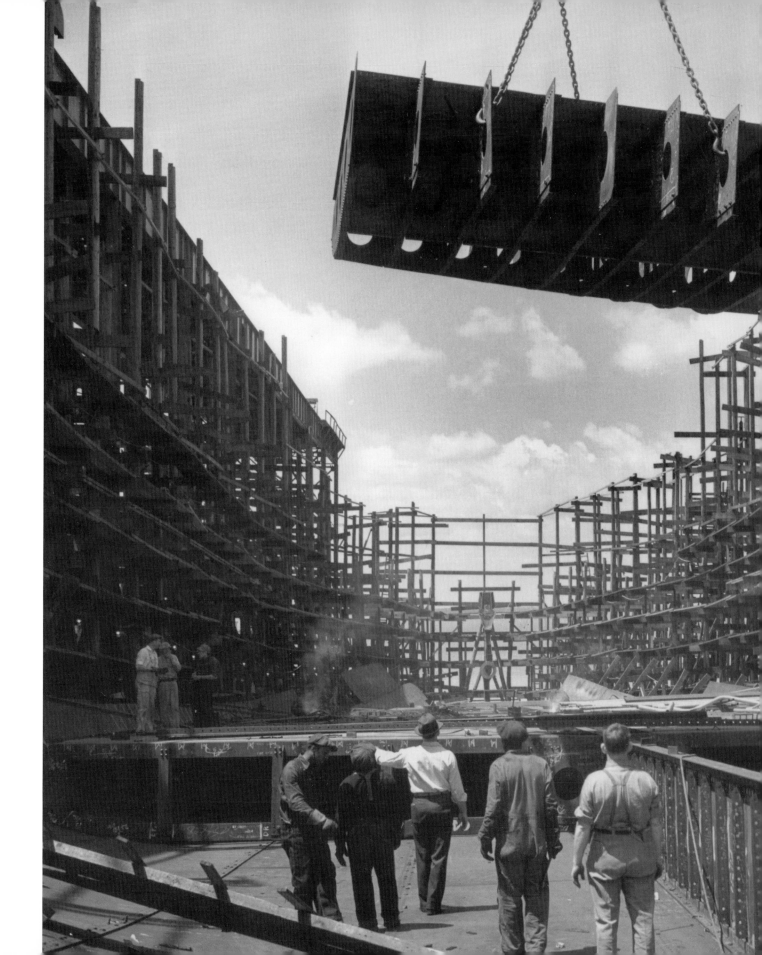

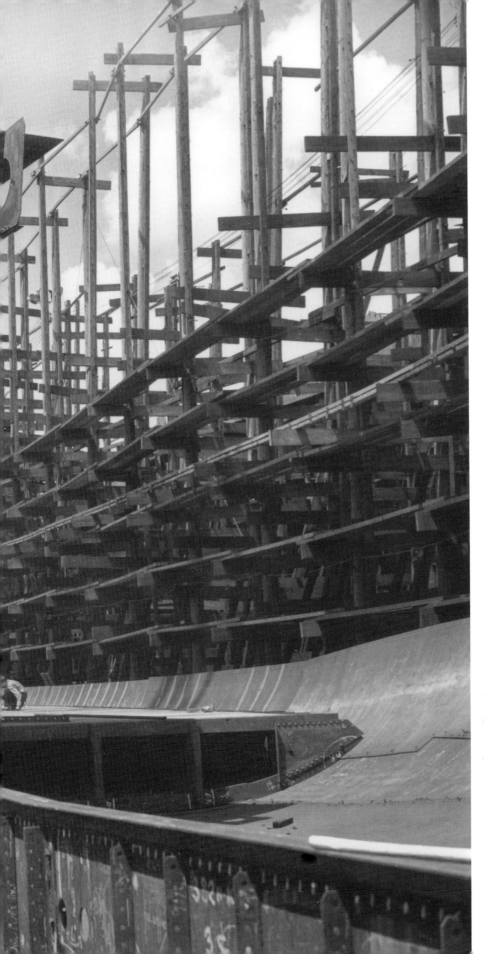

Newport News Shipbuilding and Dry Dock Company workers, standing in what will be the lowest part of a ship's hold near the keel, watch a crane lower a floor section into a naval cargo ship (C3) in October 1941. Several sections have already been installed. The United States Maritime Commission designed the C3 late in the 1930s. It was a general-purpose ship with five holds, and 465 of the ships were built between 1939 and 1947. During World War II, many were used as tenders for destroyers, submarines, and seaplanes.

Members of an artillery battery pose with their guns and support vehicles in this 1941 photograph taken in Hampton.

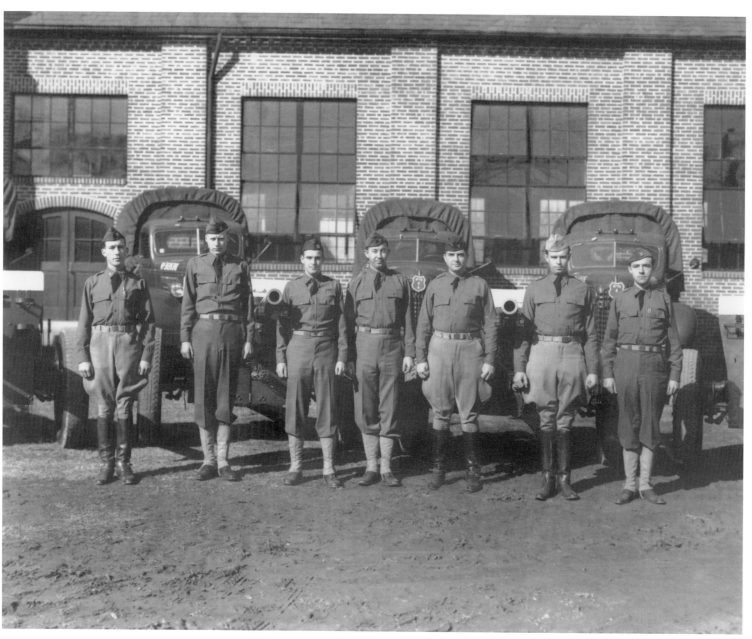

In March 1941, Farm Security Administration photographer John Vachon photographed these girls on skates in Portsmouth.

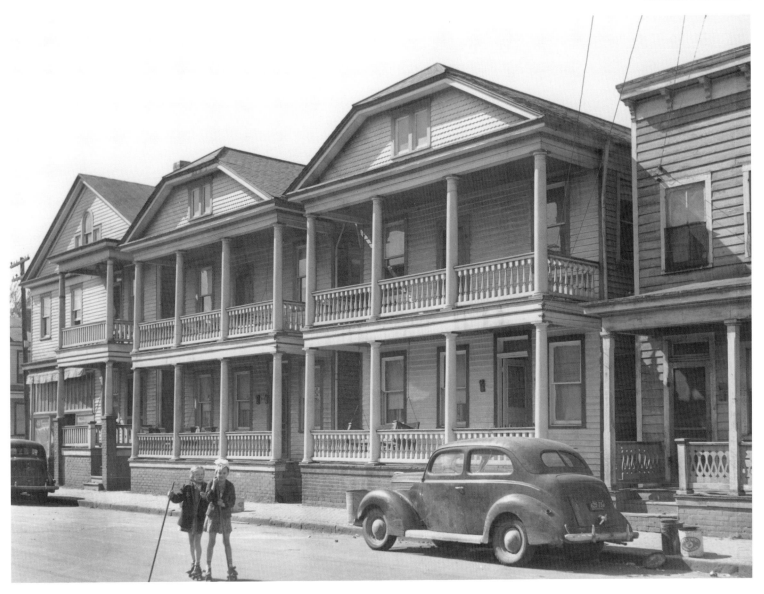

In the summer of 1941, what would become World War II was still distant from America, in faraway Europe and the Orient, and seen only in newsreels and articles. These young women at Virginia Beach play volleyball in the sand during the last carefree summer they would know for years.

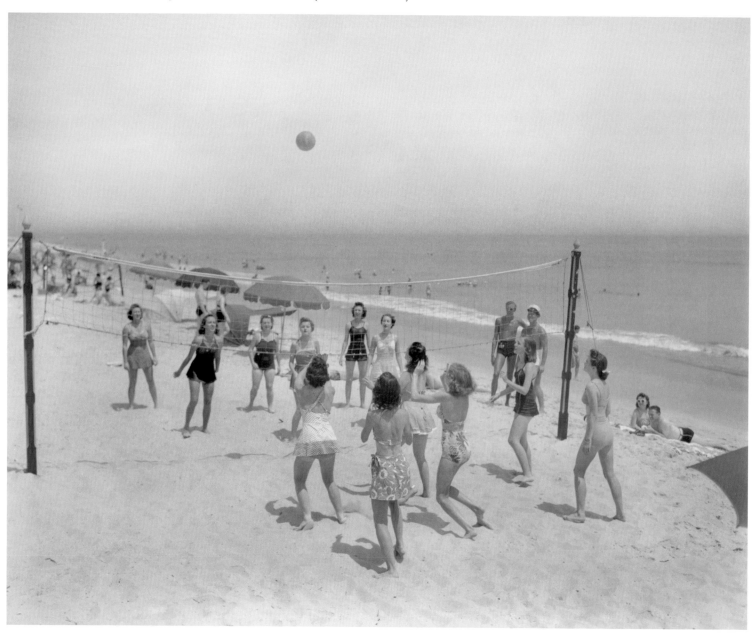

Farm Security Administration photographer Paul Carter took this picture of a shift change at the Newport News Shipbuilding and Dry Dock Company in March 1941. Streetcars wait to take some of the men home. Other workers no doubt stopped in at Jim Laracy's Blue Ribbon Beer Garden, seen on the right at 3610½ Washington Avenue, for a cold brew before heading home.

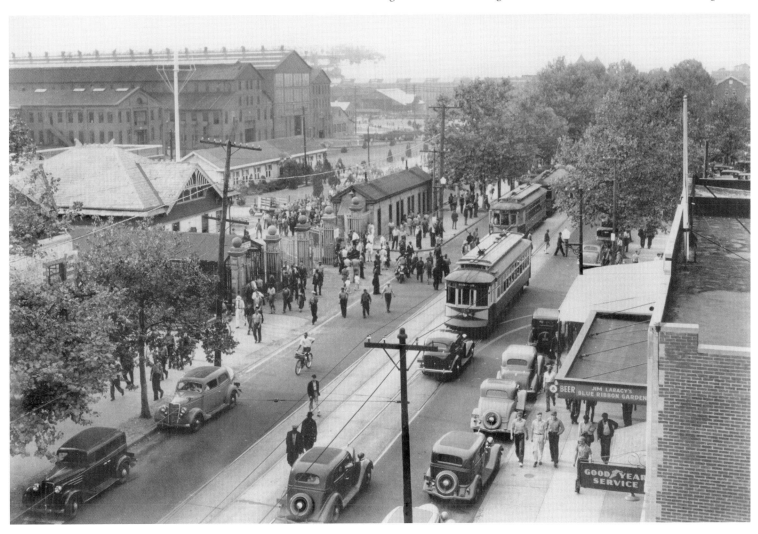

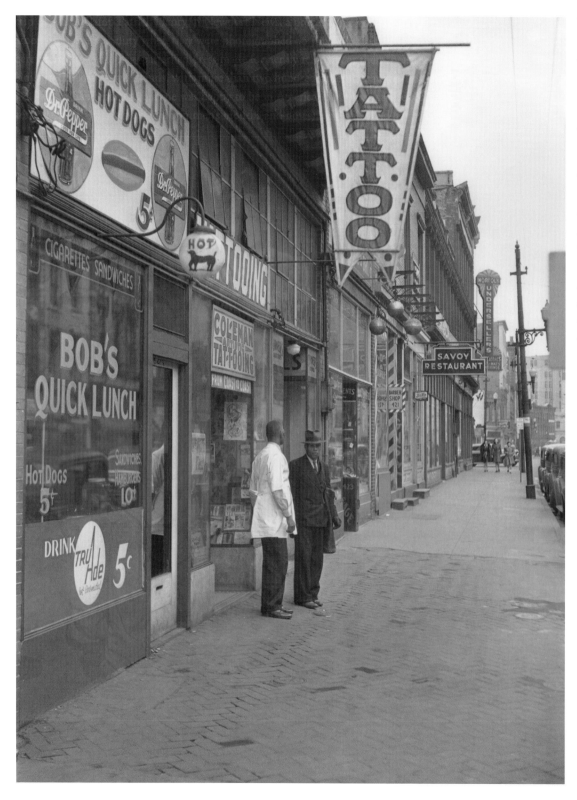

West Main Street in Norfolk featured a variety of commercial enterprises when Farm Security Administration photographer John Vachon took this picture. Bob's Quick Lunch stood at 427½ on the immediate left, with Aug B. Coleman's tattoo parlor beyond it and then the Main Street Barber Shop at 429. Another nearby tattoo artist advertised both tattoos and removals in the city directory.

At many factories, concessionaires operated lunch wagons that came to the factory grounds and sold the workers sandwiches, cigarettes, and soft drinks. Others, such as the Norfolk Navy Yard in Portsmouth, made food, snacks, and smokes available for workers at several canteens on the grounds, as well as at cafeterias that served hot meals.

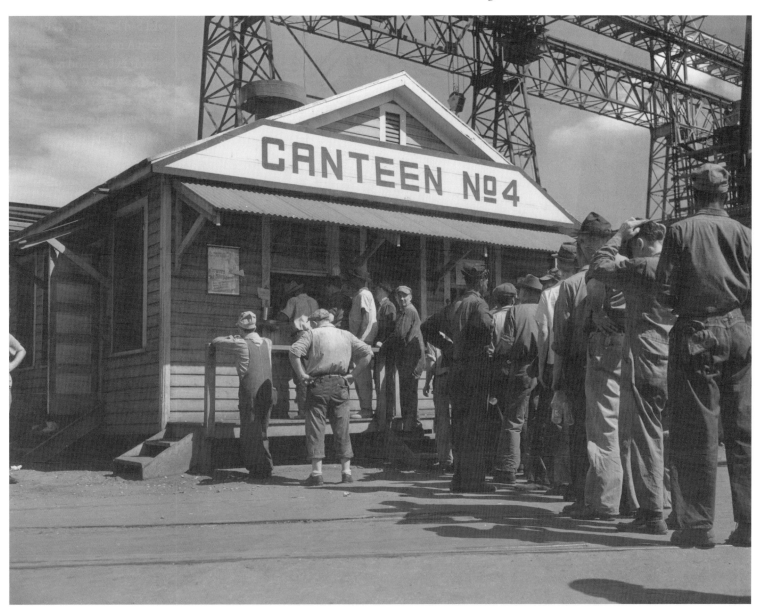

This photograph, taken before August 1942, shows old biplanes lined up on the left and right, with new single-wing fighters in the foreground. According to the original caption for the image, "A vastly expanded air station at the Norfolk Naval Operating Base bears eloquent witness to the growing might of the Navy's air arm."

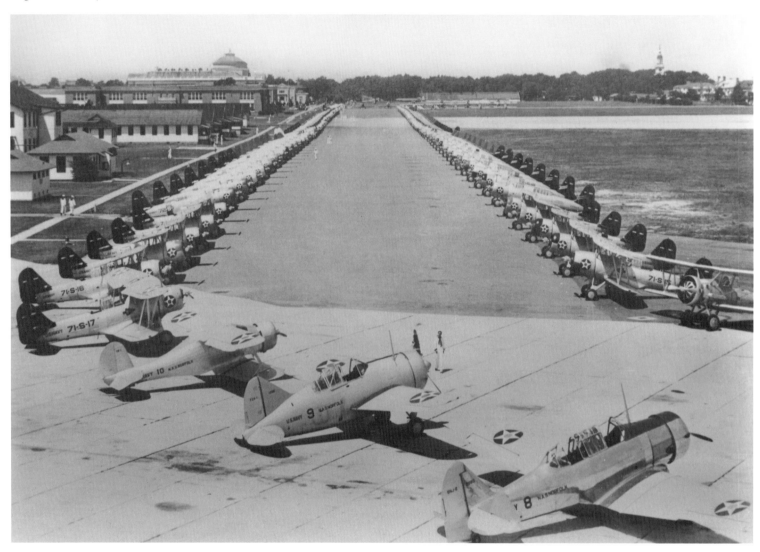

Here in 1942, the Cavalier Hotel was a true oceanfront resort, offering croquet, golf, horseback riding, shooting, and a variety of other activities for its patrons.

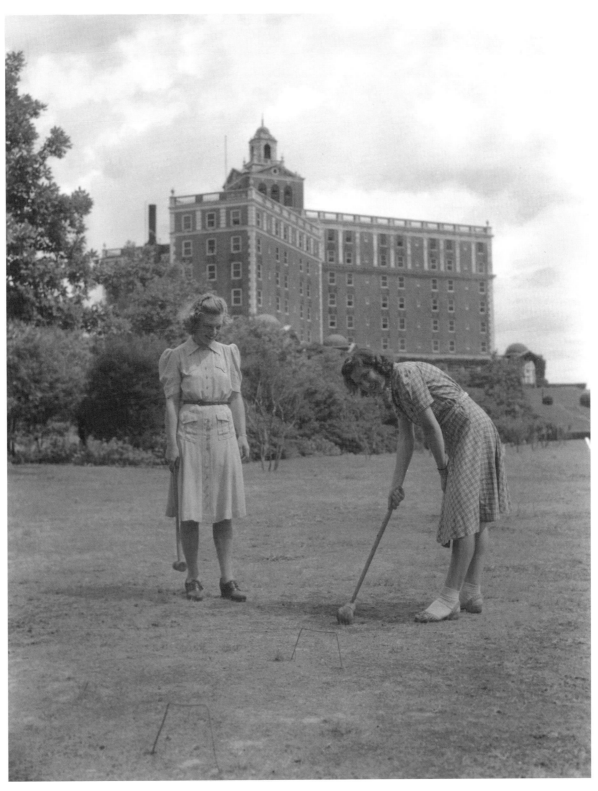

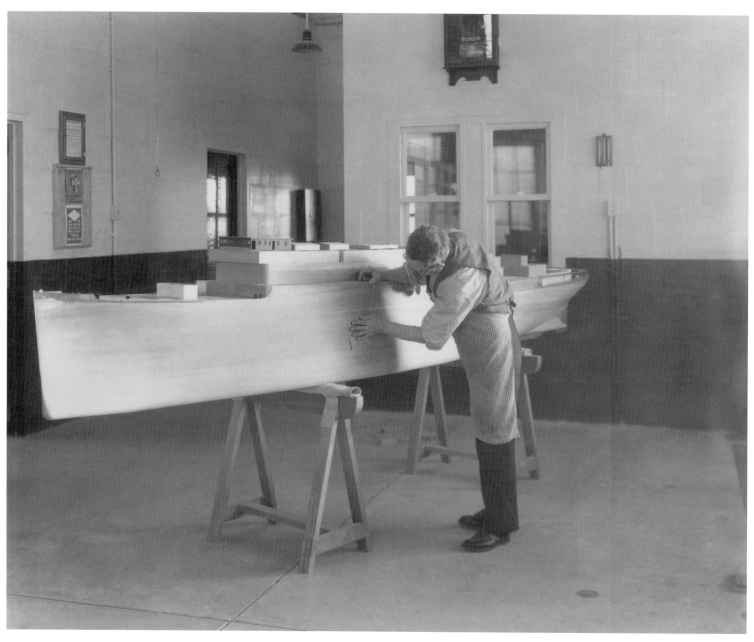

The Mariners' Museum in Newport News was founded in 1930 and is today among the leading nautical museums in the nation. In 1932, the museum decided to make quarter-inch-scale models of ships for display. Sumner B. Beese served as model engineer. In this view, a craftsman painstakingly sands a wooden model.

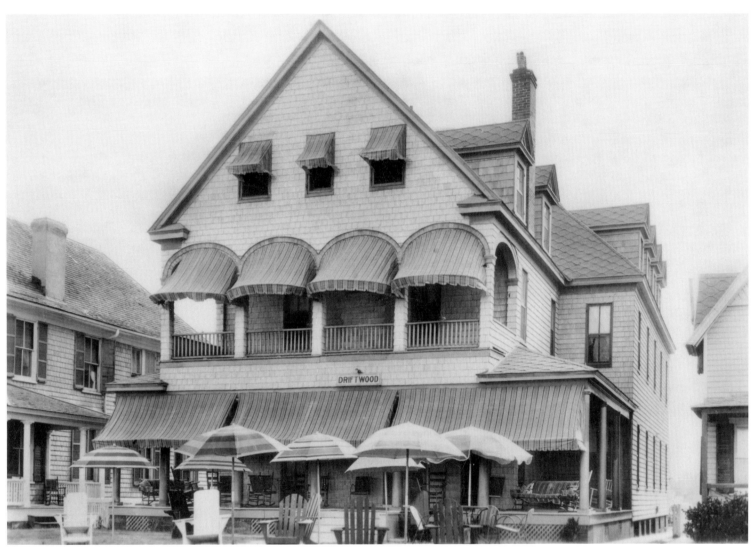

The Driftwood was typical of the small, shingle-sided hotels that used to front the ocean in Virginia Beach. This image appeared on a postcard postmarked October 14, 1943.

The Women's Army Auxiliary Corps was established May 15, 1942, when President Franklin D. Roosevelt signed the legislation passed by Congress. Although the bill authorized the recruiting of 150,000 women in the first year, Roosevelt set the goal at 25,000. When that number was passed six months later, Secretary of War Henry L. Stimson authorized the full recruitment number. Before long, women filled virtually every noncombat military role imaginable. On July 3, 1943, Roosevelt signed a new bill into law converting the WAACs to full military status as the Women's Army Corps. This parade in Newport News was held May 13, 1944, to celebrate the second anniversary of the founding of the WAACs.

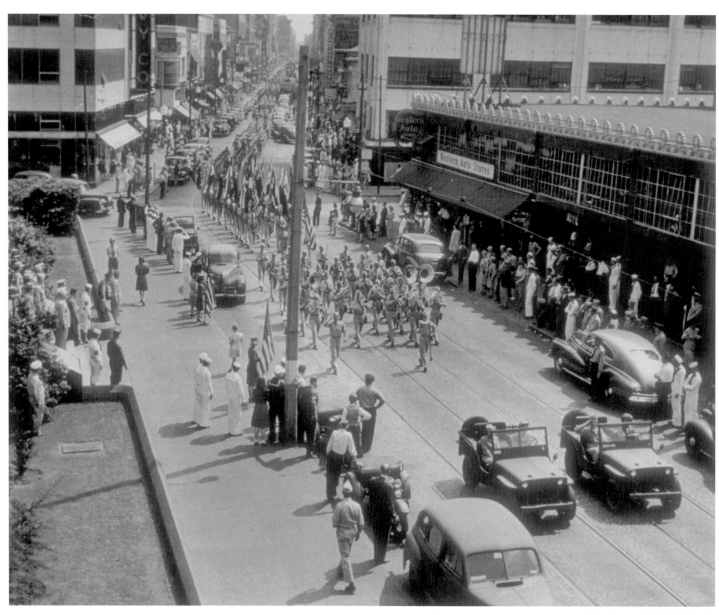

At first a part of the U.S. Army Quartermaster Corps, the Transportation Corps was designated as a separate entity on March 13, 1942, by President Roosevelt. The parade depicted here to mark the second anniversary of the Transportation Corps took place August 1, 1944. Women workers pose on the float sponsored by the Vehicle Processing Shop, Hampton Roads Port of Embarkation.

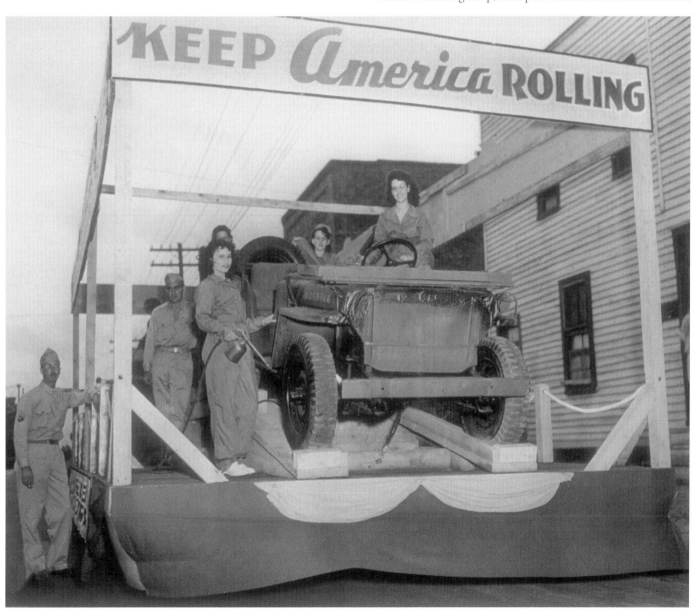

The Nehi Bottling Company building, which no longer stands, was located at 2611 Huntington Avenue in Newport News in 1944. The first plant began operations in 1931 at 338 28th Street. In 1940, brothers I. L. and J. C. Fuller bought the Nehi franchise in Newport News and moved into this building three years later. By 1946, the plant was processing 1,500 cases of Royal Crown Cola and Nehi grape and orange soda each day.

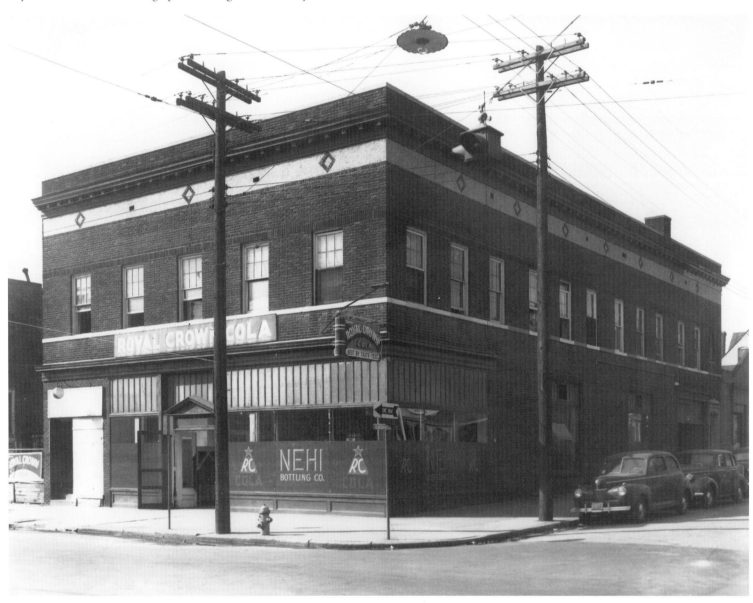

Mrs. Bradford W. Ripley II, of Dayton, Ohio, has just swung the champagne bottle against the hull of USS *Midway,* at christening ceremonies at Newport News Shipbuilding and Dry Dock Company, on March 20, 1945. Mrs. Ripley, the ship's sponsor, was the daughter of James M. Cox, former governor of Ohio, and her husband was a Navy lieutenant who died in a plane crash in the Pacific. Just behind her, looking on, is Navy lieutenant George H. Gay, Jr. He was the only survivor of the unsupported attack his torpedo squadron made from USS *Hornet* against a Japanese carrier force on June 4, 1942, during the Battle of Midway. Commissioned on September 10, 1945, USS *Midway* served the U.S. Navy until decommissioned in 1992 after taking part in the First Gulf War. The ship, now a naval aviation museum, is located in San Diego, California.

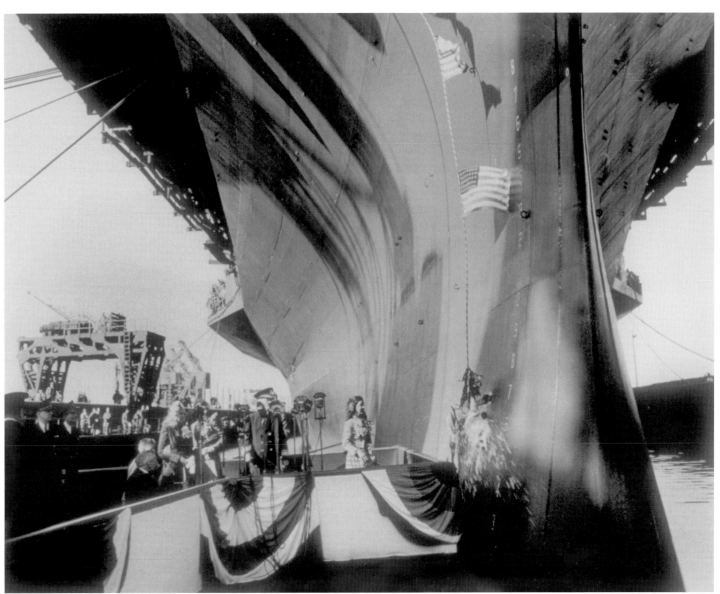

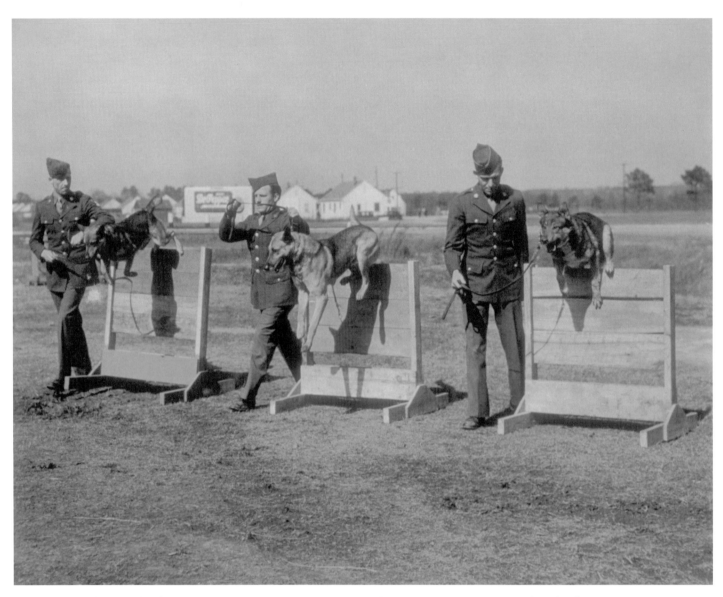

Beginning March 13, 1942, the U.S. Army Quartermaster Corps operated a War Dog program to train dogs for duty as sentries, scouts, messengers, and mine detectors. Five training centers were established—the first was in Front Royal, Virginia—and the training program lasted eight to twelve weeks. The dogs shown here on February 23, 1945, are undergoing final training at Bridge Camp, Hampton Roads Point of Embarkation, with their trainers, all military policemen, for service as sentries. Left to right are Pfc. William A. Irvin, of Bellefonte, Pa., with Rex; Pfc. Norman S. Olson, of Stoughton, Wis., with Pete; and Pvt. Howard A. Smith, of Philadelphia, Pa., with Chris.

A chaplain prepares to open the door to the Roman Catholic Italian Chapel at the Norfolk Army Base on Palm Sunday, March 25, 1945. The Forty-Hour Devotion was about to begin, and the chaplain and his assistants are bringing palms for the chapel.

This group of GIs at Camp Patrick Henry in Newport News, a processing camp for outward-bound and inward-bound soldiers, had just returned from overseas duty when they were photographed on June 22, 1945. They have adopted twelve-year-old Grace Matthews, shown here in an American flag–patterned dress made for her by relatives, as their "heroine." She had just returned from overseas herself, from Manila in the Philippine Islands, with more than two hundred other liberated prisoners of the Japanese aboard USS *General William A. Mann*. She reported that she was happy to be in America, but her memories of seeing her father and 249 other men given the "water treatment" (water poured down men's mouths and noses) were still vivid.

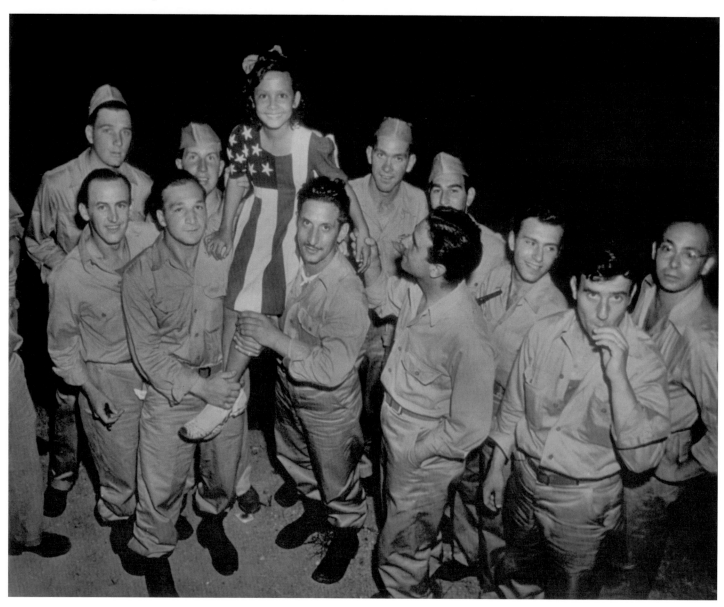

A happy day in Newport News for all concerned as the SS *Sea Tiger* is nudged against the pier on September 1, 1945. The vessel had left Marseilles, France, on August 22, to bring 2,594 troops home from World War II in Europe. *Sea Tiger* was a C3 cargo vessel commissioned on July 31, 1944.

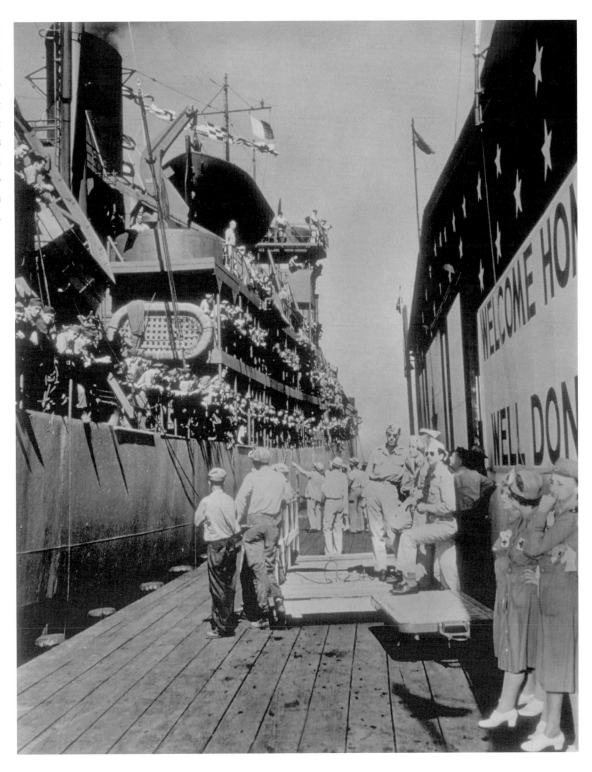

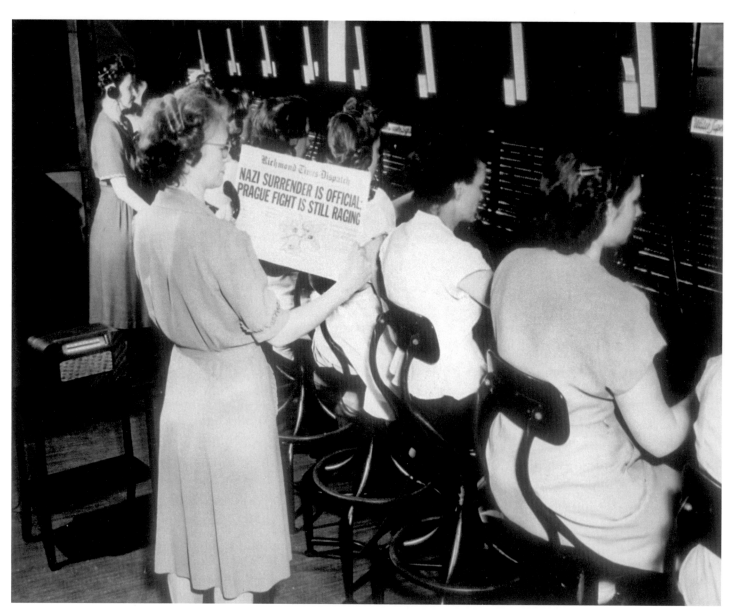

End of the war in Europe or not, work went on as usual on May 8, 1945, at the telephone switchboard in Building 201 at the Hampton Roads Point of Embarkation in Newport News. While Assistant Chief Operator Mrs. Bessie Fowlkes, of Petersburg, Virginia, studied the newspaper announcing the victory, in the background Chief Operator Mrs. Hanna Byrd, of Washington, D.C., supervised the switchboard operators.

The National Bank of Commerce was the largest financial institution in Norfolk in the 1940s, when this picture of a branch office was taken. The flagship building, fourteen stories tall, stood downtown at the corner of East Main and Atlantic streets. It was unsympathetically rehabilitated in 1968 and demolished in 1988.

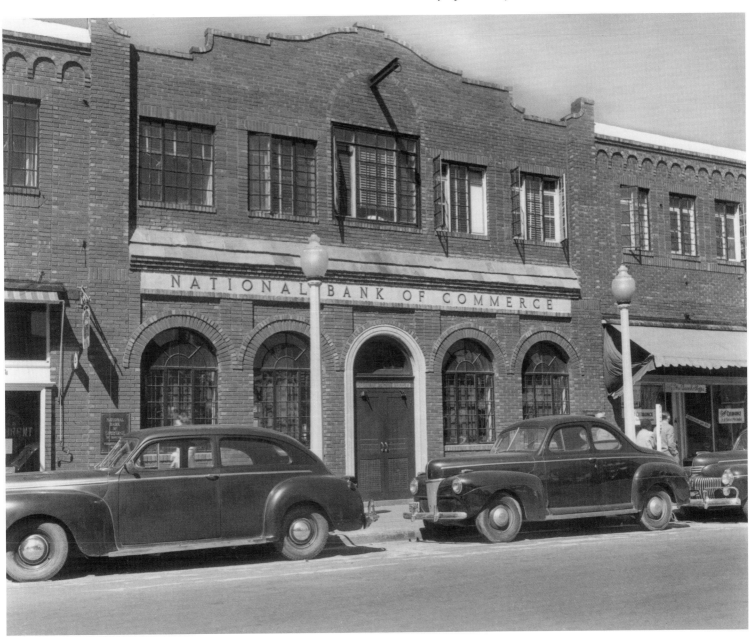

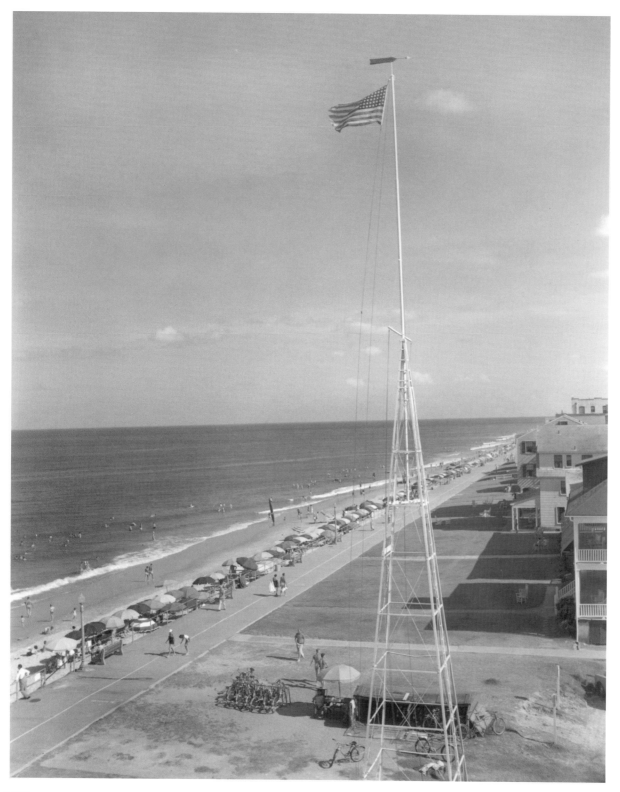

This view south along the Virginia Beach oceanfront was recorded in the 1940s. The small hotels in the picture have mostly been replaced with high-rise structures.

Until well into the twentieth century, the architecture of most bank buildings promoted the image of solidity, stability, and safety. Many were large, imposing structures. This smaller version, probably constructed in the 1930s or early 1940s, features the then-popular art deco style. Despite the human scale of the building, it appears reassuringly fortresslike, a safe place for one's money in the last years of the Great Depression. Once located in Virginia Beach on Pacific Avenue between 18th and 19th streets, the building no longer stands.

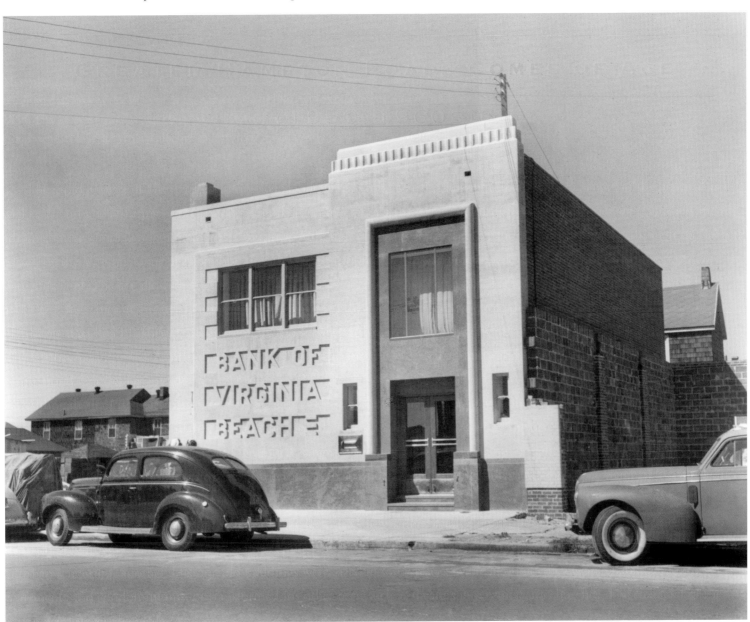

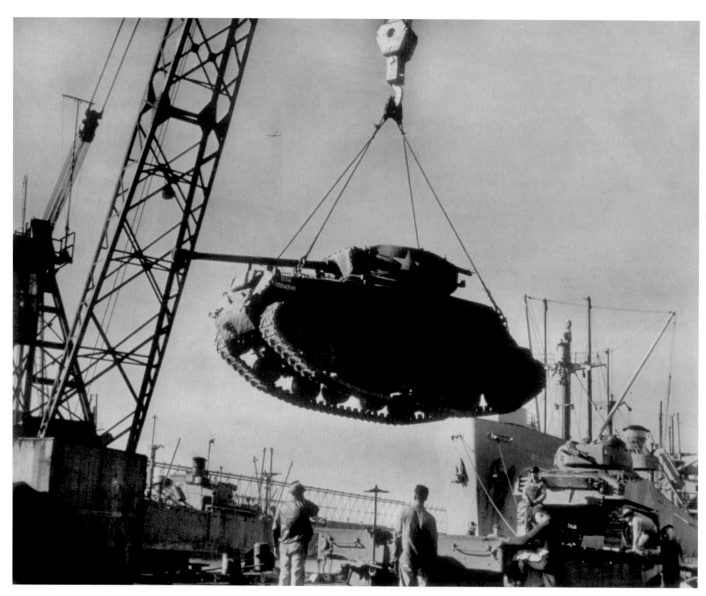

After World War II ended, huge quantities of armaments, vehicles, and equipment were returned to the United States for retirement or reuse by the armed forces. This light tank, which had just arrived from the European Theater of Operations, is shown being loaded on a flatcar at the dock in Norfolk on January 11, 1946.

Constructed in 1903 on the beachfront to replace an older station that stood a block inland, this building was one of a chain of lifesaving stations that stood along the coast to rescue people from ships in trouble. The crew shown here was expert in rescue techniques, dragging boats from the wide doors behind the men and forcing them through the surf into deeper water. Today this building, located on 24th Street at the oceanfront, houses the Old Coast Guard Station Museum and is one of the leading tourist attractions in Virginia Beach.

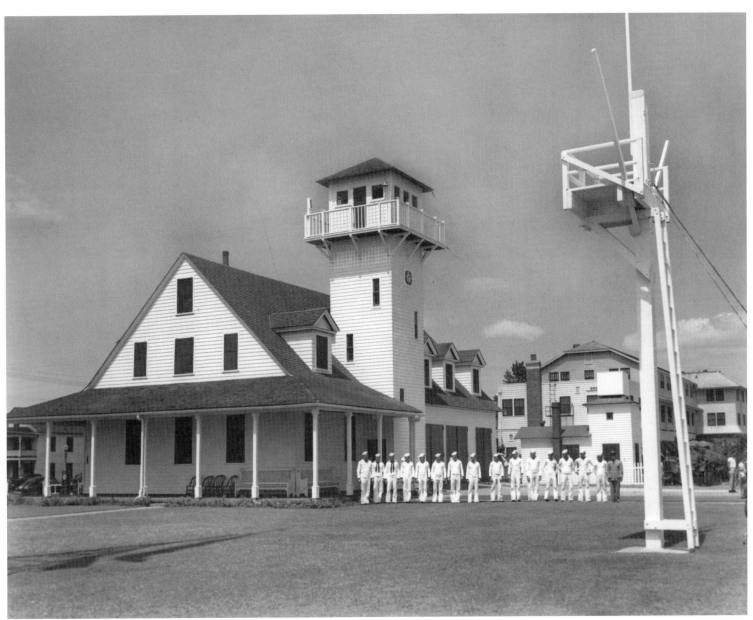

English colonists settled in the area now called Fox Hill in Hampton early in the seventeenth century. Like Buckroe Beach to the south, Fox Hill had a resort by the twentieth century. An evening baseball game is in progress there in 1947.

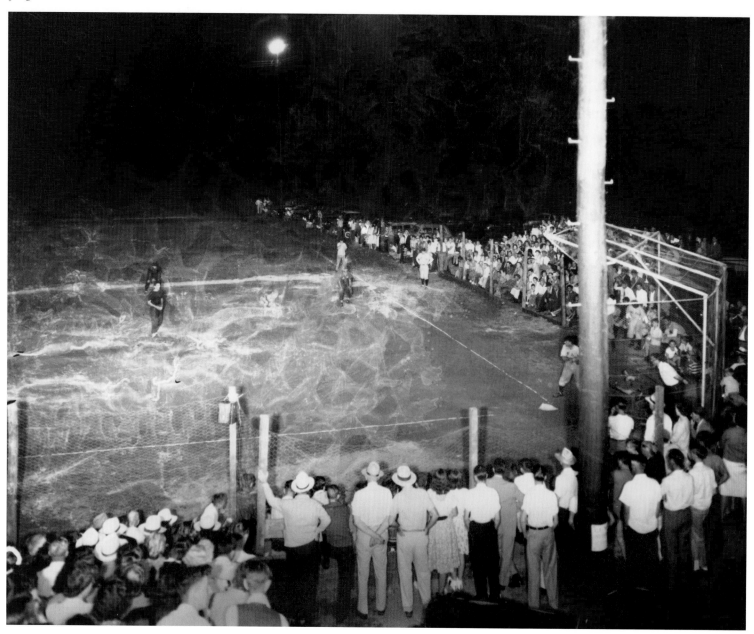

Tazewell Hall, which was relocated from Williamsburg to Newport News in the second half of the twentieth century, was constructed about 1762 for John Randolph, one of Virginia's leading colonial statesmen. The H-shaped mansion rivaled the Governor's Palace in size. John Tazewell bought it in 1778. The house was first moved from its original foundations about 1908 to make way for a street extension, and then was disassembled about 1954 and later reconstructed in Newport News. For years thereafter, it was the home of Lewis A. McMurran, Jr., a prominent Virginia politician.

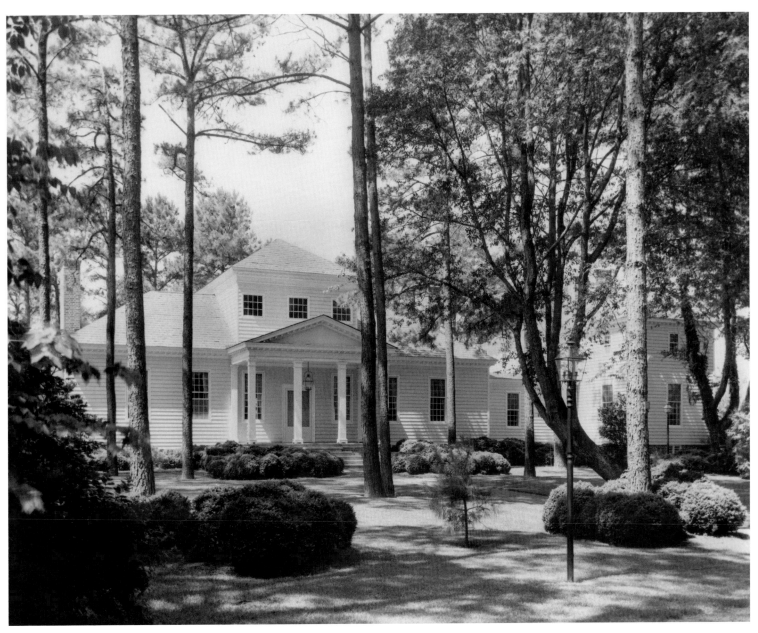

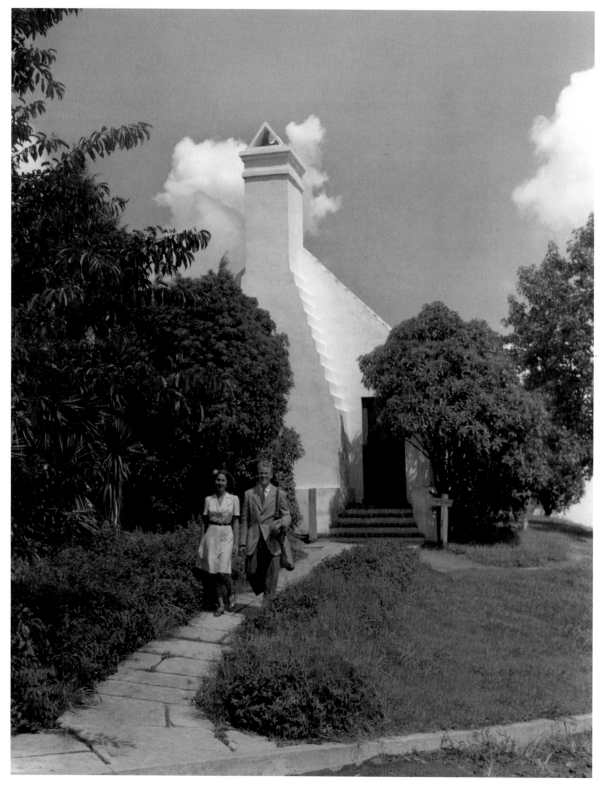

The Cavalier Hotel developed the Cavalier County Club golf course for its guests and opened it in 1930. Trapshooting and horseback riding were also available. Two guests are leaving the clubhouse here in the 1940s.

176

The Cavalier Country Club golf course was very popular with hotel guests, as shown in this 1940s view of the parking lot full of cars. Sam Snead won the Virginia Open on this course in 1935.

Recreational boaters, as well as commercial and amateur fishermen, have long plied the rivers and inlets of the Hampton Roads area. These sailboats were photographed on Linkhorn Bay in Virginia Beach in 1948.

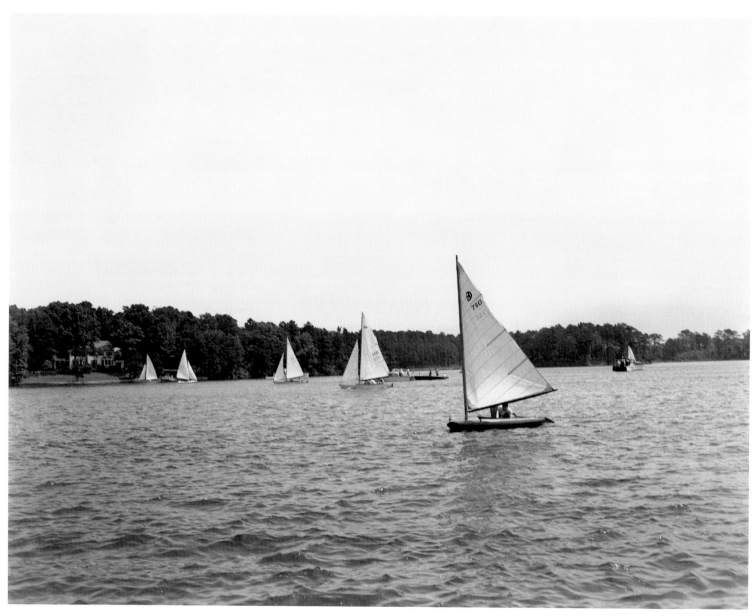

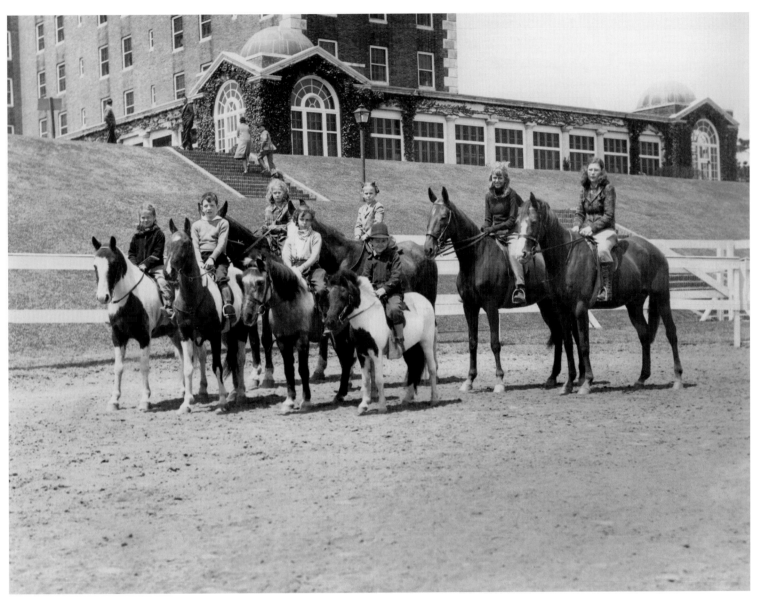

These young riders are about to learn show-ring techniques at the Cavalier Hotel in the 1940s. The hotel was constructed in 1927 as the premier resort in Virginia Beach, which had lacked a grand facility for years after the Princess Anne Hotel burned in 1907.

Young riders are shown going through their paces in the Cavalier Hotel's show ring in the 1940s. The hotel, completed in 1927 atop a sand hill about two blocks from the beach, became Virginia Beach's principal resort. During World War II, it was leased to the U.S. Navy. Amid postwar competition from newer hotels, it became a private club in 1953 and then closed in 1973, when the Cavalier Oceanfront hotel opened on the beachfront. By popular demand, the old hotel reopened three years later. Now restored to its former glory, the Cavalier on the Hill operates with Cavalier Oceanfront, and is once more a vital part of the Virginia Beach scene.

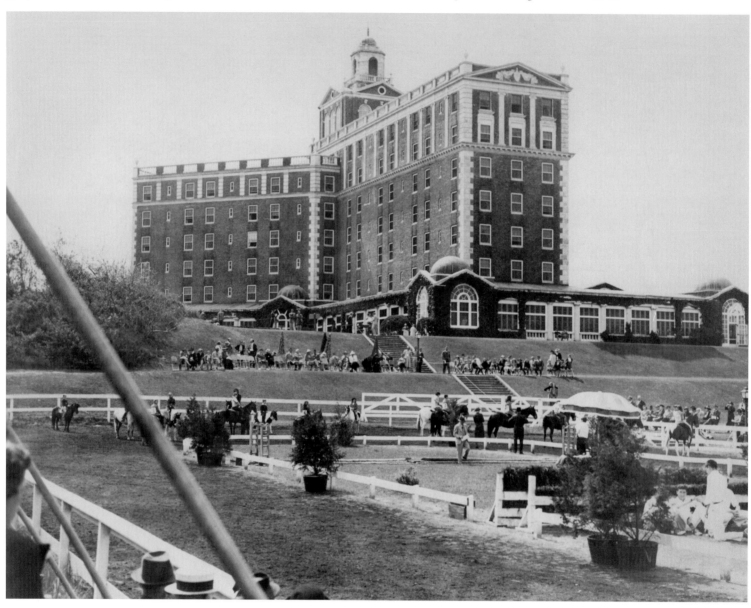

This aerial view of the Cavalier Country Club was taken in the 1940s, after boating piers replaced the trapshooting piers on the waterfront. Today the Cavalier Golf and Yacht Club is a private facility.

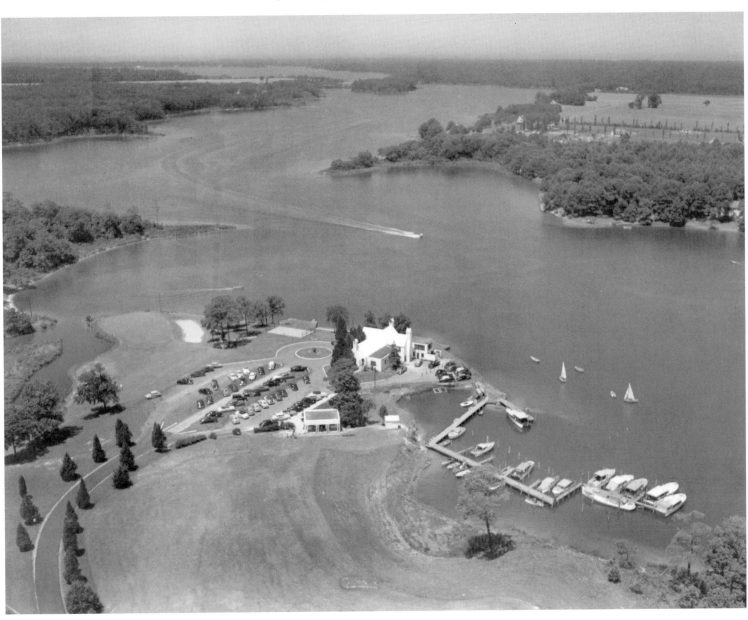

In 1898, a group of black entrepreneurs opened the Bay Shore Hotel near Buckroe Beach north of Hampton, after white businessman James S. Darling opened the Buckroe Beach Hotel the year before. Bay Shore, for years the only resort in the area for blacks, included a dance pavilion and an amusement park, as did Buckroe Beach for whites. The Bay Shore development group included Robert Russa Moton, the eminent African American educator and a founder of the United Negro College Fund. Bay Shore declined in the 1960s and was closed in 1973. The hotel, much enlarged, is shown here in 1949.

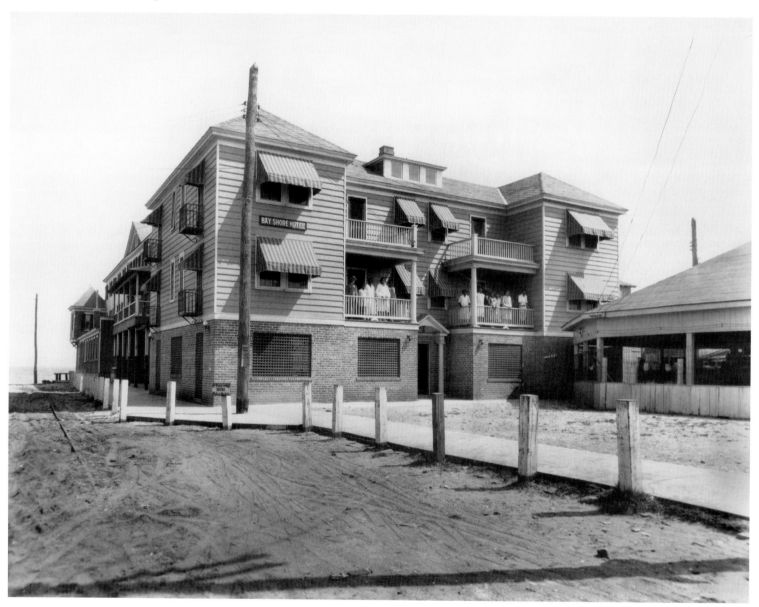

GREATER HAMPTON ROADS COMES OF AGE

(1950–1960s)

The rapid growth of Greater Hampton Roads following World War II resulted in fundamental changes in the political as well as the urban landscape of the region. Virginia is unique among the states in that its incorporated cities are politically and administratively independent of adjacent counties. Although for many years cities expanded their boundaries through special acts passed by the Virginia General Assembly, after the Constitution of 1902 was proclaimed, the legislature revised the procedure two years later. The act allowed cities to annex all or part of adjacent counties, a practice stopped only in 1987. Between 1952 and 1974, five cities in Greater Hampton Roads expanded their boundaries to subsume the surrounding counties. In 1952, Hampton absorbed Elizabeth City County; in 1958, Newport News incorporated Warwick County; and in 1963, Virginia Beach subsumed Princess Anne County, while Chesapeake absorbed Norfolk County and the city of South Norfolk. In 1972, Nansemond County became the city of Nansemond, and in 1974, it merged with the city of Suffolk, retaining the latter's name.

Although all of these cities experienced growth while suburbs spread housing developments, shopping centers, and acres of parking lots across former farmland, perhaps the most dramatic changes occurred along the oceanfront of Virginia Beach. The old family cottages all but vanished, and with increasing speed the small hotels gave way to high-rise buildings, including hotels, apartments, and condominiums. New infrastructure, such as landscaping, lighting, sidewalks, and signs, changed the appearance and ambience of the seaside resort community.

Suburban shopping centers altered not only the face of what was once rural Virginia, but also challenged the cities to keep their old downtown commercial avenues alive. Some places turned into virtual ghost towns, while others enacted one form of urban renewal or another. Historic old buildings were razed in some places, while in others they were rehabilitated into apartments and condominiums, or transformed for other uses, such as theaters into center-city churches. The character of the region was forever changed.

The challenge of balancing the past and the future continues today in Greater Hampton Roads, as elsewhere. Growth shows no sign of abating, nor does the debate about the best use of land and other resources in a way that both respects the past and addresses the needs of the future.

Oysters were once plentiful throughout the Chesapeake Bay and its tributary rivers. The commerce was so lucrative that in the 1880s and 1890s "oyster wars" were fought between oystermen in Virginia and Maryland. Today, pollution and bacteria threaten the delicacy's survival. These unidentified men were photographed in the 1950s unloading oysters in Hampton.

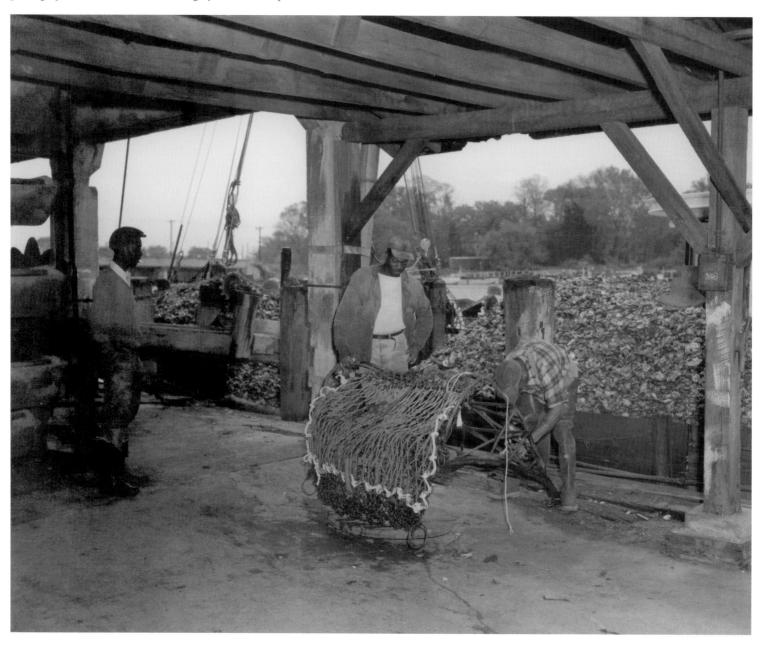

The Virginia Beach pier is located on the oceanfront at 15th Street, jutting into the water from the boardwalk. Shops selling beach and fishing gear are located on the pier near the boardwalk, while the rest of the pier is open for fishing and watching the beach scene.

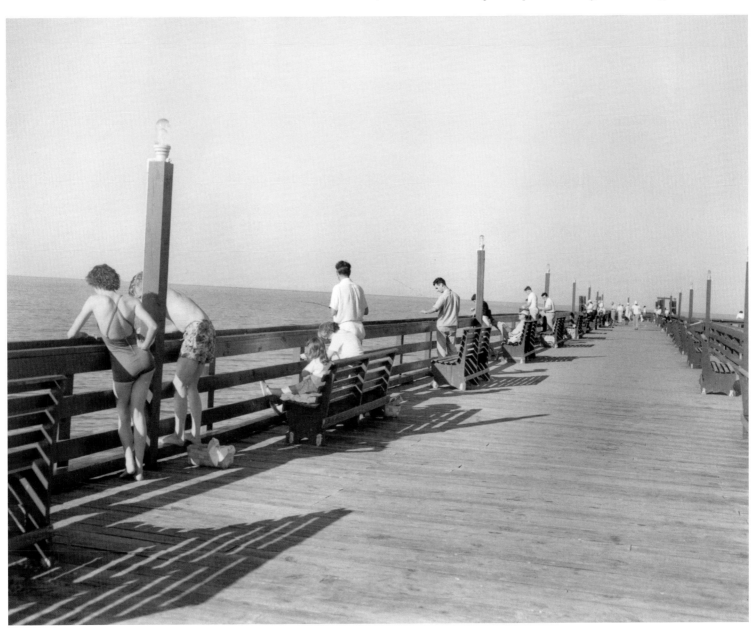

The boardwalk at Virginia Beach has been remodeled several times over the years, and since before the mid twentieth century has been made of concrete. It also has a lane for bicyclists such as this young woman, photographed in the 1950s, and another lane for pedestrians.

Except for the Cavalier Hotel, Virginia Beach had no other large hostelries until later in the twentieth century. Most of the hotels were smaller establishments, including the Avamere, long a favorite of many tourists. Two unmarried sisters from North Carolina, Maude and Virginia Leggett, came to Virginia Beach in 1918 and rented a ten-room cottage, and then leased rooms to paying guests. Later, another sister, Lena Leggett Smith, opened the Avamere in 1939. Her son, Clarence, and his wife, Peggy, operated it until 1981.

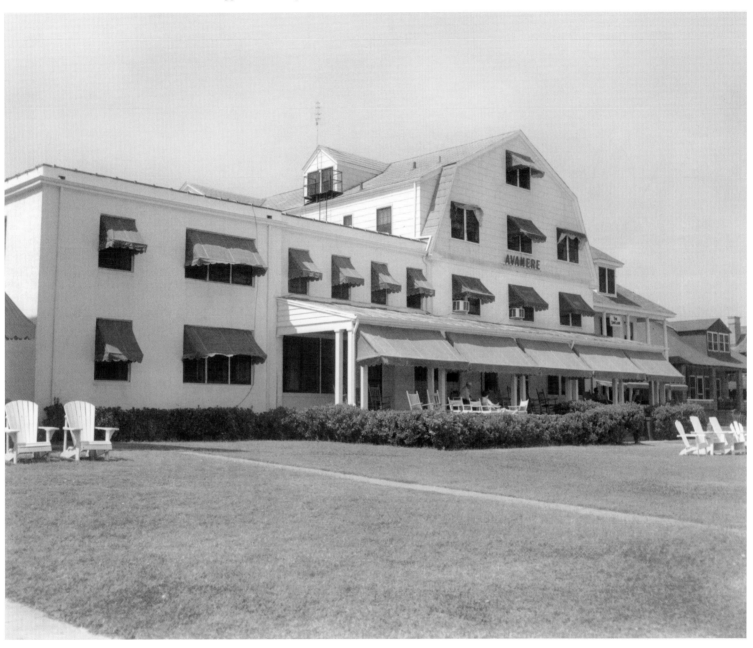

This view, recorded in the 1950s, shows Court Street north from the old post office building. In the middle distance is a sign for the Hotel Monroe, one of Portsmouth's landmark buildings. Erected in 1856, it was first called the Ocean House, and it served during the Civil War, at different times, as Confederate officers' quarters and as a Union hospital. It was destroyed by fire on August 9, 1957.

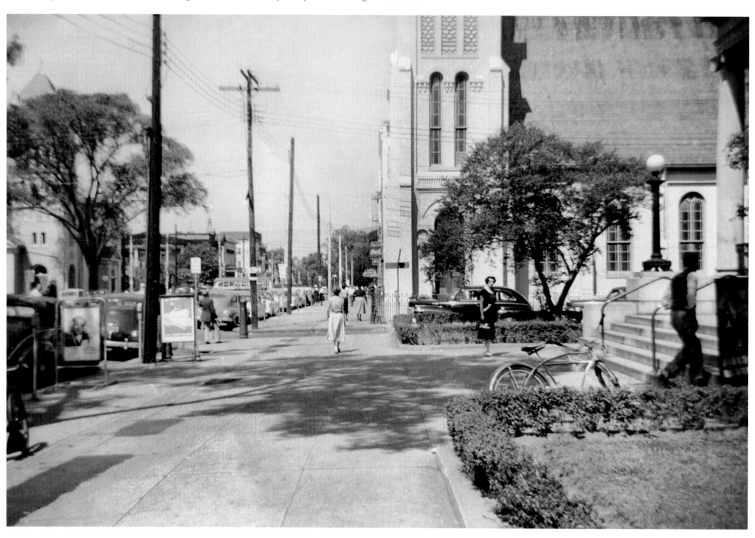

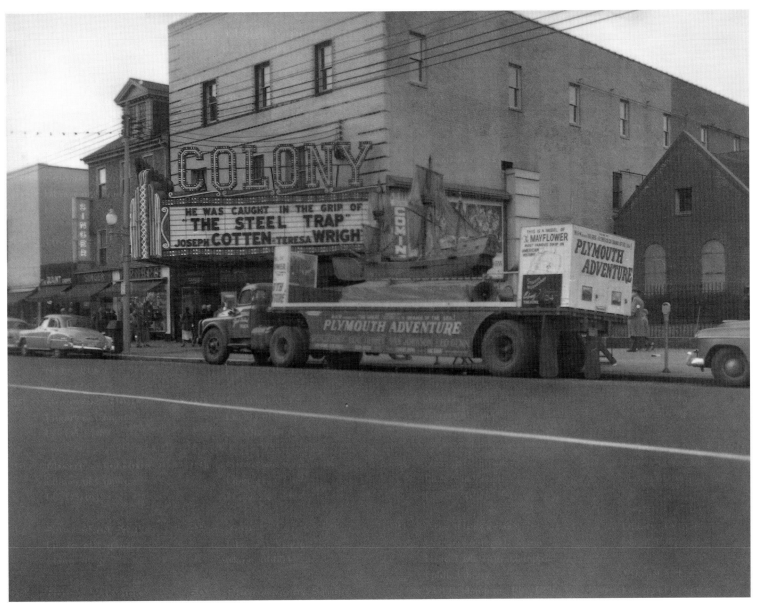

The Colony Theater, located at 430 High Street in Portsmouth, was showing one motion picture while the truck parked in front promoted another. *Plymouth Adventure* was issued in 1952, when this picture was taken. The movie starred Spencer Tracy, Van Johnson, and Gene Tierney, and told the story of the voyage of the *Mayflower* to Massachusetts. The truck parked out front carries a model of the ship. *The Steel Trap,* with Teresa Wright and Joseph Cotten, a native of Petersburg, Virginia, was a crime thriller in which Cotten played a larcenous bank official. The theater is being converted into apartments.

This view looking west on the Virginia Beach pier shows the shops near the boardwalk end of the pier as well as the small hotels that lined the beachfront.

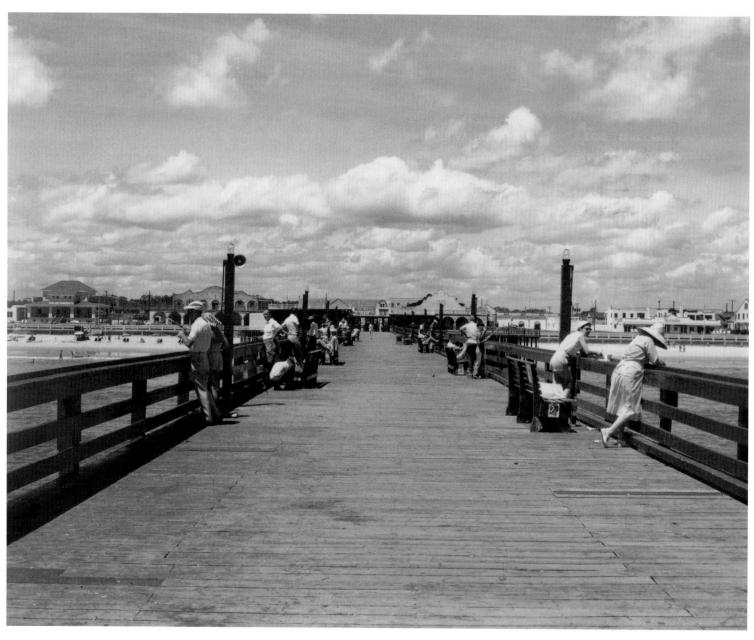

The Virginia Beach pier is visible in the distance here in 1951. Today, beach umbrellas like those shown here are seldom seen on the waterfront.

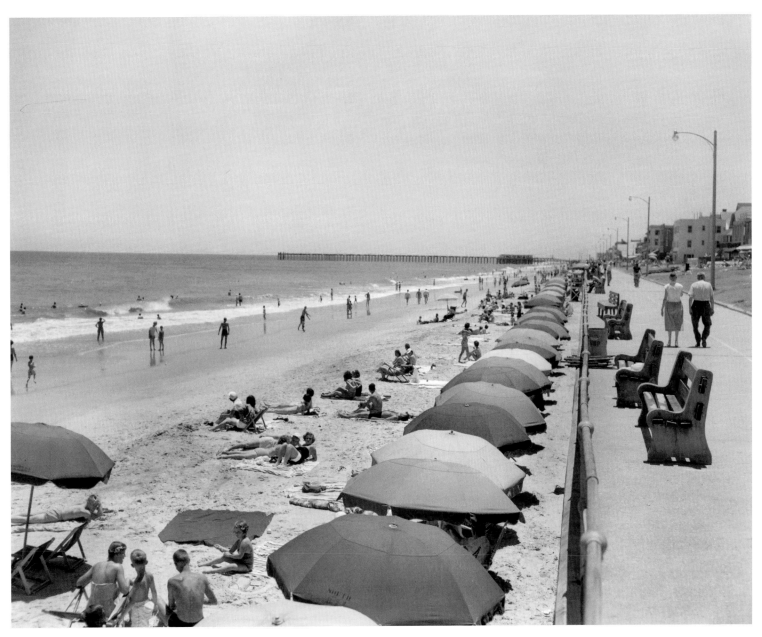

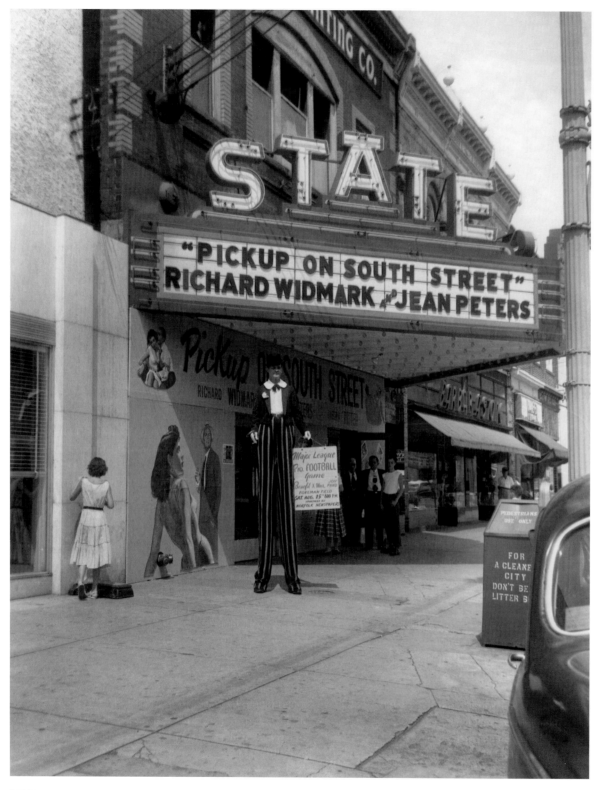

In August 1953, the State Theater at 510 High Street in Portsmouth was showing *Pickup on South Street*, a film noir spy thriller starring Richard Widmark, Jean Peters, and Thelma Ritter, who was nominated for the Academy Award as best supporting actress. The man on stilts is advertising a forthcoming professional football game. Today, the theater is closed and the building is currently in use as a church.

In 1906, J. C. Tait of Norfolk constructed a stone Queen Anne–style "cottage" at Virginia Beach on the oceanfront at 25th Street, close by the new lifesaving station. About 1922, several Norfolk businessmen acquired the house, added wings and a large extension to the rear, and transformed it into the new Princess Anne Hotel, named for Virginia Beach's long-departed resort hotel. This photograph was taken in the 1950s; the "new" Princess Anne Hotel was demolished early in the 1960s and replaced with another hotel.

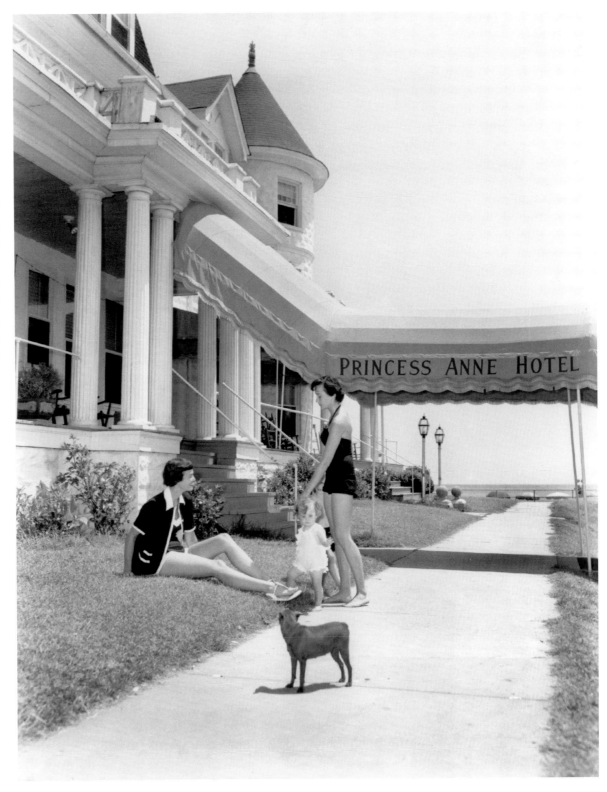

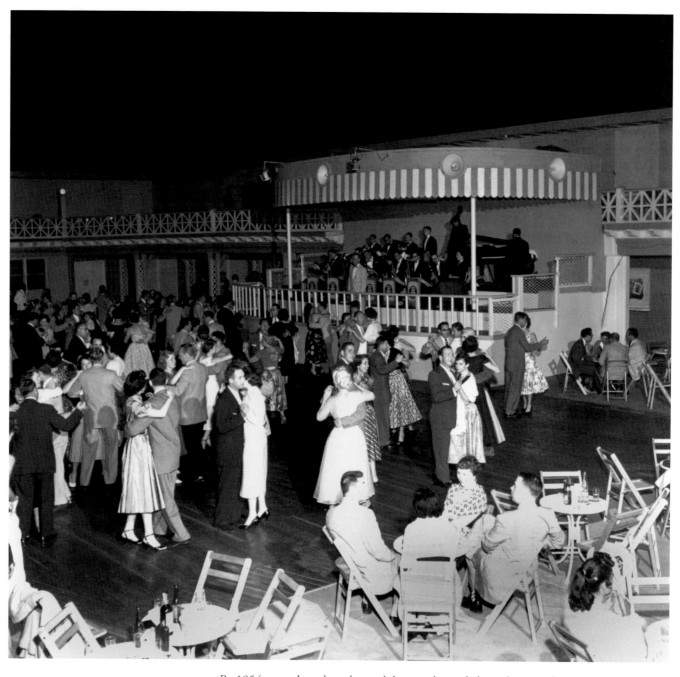

By 1954, several outdoor dance clubs were located along the oceanfront and live orchestras still played for them.

The color guard of the Booker T. Washington High School band of Suffolk marched in a parade during the annual session of the Virginia State Association of Elks, which met in Portsmouth on May 15-19, 1954. The parade moved down High Street (shown here) and then to the Portsmouth Municipal Stadium. Good weather held for the parade, but the events planned for the stadium were rained out.

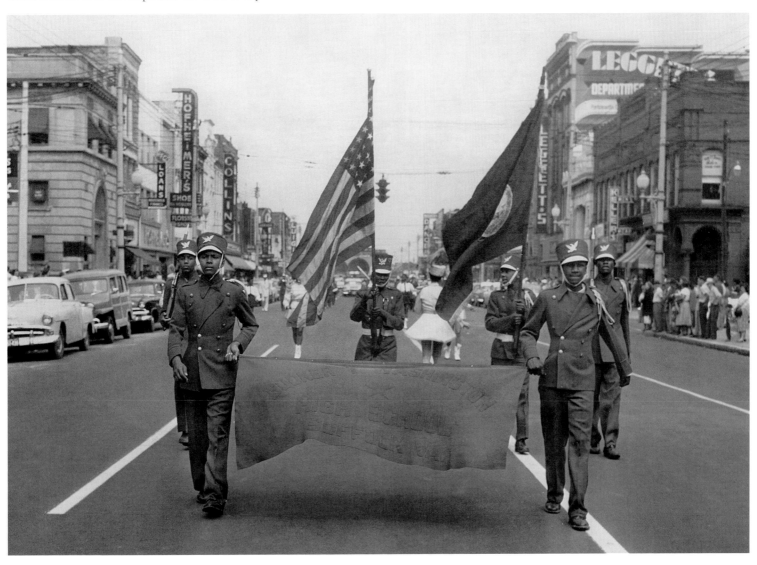

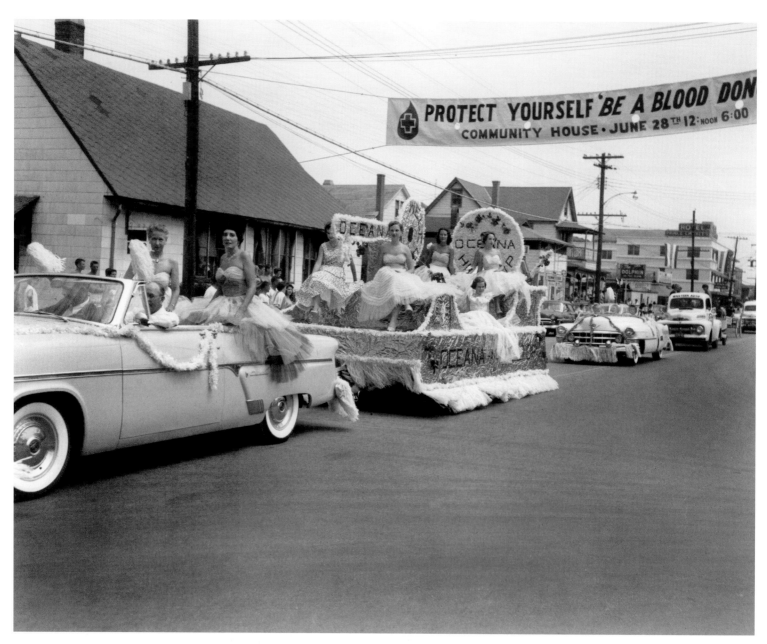

Numerous summer festivals have been held at Virginia Beach over the years. In 1954, it was the Virginia Beach Sand Festival, which included a parade of vehicles and floats.

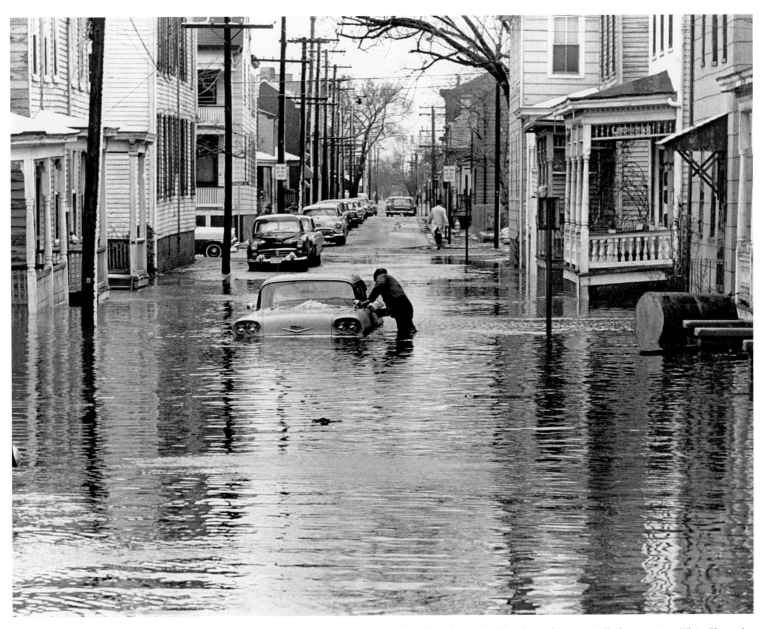

Portsmouth, like other cities in Hampton Roads, suffered periodic flooding after especially heavy rains. This Chevrolet is in high water on Glasgow Street near Middle Street in the 1950s.

A man and a teenage boy pose with their catch on the Virginia Beach pier in 1959. At right, an empty bottle suggests that someone had a Pepsi, but neglected to heed the public-service sign in the background stating, "Bottles Underfoot are Dangerous, Place in Rack."

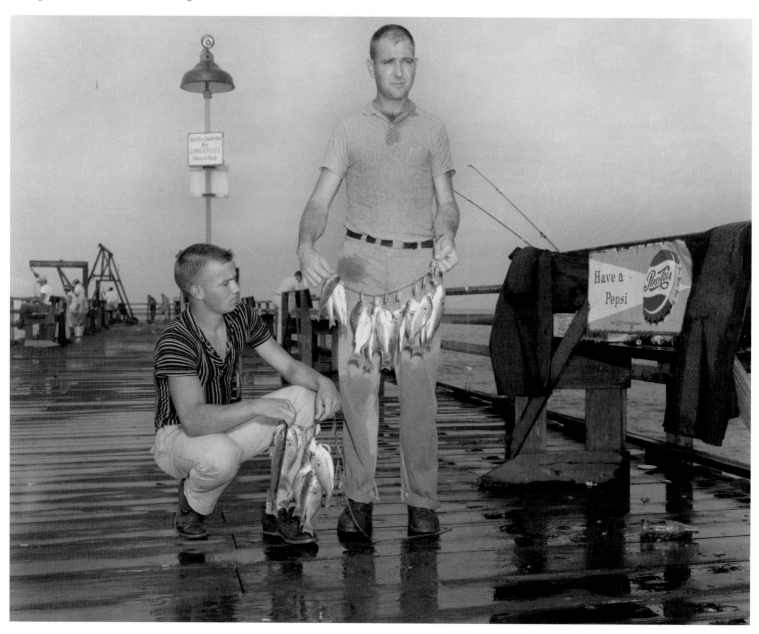

Buckroe Beach began to develop as a summer resort in 1883, when Mary Ann Dobbins Herbert opened a boardinghouse there. It started to boom late in the century when James S. Darling, of Hampton, opened the Buckroe Beach Hotel on June 21, 1897. The new hotel featured a dance pavilion, and an amusement park was soon erected nearby. Other entrepreneurs followed with additional hotels, including an African American group that opened the Bay Shore Hotel in 1898, the only resort in the area available to blacks. By the mid twentieth century, the heyday of Buckroe Beach as a resort area was passing as Virginia Beach rose in prominence, but visitors continued to come for miniature golf and other pastimes.

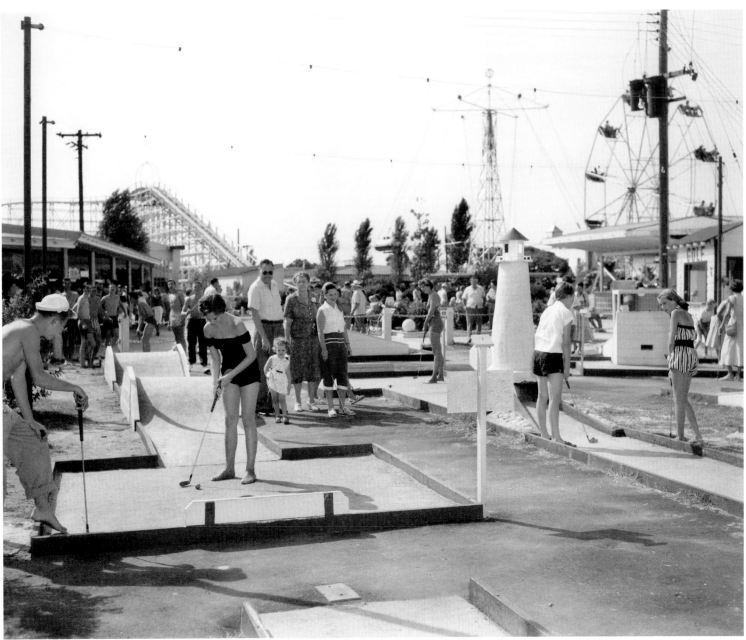

NOTES ON THE PHOTOGRAPHS

These notes, listed by page number, attempt to include all aspects known of the photographs. Each of the photographs is identified by the page number, photograph's title or description, photographer and collection, archive, and call or box number when applicable. Although every attempt was made to collect all available data, in some cases complete data was unavailable due to the age and condition of some of the photographs and records.

II SHIPYARD
Library of Virginia
07_1442_07

VI GIRLS FISHING
Library of Virginia
VCC18402

X USS SABINE
Library of Congress
LC-DIG-cwpb-03820

3 HAMPTON
Library of Congress
LC-DIG-cwpb-03817

4 DAVID D. POTTER
Library of Congress
LC-DIG-cwpb-03898

5 USS FORT JACKSON
Library of Congress
LC-DIG-cwpb-03830

6 MILITARY HOSPITAL
Library of Congress
LC-DIG-cwpb-01242

7 HAMPTON IN RUINS
Library of Congress
LC-USZ62-103066

8 NAVY YARD
Library of Congress
LC-DIG-cwpb-01294

9 HIGH STREET
Courtesy of Portsmouth Public
Library, Portsmouth, Va.
VDLP_OLT_1022014

10 DRY DOCK
Library of Virginia
07_1442_31

11 WARWICK RIVER COUNTY
Library of Virginia
07_1442_12

12 HIGH STREET
Courtesy of Portsmouth Public
Library, Portsmouth, Va.
1040002

13 PUNCHING MACHINE
Library of Congress
LC-USZ62-95566

14 QUEEN STREET
Courtesy of the Hampton
History Museum–Hampton
Public Library
VDLP_Hampton_B09_0378_
04

15 OCEANFRONT
Library of Virginia
Mann_01398

16 TRADE SCHOOL SHOP
Library of Congress
LC-USZ62-38620

17 STOCKYARDS
Library of Congress
LC-USZ62-112593

18 QUEEN STREET
Courtesy of the Hampton
History Museum–Hampton
Public Library
VDLP_Hampton_B09_0378_
03

19 CLOTHING STORE
Library of Virginia
Mann_00513

20 HYGEIA HOTEL
Library of Congress
LC-D4-21279

21 MAIL ORDERLIES
Library of Congress
LC-D4-21280

22 PRIMARY SCHOOL
Library of Congress
LC-USZ62-38620

23 BOARDING PASSENGERS
Library of Congress
LC-D4-32595

24 NATIVE AMERICANS
Library of Congress
LC-DIG-ppmsca-12031

25 CAPILLARY PHYSICS
Library of Congress
LC-USZ62-108065

26 CHAMBERLAIN HOTEL
Courtesy of the Hampton
History Museum–
Hampton Public Library
VDLP_Hampton_B03_0147_
03

27 AMERICAN CHILDREN
Library of Congress
LC-USZ62-78702

28 MELLEN STREET
Courtesy of the Hampton
History Museum–
Hampton Public Library
VDLP_Hampton_B09_0379_01

29 QUEEN STREET
Courtesy of the Hampton
History Museum–
Hampton Public Library
VDLP_Hampton_B08_0368

30 FISH MARKET
Courtesy of Portsmouth
Public Library, Portsmouth
VDLP_OLT_1015101

31 MEMORIAL CHAPEL
Library of Virginia
VCC008518-000

32 CHAMBERLAIN HOTEL
Library of Congress
LC-D4-32745

33 HORSE REEL
Courtesy of the Hampton
History Museum–
Hampton Public Library
VDLP_Hampton_B07_0343

34 HOTEL ROACHE
Library of Virginia
Mann_01371

35 SOLDIERS' HOME
Library of Congress
LC-D4-14187

36 MONTICELLO HOTEL
Library of Congress
LC-D4-14195

37 EAST MAIN STREET
Library of Virginia
Mann_00587

38 HOTEL WARWICK
Virginiana Collection, Main
St. Library, Newport News
Public Library System,
Newport News, Va.
VDLP_NN_HW_42

39 HIGH STREET
Courtesy of Portsmouth Public
Library, Portsmouth, Va.
VDLP_OLT_1025054

40 DRY DOCK
Library of Virginia
07_1442_28

41 GIGANTIC CRANE
Library of Virginia
07_1442_25

42 SILSBY BUILDING
Library of Virginia
07_1442_29

43 DRY DOCK COMPANY
Library of Virginia
07_1442_27

44 POST OFFICE
Library of Virginia
07_1442_24

45 CITY HALL
Library of Congress
pan 6a15800

46 LIGHTHOUSES
Library of Congress
LC-DIG-det-4a12491

48 SUB BOAT
Library of Congress
LC-USZ62-89963

49 YACHT CLUB
Library of Virginia
Mann_00004

50 PHOTOGRAPHY STUDIO
Courtesy of the Hampton
History Museum–Hampton
Public Library
VDLP_Hampton_B05_0204_
01

51 POST OFFICE
Library of Virginia
Mann_00095

52 MELLEN STREET SALOON
Courtesy of the Hampton
History Museum–Hampton
Public Library
VDLP_Hampton_B03_0170

53 DEEP CREEK
Library of Virginia
Mann_01814

54 HAMPTON BEACH
Courtesy of the Hampton
History Museum–Hampton
Public Library
VDLP_Hampton_B01_0016_
02

55 JAMESTOWN EXPOSITION
Library of Congress
LC-USZ62-110816

56 NAVY WARSHIPS
Library of Congress
LC-USZ62-90103

57 JAMESTOWN EXPOSITION
Library of Congress
LC-USZ62-103105

58 VIRGINIA HOUSE
Library of Congress
LC-USZ62-103104

59 FIRE DEPARTMENT
Courtesy of the Hampton
History Museum–Hampton
Public Library
VDLP_Hampton_B07_0336

60 SEWELL'S POINT
Library of Congress
LC-USZ62-59409

61 OLD POINT COMFORT
Library of Congress
LC-USZ62-90099

62 NEWTON HOUSE
Library of Virginia
Mann_00102

64 CITY HALL AVENUE
Library of Virginia
Mann_01036

65 RAILROAD STATION
Library of Congress
LC-USZ62-113355

66 PRIMARY SCHOOL
Library of Virginia
Mann_00718

67 NORFOLK CITY MARKET
Library of Virginia
Mann_00741

68 MESSENGER BOYS
Library of Virginia
Mann_00945

69 PALACE THEATRE
Library of Virginia
Mann_00690

70 PRINCESS ANNE HOTEL
Library of Virginia
Mann_01754

71 SEASIDE PARK
Library of Virginia
Mann_00072

72 VIRGINIA 1
Library of Congress
LC-USZ62-73876

73 TAYLOR BUILDING
Library of Virginia
Mann_00563